Patrick Moore's Practic

Choosing and Using
a Refracting Telescope

Neil English

 Springer

Dr. Neil English
G63 0YB Glasgow
UK
neilenglish40@gmail.com

ISBN 978-1-4419-6402-1 e-ISBN 978-1-4419-6403-8
DOI 10.1007/978-1-4419-6403-8
Springer New York Dordrecht Heidelberg London

Library of Congress Control Number: 2010935189

Printed on acid-free paper

Springer is part of Springer Science+Business Media (www.springer.com)

Preface

Four centuries ago, a hitherto obscure Italian scientist turned a home-made spyglass towards the heavens. The lenses he used were awful by modern standards, inaccurately figured and filled with the scars of their perilous journey from the furnace to the finishing workshop. Yet, despite these imperfections, they allowed him to see what no one had ever seen before – a universe far more complex and dynamic than anyone had dared imagine. But they also proved endlessly useful in the humdrum of human affairs. For the first time ever, you could spy on your neighbor from a distance, or monitor the approach of a war-mongering army, thus deciding the outcome of nations. Stoked by virginal curiosity or just the chance to make money, men of great skill and patience championed the cause to perfect the art of making and shaping ever finer lenses for an increasingly demanding public.

The refracting telescope – that which uses lenses to form an image – is distinguished from all other telescopic designs by its unique pedigree. Seasoned and perfected over several human generations, the refractor has blossomed into a magnificent array of endlessly useful optical tools. Opera glasses, gun sights, spotting scopes, binoculars, and periscopes all derive their power from the basic designs used in instruments perfected for astronomical investigation.

Although the Galilean telescope enjoyed a healthy future with the general public, astronomers who followed Galileo soon began looking for ways to perfect it. First they made the telescopes long. Then, in the early decades of the eighteenth century, a way was found to make them much shorter and

thus more convenient to use. This tendency to downsize, which was instituted nearly 300 years ago, shows no signs of abating in the twenty-first century, when small, ultraportable instruments continue to drive the market. Historically speaking, that's the long and the short of it!

The refractor is without doubt the prince of telescopes. Compared with all other telescopic designs, the unobstructed view of the refractor enables it to capture the sharpest, highest contrast images and the widest usable field. No other telescope design can beat it on equal terms. From a practical point of view, refractors are the most comfortable and least troublesome telescope to observe with. They require little maintenance and cool down rapidly to allow you to observe in minutes rather than hours. Because a refractor has more back focus than almost any other form of telescope, it can accept the widest range of accessories, including filters, cameras, and binoviewers.

A generation ago, small astronomical refractors came almost exclusively in the iconic form of a long tube with a doublet lens objective – the so-called achromatic telescope – made from flint and crown glasses, a prescription that had been frozen into place almost 150 years before. These little backyard telescopes, ranging in aperture from 2 inches up to 6 inches, produced images of the heavens so splendid they kept their owners happy for many years. They had to be made with long focal lengths to counteract the principal flaw inherent to the design – false color (or more technically, chromatic aberration). Simply put, the achromatic objective lens acts like a weak prism, spreading the different colors of light out and causing them to reach focus at slightly different points, some nearer and some further away from the eye. This had the effect of degrading the definition of the image, especially when high powers were employed. And although telescopes could be made to reduce false color to an absolute minimum, the length of the telescope had to increase to keep it entirely at bay.

The first glimmer of a breakthrough came at the very end of the nineteenth century, when British optical engineer H. Denis Taylor produced a triplet objective made with new types of glass to reduce this false color by an order of magnitude or more. These photo-visual triplets represented the first truly apochromatic forms, or refractors that exhibit little in the way of false color around bright, high contrast objects. Although the new Taylor photo-visual triplets found their way into many astronomical observatories, their great expense meant that they remained beyond the reach of all but the most well-to-do amateur astronomers, and that's more or less how the situation remained until the 1970s, when a few intrepid optical designers, experimenting with new and improved types of glass, gave way to a new wave of refractor building the likes of which we have not seen in over 300 years. New kinds of artificially grown crystals, fluorite especially, could be fashioned into objec-

tive lenses that could eliminate the spurious color thrown up by traditional achromats. Yet these early "Apos," meticulously assembled by such illustrious manufacturers as Zeiss, Astro Physics, and Takahashi, were still prohibitively expensive to most amateur astronomers and thus remained dream 'scopes for the majority of us.

In the last decade, though, the tide has finally turned in favor of the amateur, with the introduction of a wide variety of high quality Apos available at affordable prices. Ranging in size from ultra-portable (2-inch) 50mm to 8-inch (200mm), there's one to suit everyone's budget. This, together with a wide range of traditional achromatic refractors and spotting 'scopes being sold across the world, means that there's never been a better time to own a refractor for nature study, astronomy, or photography. And that's what this book is all about – how to choose and use a refracting telescope, both astronomical and terrestrial, to suit your purposes.

After briefly delving into the long historical pedigree of the refracting telescope, we'll continue Part 1 of the book by taking a closer look at all aspects of the design and manufacture of both traditional achromats and their various forms (short-tube, medium-, and long focus), as well as looking at some celebrated classic 'scopes from the past. In Part !!, there is more of the same thing, only this time round it's with Apos. By first exploring the very nature of apochromatism, we then provide a comprehensive survey of the various genres of Apo refractors currently being sold, including doublets, triplets, and four-element designs, and discuss the meritorious aspects of a selection of popular models used by amateur astronomers. In addition, there is a a chapter in Part II of the book dedicated to sports optics, those small, highly portable models used by nature enthusiasts and astronomers with a passion for travel. An exploration of the relative merits of buying a dedicated spotting 'scope to the new range of economically priced ultraportable Apos marketed at the amateur astronomy community comes after this. Is an ultra-expensive Leica or Swarovski really in your future?

Maybe you already own one or more refracting telescopes. Then you may find Part III of the book of considerable use. What kinds of accessories might be beneficial to your viewing experience? You'll find some advice in the chapter dedicated to kitting out your refractor. Does your telescope deliver the goods out of the box? We'll be looking at some simple daylight and nighttime tests that can be performed on your telescope to assess its quality. Enjoying your refractor depends a lot on how well mounted it is. Accordingly, there will be a brief survey the types of mounting – alt-azimuth and equatorial – available to skygazers to give you an idea of what best suits you. The well-corrected, unobstructed optics of refractors has made them popular choices for astro-imagers and wild life photographers alike. I'll be

sharing some pearls of wisdom that I've learned from some experienced astrophotographers, who routinely use their refractors to create some of the most awe-inspiring celestial portraits ever made.

The refractor has enjoyed an illustrious career spanning the entire history of modern astronomy. But where does its future lie? What's more, now that synthetic ED glass is available cheaply, is it just a matter of time before the humble crown-flint achromat disappears off our radar forever? In the last chapter of the book, we've canvassed the opinions of a number of people who share a passion for the refracting telescope, as well as describing an instrument that helped change the author's own views on the matter irrevocably.

The units discussed in the book are a mixture of the old and the new. Aperture is in units of inches, as this seems to be the way the overwhelming majority of amateurs choose to characterize their instruments. There are also some metric conversions for those few who seem to prefer metric (Do you really prefer 102mm to 4 inches?). In all other matters, standard units are assigned to physical quantities (such as wavelengths of light expressed in nanometers). Technical language has been kept to a very minimum, because it is largely unnecessary to understanding the crux of many of the optical issues discussed in the book. You can always have a look at the glossary and the various appendices if you feel inclined to dig a little deeper.

This book could have been twice as long, so rich and diverse is the history of the refracting telescope. Only a few models within a given genre are discussed. If your telescope has not been mentioned, we apologize unreservedly.

The making of this book was an adventure in discovery, the likes of which I did not expect and I have thoroughly enjoyed the experience. I knew refractors were going to be popular, but I was quite unprepared for the pure, unbridled passion people of all creeds and cultures have for their refracting telescopes. Failing that, if you're just plain curious and would like to know why so many people express such boundless enthusiasm for these instruments, then pull up a seat and enjoy the ride!

September 2010

Dr. Neil English
Fintry, Scotland, UK

Acknowledgements

I found this book to be an extraordinarily challenging undertaking, attempting as I was to summarize the current state of affairs in the constantly evolving world of the refracting telescope. Such a task, naturally, could not have been pulled off in isolation. It simply wasn't possible to look through every telescope discussed in the book. And I have a great many individuals to thank for taking time out from their busy lives to answer my questions. Very special thanks are extended to Vladimir Sacek, author and creator of that marvellous online resource www.telescopeoptics.net, to Christopher Lord of Brayebrook Observatory, Cambridge, and to Es Reid, for their many helpful discussions on the refracting telescope. I would also like to acknowledge the wonderful help of Richard Day, founder of Skylighttelescopes.co.uk for providing high resolution images of some fine refractors of every vintage, and to Bill Jamieson, who kindly provided his time to reproduce some images for me. Special thanks also to Barry Greiner of D & G Optical for a useful discussion on the future of the achromatic refractor. I'd also like to thank Antony McEwan, Kevin Berwick, Seigfried Jachmann, Clive Gibbons, Brian Grider, Doug Sanquenetti, Bill Drelling, Phil Gulvins, Dave Tinning, Chris Beckett, Ted Moran, Josh Walawender, Stuart Ross, Ian King, David Stewart, Jim Roberts, John Currie, Karl Krasely, Robert Ayers, Pollux Chung, Lee Townend, Ron Laeski, Ted Moran, Nathan Brandt, Frank Bosworth, Geoffrey Smith, John Cameron, J.D. Metzger, and Dennis Boon. Special thanks is also extended to Robert Law of Dundee Mills Observatory for taking the time to show me round the 10-inch Cooke refractor. Finally, I'd like to say a big thank you to Maury Solomon and the editorial team at Springer for a job well done.

Contents

The Achromatic Refractor

The Refracting Telescope: A Brief History

The history of the refracting telescope is an extraordinarily long, rich, and complex one. Indeed, it was beyond the scope of this book to recount all the contributions made by the many individuals that shaped the long and distinguished history of the refracting telescope. Truth be told, this book could have been dedicated to this end alone!

What follows is an overview of the key players that helped shape the evolution of the refractor over four centuries of history. Those wishing to dig a little deeper are encouraged to consult some of the reference texts listed at the back of the book.

Nobody knows for sure where the telescope was invented. One thing is certain, though. Ancient human societies – the Phoenicians, Egyptians, Greeks, and Romans – were quite familiar with the remarkable properties of glass. Historians inform us that the telescope was first discovered by Hans Lippershey, a spectacle maker from Middelburg, Holland, in 1608. Apparently, he or one of his children accidently discovered that by holding two lenses in line with each other, distant objects appeared enlarged.

However, there is circumstantial evidence that the principle of the telescope was elucidated significantly earlier, maybe as early as the middle part of the sixteenth century. Whatever the truth of the matter, it is clear that by May 1609, the basic design features of the spyglass – using a convex lens as an objective and a concave eye lens – had reached the ears of a

N. English, *Choosing and Using a Refracting Telescope*, Patrick Moore's Practical Astronomy Series, DOI 10.1007/978-1-4419-6403-8_1, © Springer Science+Business Media, LLC 2011

fiery Italian scientist, Galileo Galilei, while visiting Holland. Despite not having a prototype in his possession, he was soon able to duplicate the instrument, mostly by trial and error. He also managed to increase its magnifying power, first to 9, then to 20, and, by the end of the year, to 30. Moreover, rather than merely exploiting the instrument for practical applications on Earth, he started using it to make systematic observations of the heavens to learn new truths about the universe.

Within 3 years Galileo had made several startling discoveries. He discovered that the Moon had a rough surface full of mountains and valleys. He saw that innumerable other stars existed in addition to those visible with the naked eye. He found that the Milky Way and the nebulae were dense collections of large numbers of individual stars. The planet Jupiter had four moons revolving around it at different distances and with different periods. The appearance of the planet Venus, in the course of its orbital revolution, changed regularly from a full disc, to half a disc, to crescent, and back to a half and a full disc, in a manner analogous to the phases of the Moon. The surface of the Sun was dotted with dark spots that were generated and dissipated in a very haphazard fashion and had highly irregular sizes and shapes, like the clouds above Earth. While they lasted, these spots moved in such a way as to imply that the Sun rotated on its axis with a period of about 1 month.

Many of these discoveries were also made independently by others; for example, lunar mountains were also seen by Thomas Harriot in England before Galileo reported them, and sunspots were seen by the German astronomer Christoph Scheiner. However, no one understood their significance as well as Galileo. His telescopic adventures heralded a revolution in astronomy, providing crucial, although not conclusive, confirmation of the Copernican hypothesis of Earth's motion.

Galileo's instruments, as revolutionary as they were, must have been very frustrating to use. For one thing, the usable field of view was prohibitively narrow, and the design was limited in the range of magnifications it could use. That much was clear to the German astronomer Johannes Kepler, who received a Galilean telescope as a gift from a friend in 1610. Within a year, the great scientist had made significant improvements to Galileo's telescopic design. Kepler replaced the concave lens of the eyepiece with a convex lens. This allowed for a much wider field of view and greater eye relief, but the image for the viewer is inverted. What's more, considerably greater magnifications could also be reached with the Keplerian design, allowing higher power views of the Moon and planets to be made. Another bonus was its ability to project images – very useful for making solar observations.

The Keplerian modification was a good step forward from its Galilean counterpart, but the refracting telescope was still far from the perfec-

tion it would reach in the centuries ahead. Simple glass lenses act like weak prisms, bending, or refracting, different colors (wavelengths) of light by different amounts. Blue is bent most and red least. This means that each color has a slightly different position of focus. If you choose to focus on one color, all the others appear as unfocused discs. Indeed, were Galileo able to see in only one color or wavelength of light, the performance of his telescope would have been considerably improved.

The reality for the observer, however, was that bright objects were surrounded by obscuring rings of color; a phenomenon known technically as chromatic aberration. Now, although these color fringes might have delighted a child filled with idle curiosity, they were downright annoying to anyone wanting to see fine detail in a magnified image.

It wasn't long before men of ingenuity devised a panacea of sorts. Optical studies by the French mathematician René Descartes demonstrated that the image quality of convex lenses could be improved my making the curvature of the lens as shallow as possible, that is, by increasing the focal length of the lens. This strategy increases the depth of focus so that the eye can accommodate the spread of colors with an improvement in performance. There was a caveat, however: modest increases in aperture had to be accompanied by huge increases in focal length, making such telescopes less and less manageable.

One of the first individuals to build really long refractors was the wealthy Danish brewer-turned-astronomer Johannes Hevelius (1611–1687) of Danzig, whose instruments reached 150 ft in length. By 1647 Hevelius published his first work, the *Selenographia*, in which he presented detailed drawings of the Moon's phases and identified up to 250 new lunar features. The *Selenographia* influenced many of the great scientists of the emerging Europe, not the least of which were the brothers Constantine and Christian Huygens in Holland. Dejected by the shoddy performance of the toy-like spyglasses offered for sale by merchants, they set to work grinding and polishing their own lenses for the purposes of extending the work initiated by Hevelius. Between 1655 and 1659, they produced telescopes of 12, 23, and finally a 123-ft focal length. Instead of using a long wooden tube to house the optics, as Hevelius had done, the Huygens' brothers placed the objective lens in a short iron tube and mounted it high on a pole. Then, using a system of pulleys and levers, the eyepiece was yanked into perfect alignment with the objective. Christiaan Huygens used a more modest instrument (with a 2.3-in. objective and 23-ft focal length) to elucidate the true nature of Saturn's ring system, as well as its largest and brightest satellite, Titan.

Christiaan Huygens not only built long refractors, he was an innovator as well. Not satisfied by the standard single convex lens that formed the eyepiece

of all refractors of the day, Huygens designed a much better prototype, consisting of two thin convex elements with a front field lens having a focal length some three times that of the eye lens. The result was an eyepiece – the Huygenian – which yielded sharper images and slightly less chromatic aberration over a wider field of view than any eyepiece coming before. Curiously, Huygens also hit on the idea of lightly smoking the glass from which his eyepiece lenses were fashioned, so as to impart to them a yellowish tint. This cunning trick further suppressed chromatic aberration, much in the same way as a light yellow filter does when attached to a modern refractor. Huygens also appreciated the benefits of proper baffling in designing his telescopes. Placing circular stops along the main tube, these prevented stray light reflected from the sides of the tubes from entering the eyepiece, thereby greatly increasing contrast. Constantine and Christiaan Huygens produced some monster lenses, too. The largest recorded had an aperture of 8.75 in. with a focal length of 210 ft!

Seventeenth-century telescope makers tested their lenses either in the workshop but especially on well-known celestial objects. In addition, skilled opticians could get a good idea of the quality of a lens from an examination of the reflections off its polished surface. Yet, it is fair to say that these innovators improved their telescopes mostly by trial and error, since a proper, all-encompassing theory of optics was still forthcoming. For example, Hevelius, observing with his 150-ft refractor, spent a considerable length of time measuring the apparent diameters of stellar "discs" in order that he might deduce their true size. So, too, did other great observers of the age, including John Flamsteed and Giovanni Domenico Cassini. It was not until the advent of a complete wave theory of light that such discs could be explained and are, in fact, quite unrelated to the actual diameter of a star.

Soon, the art of fashioning long focus refractors moved south to Italy, where Eustachio Divini in Bologna and Giuseppe Campani of Rome produced the finest telescopes of the late seventeenth century. Such instruments were used by Cassini to discover the gap in Saturn's rings that bears his name, as well as four new satellites of the planet. He also deduced the correct rotation period for the planet Mars, which turned out to be just a little longer than a terrestrial day. With a similar telescope, the Danish astronomer Ole Romer, witnessing a timing glitch in the eclipse of a Jovian satellite, incredibly deduced the speed of light – 300,000 km/s.

Romer is also credited for inventing the meridian transit circle telescope (usually just called the meridian circle), an instrument used for measuring precise star positions and the determination of time. A highly specialized device, the meridian circle is a rigidly mounted refractor positioned along a line passing from north to south through the zenith. A star's position is

measured as it crosses, or "transits," a set of crosshairs mounted where the eyepiece would normally be. A star's transit time, measured against a celestial reference frame, provides its celestial longitude, or Right Ascension. A star's altitude can also be measured directly and in turn converted directly into its celestial latitude, or Declination. When developed further in the eighteenth and nineteenth centuries, the meridian circle could be used to measure stellar positions to accuracies approaching 0.05 arc seconds (one arc second = 1/3,600th of an angular degree). Although meridian circles are no longer used, the legacy of the measurements carried out by our astronomical ancestors form the basis of many of our star catalogs today.

Although the largest "aerial" telescopes were certainly difficult to use because of their unwieldiness, the same is not really true of smaller instruments. In a delightful article published in *Sky & Telescope* back in 1992, the planetary scientist and amateur astronomer Alan Binder described his impressions of a homemade seventeenth-century telescope. Calling it the "Hevelius," it sported a 3-in. planoconvex lens with a focal length of 17 ft (F/68). The objective was mounted on an elegant wooden optical tube and hoisted on an observing pole. Altitude and azimuth adjustments could be made by using a crank, cord, and pulley system. Binder also constructed some seventeenth-century style eyepieces of Keplerian and Huygenian design. These eyepieces delivered magnifications of 50×, 100×, and 150×.

Binder went on to study a host of celestial objects including the brighter planets, the lunar surface, and brighter deep sky objects. His conclusions were very surprising. Not only was the 17-ft Hevelius remarkably easy to use, it was comparable to the views served up by his "comparison" scope, a modern 4.5 in. F/7 reflector. False color was remarkably suppressed and only prominent around bright stars and Venus, while spherical aberration was also very well controlled. It had a resolution – based on his studies of tight double stars – only a notch below that of a basic, modern refractor. Indeed Binder goes on to claim that these aerial telescopes were actually better in many ways than the early achromatic refractors (to be discussed shortly) and reflectors produced up until the mid-eighteenth century. Focal length, it seems, was the magic ingredient needed to correct for optical imperfections. Because they possessed enormous depth of focus, the eye was more easily able to accommodate the aberrations inherent to a single lens objective. That said, some scientists were already thinking of ways of downsizing these telescopes into more manageable packages. For instance, in 1668, Robert Hooke suggested using a system of mirrors that, by successive reflections, could "fold" a 60-ft focal length telescope into a box only 12 ft long. His idea, unfortunately, never caught on, not least because of the poor quality of flat mirrors of the day.

Newton's Error

Long focus refracting telescopes were standard equipment at all the major observatories of Europe when Isaac Newton was performing his first experiments in physical optics. Why glass focused blue light closer to and red light further away from the lens was still a profound mystery. Most of the great scientists of Europe at this time considered white light to be pure and all colors to be contaminations of white light. Newton, however, considered an alternative idea – that colors are primary qualities and white light is our perception of their combination.

Beginning in 1663, the great genius, then in his early twenties, began making grinding and polishing machines in order that he could investigate for himself the aberrations of lenses. By 1666, after having performed many artful experiments with prisms, he became satisfied that white light was in fact made up of a rainbow of colors. What is more, Newton despaired of ever finding a glass lens that could bend light without causing the colors to disperse. In other words, Newton came to the firm conclusion that refraction through a glass objective *always* involved dispersion.

It was this conclusion that led him in the end to his reflecting telescope:

> Seeing therefore the Improvement of Telescopes of given length by Refractions is desperate, I contrived heretofore a Perspective by Relexions, using instead of an Object-glass, a concave metal.

Newton's enormous status in the Enlightenment did much to stunt the development of the refractor for many decades to come; a reminder that intellectual brilliance is no guarantee against being dead wrong! But one of Newton's contemporaries did beg to differ. In 1695 James Gregory, then the Savillian Professor of Astronomy at Oxford University, refuted Newton's conclusion that dispersion of light always accompanied refraction. Gregory's inspiration was the extraordinary human eye:

> Perhaps it to be of service to make the object lens of a different Medium, as we see done in the fabric of the Eye, where the crystalline Humour (whose power of refracting the Rays of Light differ very little from that of Glass) is by Nature, who ever does anything in vain, joined with the aqueous and vitreous Humours (not differing from the water as to their power of refraction) in order that the image may be painted as distinct as possible upon the Bottom of the Eye.

Gregory believed, erroneously as it turned out, that the human eye provided sharp images without chromatic aberration. Perhaps it was just such reasoning that led to the next momentous breakthrough in refractor design. For in 1729, the English barrister and amateur optician, Chester Moor

Hall, having experimented with prisms made from two types of glass, one flint and one crown, elegantly showed that one could achieve refraction with little or no dispersion. Moor Hall followed this up by commissioning the construction of the first doublet objective consisting of a concave element made from flint glass and a matching convex element fashioned from crown glass.

Moor Hall was no businessman, however, and thus he never pursued the idea on a commercial basis. Although he kept the design hidden, the secret of the crown-flint doublet was reverse-engineered by a nosy lens maker – George Bass – who happened to be subcontracted to work on both lenses at the same time. News of Moor Hall's marvelous lens spread slowly among the opticians of London, where for the most part, its significance was largely unrecognized. However, all that changed in 1750 when the design was made known to John Dollond, a London instrument maker. After conducting his own – and largely unique – set of optical experiments, he was able to produce a variety of crown flint doublets, which he dutifully presented to the Royal Society in 1758. Meanwhile his son, Peter Dollond, applied for a patent. Moor Hall twice attempted to challenge the patent on the grounds that he was the inventor. The core of Dollond's challenge was predicated on the fact that his firm was the first to demonstrate it to the public and thus should be the first to profit from it. Dollond won his day in court and the rest, as they say, is history.

The name "achromatic" (meaning color-free), however, was first coined by the amateur astronomer John Bevis, who claimed that one of Dollond's 3-ft focal length telescopes "could now produce the same quality image as a non-achromatic telescope of 45 ft focal length." Statements like that make powerful advertising, and soon orders came flooding in from all across Europe to purchase these new achromatic telescopes.

The elder Dollond died in 1761, and the business was re-structured and expanded by his son Peter. While the elder Dollond was a tinkerer and adventurer in optics, the younger was more entrepreneurial in outlook. It is said that he assembled his achromatic objectives largely by trial and error. If a crown-flint doublet didn't meet with his personal standards, the combination was discarded. What's more, we know next to nothing about the methods he used to work his glasses. It seems Dollond preferred to keep his techniques to himself and a few select opticians in his employ – justifiable enough, given his endeavors to establish a major business for a world market. Needless to say, over the next few decades Dollond made a fortune. In 1780 he introduced the "Army telescope" with a mahogany brass bound body and brass-collapsible tubes. Dollond also introduced small "Achromatic Perspective Glasses" and even prism kits (with crown and flint elements) "arranged to demonstrate the principle of the achromatic objective."

Although many of Dollond's telescopes were fine terrestrial and astronomical instruments, residual color, though greatly reduced, was still present, especially around bright stars, planets, and the lunar surface. Dollond's best achromatic doublets were relatively small in aperture (between 2 and 4 in.) and had a fairly long focal length. Unfortunately, as we shall explore in more detail in the next chapter, the precise way in which a crown glass disperses light is always slightly different from a flint. And so the flint does not have the capacity to perfectly nullify the crown's chromatic aberration. This lack of perfection leaves, in all lenses, a residual color error of greater or lesser extent.

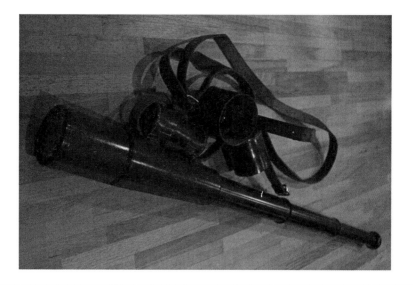

Grandfather of spotting scopes, a Dollond terrestrial telescope (Image credit: Richard Day)

John Dollond, pioneer and adventurer in optics, was well aware of the deleterious effects of small amounts of spherical aberration in the images his achromatic doublets threw up. We'll get to the meat of this and other aberrations in the next chapter, but for now suffice it to say that spherical aberration has the effect of rendering high contrast details on planetary and lunar subjects a bit 'soft' and ill defined. Dollond set to work contriving ways of reducing it in new ways that didn't involve extending the focal length of the telescope. Dollond imagined a kind of "modified" flint glass, with the right refractive and dispersive properties to mate with the crown

glass in order to reduce spherical aberration still more. Being severely limited in the types of glasses available to him, he hit upon an ingenious idea – what if you use crown glass to "tweak" the dispersive powers of the raw flint so that it mated better with another crown element? In other words, the "triplet" objective uses the natural differences between the refractive (bending) powers of the two types of glass to reduce both chromatic and spherical aberration even more. Largely by trial and error, he managed to create a prototype triplet objective that saw first light in 1757, creating considerable interest from some of the most illustrious astronomers of the age. The then Astronomer Royal Neville Maskelyne was so impressed by one of Dollond's triplets – a 3.75 in. instrument – that he had it mounted in a small room all by itself. James Short, better known for his contributions to the development of the reflecting telescope, having looked through a similar Dollond triplet at 150× remarked that it "gave an image distinctly bright and free from colors."

But Dollond's early triplets, promising though they appeared, never gained much headway in the bustling eighteenth-century telescope industry. Because of their greater optical complexity, they were expensive to make to a consistently high standard. Worse still, the difficulty of crafting large, optical-grade glass blanks meant that their small sizes (5 in. or smaller) prevented them from competing with other telescope designs gaining popularity at the time.

Dollond telescopes slowly replaced the long and awkward simple refractors of the observatories of Europe. Their much greater portability meant that they could be installed on heavy-duty clock-driven mounts and were far easier to operate. But unlike later adventurers in refractor optics, Dollond wasn't motivated by building larger and larger aperture telescopes. Even by the beginning of the nineteenth century, flint glass discs of flawless quality greater than about 4 in. in diameter were as rare as hens' teeth. Unless some way could be found to cast large, high-quality glass discs, the refracting telescope would have to stay relatively small.

The Dollond business, centered as it was in England, might well have continued to be the epicenter of refracting telescope innovation were it not for a short-sighted policy of the government. An exorbitant duty was placed upon the manufacture of flint glass, and as a result, the English trade was almost entirely stamped out. Necessity is the mother of invention, and the lack of large high-quality flint glass blanks led some opticians to device novel approaches to the design of the achromatic refractor. One such adventurer was Albert Rogers who, in a paper to the Royal Astronomical Society in 1828, described a Dialyte refractor. Instead of having a full aperture crown and flint objective, Rogers proposed placing a smaller

crown element further back on the tube. That would mean that a full-sized flint lens need not be made. The problem with this design was that it introduced significantly more optical aberrations, which made the device impractical to manufacture. The only way around the problem of building large refractors was to solve the problem of producing high-quality glass blanks. And that evolutionary step came from the heart of Europe.

In 1780 a Swiss bell-maker turned optician, Pierre Louis Guinand, began experimenting with various casting techniques in an attempt to improve the glass-making process. After 20 years in the wilderness, Guinand finally hit on a reproducible way of casting flawless glass blanks with apertures up to 6 in. in diameter. Moving to Germany, he was to later team up with some of the most prolific telescope makers of the era, especially the young Bavarian Joseph Fraunhofer. Under the aegis of Guinand, Fraunhofer carefully studied the Dollond doublet objective and introduced significant changes to its design. Fraunhofer made the front surface more strongly convex. He then made the two central surfaces slightly different in shape and introduced a very small air gap between them. The innermost optical surface was nearly flat. Such an objective – the Fraunhofer doublet – was able to bring two colors of light to a precise focus, greatly reducing false color as well as virtually eliminating an optical flaw known as spherical aberration (this renders images a bit "soft" or drained of detail at high powers). Fraunhofer's so-called aplanatic refractors became the new standard by which all future refracting telescopes were measured for more than a century to come.

To get the high-quality glass his telescopes demanded, Fraunhofer also had to develop better grinding machines that depended less on the manual skill of his opticians. He improved the furnaces from which his glass was annealed, thereby removing defects – usually in the form of tiny bubbles – from its intricate crystalline structure. But the crowning glory of Fraunhofer's genius is exemplified by the great 9.5-in. Dorpat refractor, which saw first light just 2 years before his tragic death in 1826 at the age of 39. The famous Russian astronomer and director of Dorpat Observatory, F.G. Wilhelm Struve, commented that upon seeing the instrument, he was unable to determine "which to admire most, the propriety of its construction… or the incomparable optical power, and the precision with which objects are defined." Struve and other astronomers used the telescope with extraordinary high magnifications to survey over 120,000 stars. Equally impressive was the beautiful equatorial mount designed to allow the great refractor to track the stars with hitherto unequalled precision. A slowly falling weight provided the energy to drive the telescope mount, which completed one revolution in a single day. The Great Dorpat refractor remains to this day a monument to human engineering. Indeed,

his 9.5 in. refractor compares very favorably to the finest achromats built over the last two centuries.

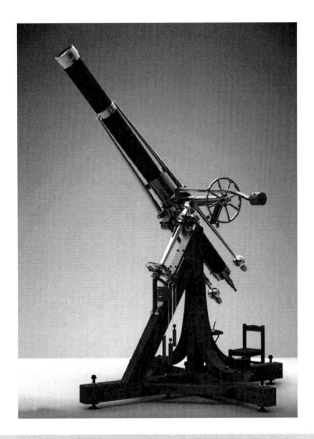

Model of the Great Dorpat refractor designed by Fraunhofer (Image credit: Institute of Astronomy Cambridge Archives)

Fraunhofer's instruments quickly established themselves as the finest available in the world, and German optics became the standard by which all other rivals were compared. The successors to Fraunhofer's business – Merz & Mahler – used Fraunhofer's blueprint to build even larger instruments. In 1839, they produced the 15 in. (38 cm) refractor at Pulkovo Observatory, Russia, and a twin instrument for the Harvard College Observatory in the United States. It was this instrument that William Bond and Henry Draper used to make the first crude photographs of stars around 1850.

Meanwhile in England, another great telescope maker was making a sterling reputation for himself. Thomas Cooke was born in 1807 at

Allerthorpe, Yorkshire. He received only the merest of formal education, as he had to leave school early to help out in his father's business. But Cooke was bright and curious and read widely. After studying mathematics and optics he attempted to make a small achromatic telescope, and the results encouraged him to start his own optical business in York, crafting instruments and selling them to friends. Inspired by optical giants such as Fraunhofer and Mahler, Cooke invested his time constructing medium aperture equatorially mounted telescopes between 4 and 9.5 in., which found their way into some of the great observatories, first in Europe and then in North America. Cooke's rapid progress was due in good measure to his being able to obtain large discs of optical glass from the nearby city of Birmingham.

The fine 10-in. Cooke refractor at Mills Observatory, Dundee, Scotland

Cooke's largest instrument, the 25-in. Newall refractor, was, for some time, the largest in the world. It took 7 years to build, and some say it was the death of him, for the elder Cooke passed away in 1868, a year before it was completed. This instrument was commissioned by a wealthy amateur, Robert Stirling Newall. The 29-ft optical tube was mounted astride a 19-ft high cast iron pillar on a German-type equatorial mount on the grounds of his private garden in Gateshead. Unfortunately, the great instrument couldn't have had a less favorable position; the sky was seldom if ever clear and steady enough to take full advantage of the telescope's superlative aperture. Writing in 1885, Newall said of the 25 in., "I have had one fine night since 1870! I then saw what I have never seen since." Today, the 25-in. has found a new home at Penteli Observatory, just north of the city of Athens, Greece. It's been there since 1958.

Progress in telescope making in the New World was slow to take off. Indeed, the largest telescope in the United States before 1830 was a 5-in. Dollond achromat. The paucity of public observatories across the nation in the early nineteenth century is evidence enough that the country had not yet fully exploited her latent talent for astronomical adventure. America needed a great lens maker, and it found its answer in a Massachusetts portrait painter named Alvan Clark.

This mid-nineteenth century Cooke achromat had an uncoated lens

An amateur astronomer, Clark tried his hand grinding small mirrors and lenses. As anyone who has performed such a task knows, it's a time-consuming activity. But his patience paid off. Unlike Cooke and Fraunhofer, Clark's approach to practical optics was more intuitive than theoretical. That much became clear when he was first granted an opportunity to look through the great 15-in. Harvard refractor. It was a moment that was to change the course of his life. In his memoirs, Clark wrote,

> I was far enough advanced in the knowledge of the matter (optics) to perceive and locate the errors of figure in their 15-inch glass at first sight. Yet, these errors were very small, just enough to leave me in full possession of all the hope and courage needed to give me a start, especially when informed that this object glass alone cost $12,000.

And start he did, closing his art studio to master the art of figuring old lenses. His first instrument had a 5.25 in. aperture, followed by an 8-in., both of which were as good as any of European origin. Naturally, being an unknown, he at first found it hard to sell his instruments. What he needed was someone with great astronomical gravitas to champion his cause. If the astronomers didn't come to his telescopes, then he'd have to bring his telescopes to them. In 1851, Clark wrote to the prominent English amateur astronomer the Reverend William Rutter Dawes, describing to him the close double stars he had observed with his 7.5-in. refractor. Impressed, Dawes sent Clark a more extensive list of close binary stars for him to split, together with an order for the same object glass!

With his Clark refractor, Dawes later wrote that he had enjoyed the finest views of Saturn he had ever seen. Clark's reputation in England spread like wildfire, and he soon received another order from a certain William Huggins, who had used the lens as the centerpiece for his pioneering work in astronomical spectroscopy. In the summer of 1854, Dawes invited Alvan Clark to London, where he was introduced to Lord Rosse (of Leviathan fame) and Sir John Herschel. These meetings did much to cement Clark's reputation as an instrument maker of the highest order.

A nicely restored 9-in. Clark refractor made in 1915 (Image credit: Siegfried Jachmann)

To this day, very little is known regarding Clark's methods for producing his lenses. Like the Dollonds of the previous century, they left no records of their procedures. But nothing was done in secret, either. The factory often welcomed curious visitors. One snooty caller quipped that the methods employed were crude and inferior to those used by European standards. But Alvan Clark never professed himself to be an optical theorist. He apparently had a very fine intuition for crafting some of the finest refractors in the world. He could apparently detect tiny irregularities on the surface of the lens and often retouched it using his bare thumbs while examining the image at the eyepiece. We do know that polarized light was often used by many nineteenth-century makers – the Clarks included – to inspect their optical glass and the finished lens. The test was as simple as it was telling. Inhomogeneous glass would usually reveal streaks or splotches, whereas a well-made optic would not.

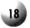

As news spread of the incredible discoveries the Clark telescopes were making in the hands of these astronomical evangelists, it wasn't long before orders for Clark telescopes came flooding in. His first major commission was an 18.5 in. refractor for the University of the Mississippi. Such was the confidence in his own abilities that Clark sold his home to invest in new premises – at Cambridge, Massachusetts – to build and test the new object glass. Accompanied by his two sons, George and Alvan, he constructed a 230-ft long tunnel to evaluate the optical prowess of his objectives on artificial stars. But it was while testing a tube assembly prototype of the same object glass that Clark discovered the faint and elusive companion to Sirius; the white dwarf star we know today as Sirius B. The Clarks went on to build the largest and finest refractors the world has ever seen, the finest of which are the 24-in. refractor at Lowell Observatory used to divine the Martian "canals," the 26-in. instrument at the U. S. Naval Observatory used by Asaph Hall to discover the asteroid moons of Mars, the 36-in. Lick refractor in California and the largest still in existence, and the 40-in. at Yerkes Observatory, Wisconsin. For the record, a 49-in. lens with a focal length of 187 ft was also made by the Clarks, but subsequent tests revealed it to be rather poor optically. The enormous weight and extreme difficulty in casting, figuring, and polishing such large lenses meant that refractors had reached their natural limit in terms of size. Reflectors would go on to win that prize.

No text on the refracting telescope would be complete without mentioning the great Pennsylvanian optician John Brashear (1840–1920), who hand-built excellent instruments ranging in size from 4 to 30 in. in aperture. From school he became an apprentice to a machinist, and at the age of 20 became a master of the trade. At age 21, he went to Pittsburgh and spent the next 20 years there working as a millwright. In his spare time, Brashear educated himself in optics, astronomy, and telescope making. By 1870 Brashear had built his first telescope in his South Side home and immediately opened his doors to neighbors, friends, and strangers to observe the sky. Dr. Samuel Pierpont Langley, the director of the Allegheny Observatory, encouraged him to establish a workshop for astronomical instruments. The workshop became the John Brashear Company, an internationally established maker of superb optics. Dr. Brashear died in 1920, leaving a legacy of craftsmanship and astronomical instruments still treasured and used today. Incidentally, Brashear was the first of the great nineteenth-century opticians to meticulously record his work for others to follow.

Just as the great refractors at Lick and Yerkes saw first light, the era of the super large aperture dawned on the world's stage, and interest in creating still bigger lenses dried up. The technical challenges associated

with casting, figuring, polishing, and mounting large refractors had reached their limit, and even today it is not generally considered feasible to go beyond the benchmarks set the Clark telescopes. But that didn't dissuade other individuals to build smaller observatory-class instruments. The beautiful refractors of Howard Grubb (Dublin, Ireland) are a case in point. Optically similar to the those fashioned by Cooke, his chief competitor in the latter half of the nineteenth century, Sir Howard Grubb personally supervised the design of many smaller instruments in the 10-in. aperture class (the Grubb refractor at Armagh Observatory is a fine example), but later developed the engineering skills to build some enormous refractors, such as those that grace Vienna Observatory (26-in.) and his largest, the 28-in. refractor at the Royal Greenwich Observatory in England. To this day, the 28-in. remains the largest classical achromatic refractor in the U.K.

The 10-in. Grubb refractor at Armagh Observatory (Image credit: Armagh Observatory, Northern Ireland)

Although refractors reached their size limit at the end of the nineteenth century, further innovations in the twentieth century improved both their performance and versatility. For instance, optical glass transmits most, but not all, light passing through it. What's more, the highly polished glass

surfaces of both the objective and the eyepiece reflect a small percentage of the light that strikes their surfaces. These collectively result in some light loss as well as introducing ghosting in the images. Alvan Clark & Sons in the United States and Carl Zeiss in Germany partially remedied the problem of internal reflections by filling the gap between the crown and flint elements with oil. These oil-spaced objectives reduced internal reflections by about 2%. The oil also helped smooth out some of the remaining irregularities in the figuring of the lenses. But there was a downside to using it. For one thing, changes in temperature caused the objectives to expand and contract during use, causing leakages. Worse still, slow chemical changes to the oil caused it to become cloudy after a few years of use and thus had to be replaced by fresh oil.

Late nineteenth-century lenses, such as those used nowadays, were not immune to tarnishing slowly, especially in humid climes. Now that ought to have reduced the overall light transmission of the lens still further. H. Denis Taylor considered the problem back in 1886 and carried out careful tests comparing the light transmission of old, tarnished glass with new, "clean" objectives. To his great surprise Taylor discovered that some of the older, tarnished lenses had the greater light transmission and seemed to reduce ghosting in the images! What's more, the tarnished layer had a refractive index (a measure of how much light is bent while passing through a transparent material) between that of glass and air. The tarnished layer clearly had the effect of reducing the amount of light loss by reflection off the glass surfaces. A proper understanding of this phenomenon took a few more decades to unravel, when in 1935 the Ukrainian-born Alexander Smakula, an optician working for the Carl Zeiss Optical Company, learned how to apply very thin coatings of magnesium fluoride (MgF_2) to the surfaces of the lenses, decreasing light loss due to reflections from 4 to just 1%. These so-called anti-reflection coatings, which we'll explore in more detail in the next chapter, actually remained a German military secret until the early stages of World War II.

H. Denis Taylor was also the first optician to produce a truly apochromatic objective (bringing three colors of light to a common focus) for telescopes, heralding a new revolution in refractor optics that continues apace today. We'll be exploring this exciting new dimension to the refracting telescope in Part 2 of the book. For now, though, we're ready to take a more in depth look at the telescopes that served amateur and professional astronomers so well for the bulk of the instrument's history – the classical achromat.

CHAPTER TWO

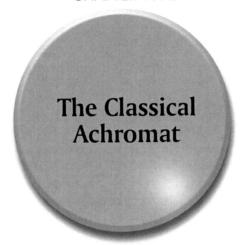

The Classical Achromat

Achromatic refractors are everywhere. Advertisements for them pop up in shopping catalogs and newspaper supplements. They continue to adorn the windows of camera stores and toy stores. They flood the virtual warehouses of eBay, and even our youngest kids learn to recognize them from the many cartoons that feature them. They form the basis of our binoculars, monoculars, and opera glasses, and our rifle sights and finders for our big telescopes. That said, the vast majority of people are totally clueless about how they really work and how best to use them. A little knowledge can be a very powerful tool, though, and it may surprise you that with only a little bit of background information, you can more easily appreciate your telescope's strengths and weaknesses and how best to optimize its performance.

The year 1824 marks a very special year for the telescope. That was the year in which Joseph Fraunhofer created the first recognizably modern refractor, and chances are the one you own or have owned in the past is built on much the same blueprint. Most modern achromats use a roughly biconvex front element made from crown glass (BK7 most likely) and a near plano-concave flint element (F2 most likely). Both of these kinds of glass are very easy to produce and work with. As an added bonus, they are remarkably stable and weather resistant, so they should last several lifetimes if well cared for.

Later optical masters introduced slight modifications to the Fraunhofer prototype, most often to cut costs. As we saw in chapter "The Refracting Telescope: A Brief History", the Fraunhofer doublet consists of two lenses, an outer crown element and an inner flint element separated by a

N. English, *Choosing and Using a Refracting Telescope*, Patrick Moore's
Practical Astronomy Series, DOI 10.1007/978-1-4419-6403-8_2,
© Springer Science+Business Media, LLC 2011

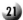

small air gap. So there are four surfaces to shape. The outside surface of the crown lens (the surface exposed to the air) is usually denoted by R_1 and its inner surface by R_2. Similarly the outer surface of the flint glass is denoted by R_3 and the surface nearest the eyepiece (innermost) is R_4. Opticians define curvature as positive if it curves outward and negative if it curves inward. What's more, the amount of curving is denoted by a parameter known as the "radius of curvature." The greater the radius of curvature the more gently the lens curves. The signs are reversed for the back surface of the lens: if R_2 is positive the surface is concave, and if R_2 is negative the surface is convex. So, in an air-spaced achromatic doublet, just four radii of curvature need be specified in order to distinguish, say, a 'typical' Fraunhofer doublet from a Clark doublet. We can use these numbers to quantitatively illustrate the basic similarities and differences between the various objectives built by opticians over the centuries.

Suppose we wish to design a 4-in. F/15 Fraunhofer doublet. A typical prescription might be:

$R_1 = 912$ mm
$R_2 = -533$ mm
$R_3 = -539$ mm
$R_4 = -2{,}213$ mm

A 4-in. objective produced by Alvan Clark & Sons would have a simpler prescription:

$R_1 = 912$ mm $= -R_2$
$R_3 = -867$ mm
$R_4 = -2{,}213$ mm

Here's an even easier prescription for a 4 in. It's called the Littrow objective after the Austrian astronomer Joseph von Littrow (1781–1840), who first devised it.

$R_1 = 912$ mm $= -R_2 = R_3$
R_4 is flat

A typical Cooke achromatic doublet from the mid-nineteenth century would have a prescription like this:

$R_1 = 559$ mm
$R_2 = -839$ mm
$R_3 = -786$ mm
R_4 is flat

All of these classical achromatic objectives have air spaces between the crown and flint elements. Typically the separation is very small – about the same thickness as a postage stamp (between 0.02 and 0.05 mm). Although the original Fraunhofer doublet was designed with a narrow air gap, like the one illustrated above, other designs use a wide gap, or indeed others have a narrow gap with the edges of the lenses touching (called a contact doublet) or a bonded (cemented) assembly. The benefits of a bonded assembly are increased mechanical strength, durability, and overall transmission as a result of fewer reflections produced by external surfaces. Appendix 1 lists the types of objectives created by master opticians over the centuries.

Why the different original designs? Well, the Clark objective, for example, requires only three distinct surfaces to shape, as compared with four for the Fraunhofer design. What's more, the Clark lenses can be made thinner than in the Fraunhofer, which, taken together, means that a Clark objective can be produced more cheaply, easily, and quickly than its Fraunhofer counterpart. The optical properties of all of these achromatic doublets are very similar, differing only slightly in their ability to control the various optical aberrations. These early refractor builders, as we saw in chapter "The Refracting Telescope: A Brief History", were tightly constrained by the availability of high-quality glass blanks to grind their lenses. Thus, the basic designs used by the great refractors of yesteryear were driven, as they largely are today, more by economics than the attainment of absolute optical perfection.

That said, there are always mavericks in the field who tried entirely different ways of rendering a high-quality achromatic objective. For example, in the middle of the nineteenth century John Brashear in America and Carl August Von Steinheil in Germany often placed the flint element in front of the crown. The reasons for this are unclear (both designers believed it gave slightly better images than the Fraunhofer prescription), but it could be due to the fact that the grade of flint glass used at the time was slightly more weather resistant than the crown glasses employed at the time. Such 'flint first' objectives are rarely made today. The Steinheil, for example, requires stronger lens curvatures than the Fraunhofer doublet to function satisfactorily. Almost invariably, the Fraunhofer design is the one likely to be employed in the vast majority of high quality commercial achromats produced today and the kind we'll concentrate on.

Modern achromatic doublet objectives are designed to bring two precise wavelengths (colors) of light to a common focus – red (656 nm corresponding to the Fraunhofer C spectral line) and blue green (486 nm corresponding to the Fraunhofer F spectral line). That wasn't always the case, though. The great refractor builders of the nineteenth century chose to

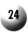

achromatize the F with B line, which lies further into the deep red. This was done to best accommodate the simple eyepiece designs used at the time.

In a contemporary C-F corrected achromat, colors lying outside this range of wavelengths (called the C-F focus) remain unfocused. These include deep red at one end of the spectrum and violet at the other. But that's not a big problem. Fortunately, the human eye is not terribly sensitive to either of these radiations, and for the most part the position of C-F focus imparts a very natural color to the image. In an ideal objective, all wavelengths between the C (red) and F (blue-green) Fraunhofer lines ought to be brought to a single focus, but in practice there is some color spread in the final image. This is what opticians call secondary spectrum and is the origin of the false color (chromatic aberration) seen in almost all achromatic refractors.

The Truth about False Color

It's actually quite easy to see if your achromatic refractor is properly corrected for visual use. Although you can discern a lot in daytime tests, a nighttime star test will be more sensitive. We'll explore star testing in much more detail in chapter "Testing Your Refractor", but here's a brief overview. Take a nice, long-focus 3-in. F/15 instrument. Look at a bright star such as Vega or Sirius (if you live in the Southern Hemisphere) using a high magnification, say 30–50× per inch of aperture. First observe the star at sharp focus. At this focal ratio, our 3-in. refractor should display little or no false color when sharply focused. You'll probably see a faint violet halo around the brightest stars, but that's quite normal. Now rack the focuser outward until the image of the star takes on the form of a bright central spot surrounded by a series of diffraction rings. Look at the color of the rim of these rings. It should appear green or greenish yellow. Next rack the focuser inward, past the position of best focus, until you get a similarly sized diffraction pattern. The rim should now look purple-violet in color.

The amount of residual color observed in an achromat depends on only two parameters; the diameter of the object lens and the focal ratio of the telescope. The latter number is easily found by dividing the focal length of the objective lens by the diameter of the lens. For example, a 100 mm diameter achromat with a focal length of 1,000 mm is said to have a focal ratio of 1,000/100 or F/10.

One neat way of expressing the amount of false color to expect in an achromatic refractor is to divide the focal ratio of your scope by its diameter in inches. This called the Chromatic Aberration (CA) index. For example,

Equivalent Chromatic Aberration
of Achromatic Refractors

		F	O	C	A	L		R	A	T	I	O		
obj/mm	obj/in.	3	4	5	6	7	8	9	10	11	12	15	18	20
60mm	2.36	1.27	1.69	2.12	2.54	2.966	3.39	3.81	4.24	4.66	5.08	6.36	7.63	8.47
70mm	2.75	1.09	1.45	1.8	2.18	2.54	2.9	3.27	3.63	4	4.36	5.45	6.54	7.27
80mm	3.14	0.96	1.27	1.59	1.91	2.229	2.55	2.87	3.18	3.5	3.82	4.78	5.73	6.37
90mm	3.54	0.85	1.13	1.41	1.69	1.977	2.26	2.54	2.82	3.11	3.39	4.24	5.08	5.65
100mm	3.93	0.76	1.02	1.27	1.53	1.781	2.04	2.29	2.54	2.8	3.05	3.82	4.58	5.09
120mm	4.72	0.64	0.85	1.06	1.27	1.483	1.69	1.91	2.12	2.33	2.54	3.18	3.81	4.24
127mm	5	0.6	0.8	1	1.2	1.4	1.6	1.8	2	2.2	2.4	3	3.6	4
152mm	6	0.5	0.67	0.83	1	1.167	1.33	1.5	1.67	1.83	2	2.5	3	3.33

Conrady standard CA ratio>5 ▮
Sidgwick standard CA ratio>3 ▮
5" f/9 equivalent CA ratio>1.78 ▨
6"f/8 equivalent CA ratio>1.25 ▨

Visual levels of Chromatic Aberration
Minimal or no CA ▮
Filterable levels of CA
Unacceptable levels of CA ▮

f/ratio divided by objective diameter in inches=CA ratio

False color levels for different apertures and focal ratios (Image Credit: Chris Lord)

an 80 mm (3.14 in.) F/5 refractor has a CA index of 5/3.14 = 1.59. Most seasoned observers suggest that for false color to be reduced to an almost insignificant level, the F ratio needs to be greater than about three times the diameter in inches (or 0.12 times the diameter in millimeters). So, in order to be virtually color free, a 100 mm refractor needs to have a focal length of 1,200 mm – 20% longer than its actual focal length. That much is borne out in observations of bright stars made with this refractor. High magnification images of bright stars such as Vega reveal a tiny, sharp disc of light, technically known as the Airy disc, surrounded by a faint halo of unfocused violet light.

Many have come to accept the Sidgwick standard (CA index > 3) for an achromat to perform in such a way so as to ensure false color doesn't interfere with the view. Others are less forgiving, choosing instead to adopt the Conrady standard (CA index > 5) as the benchmark, a condition that requires the focal ratio to be five times the diameter of the aperture in inches. Which standard you adopt depends on your own experiences.

Chromatic aberration (false color) shoots up as the diameter of the lens increases and/or as the focal ratio falls. A 4-in. F/5 objective, for example, will display the proverbial 'gobs of color' around high contrast objects if used at moderate or high magnification. Indeed, while you can get clean images up to, and in excess of, 200× with a 4-in. F/10 achromat, you're limited to about 80× or so with the F/5 instrument.

Chromatic aberration does more than just make bright objects appear with purplish fringes; it actually robs the image of critical, high contrast

detail. That's so, whether you're observing by day or by night. During the day, high contrast details of objects such as green leaves set against a bright sky background are drowned out in a purplish haze. This is especially obvious when the magnification used is high. To see how it detracts from nighttime views, think back to the Airy disc one sees when a star is focused at high power. The greater the chromatic aberration, the smaller the fraction of starlight that ends up tightly focused inside the Airy disc. That corresponds to loss of information from the image. Even at lower powers – such as those employed to surf broad swathes of the summer Milky Way – excessive chromatic aberration can noticeably decrease the contrast between the star fields and the background sky.

That said, if you find chromatic aberration objectionable, there are steps you can take to reduce its effects. The easiest remedy is to stop down the aperture of the lens. For instance, stopping down the aperture from 4 to 2 in. results in an increase in focal ratio from F/5 to F/10. The resulting image will be considerably dimmer, but it will also be sharper and far less colorful. Another strategy is to simply filter out some of the unfocused color using either a light yellow filter (a #8 Wratten is good) or one of a variety of so-called minus violet filters. A number of optical companies manufacture these filters – including, Sirius Optics, Baader Planetarium, and William Optics – which screw directly into the bottom of your 1.25- or 2-in. eyepiece. These work by effectively cutting off the violet end of the spectrum reaching the eye. They do work well on the Moon and planets and can indeed allow you to press higher magnifications into service with your telescope but often at the expense of introducing a moderate color cast – usually yellow or green – to the image.

Chromatic aberration is a much maligned problem, judging by the attention it receives in the astronomy forums. But for some, the chromatic aberration presented by a 3- or 4-in. F/10 refractor, say, is really a non issue. The effect is actually quite mild and doesn't appreciably affect the image of even really tough objects like Jupiter. You may not want to bother using a minus violet filter on these instruments either. Indeed, you may come to love the aesthetic effect the purplish halo imparts to your high power observations of the giant planet and close double stars. Bear in mind also that the giant refractors of the past suffered far more badly. Take the greatest of them all, the 40-in. Yerkes refractor. To achieve the kinds of color correction enjoyed by a 4-in. F/12 refractor, it would have to operate at F/120 – as long as a football field! In reality, the giant Clark objective operates at F/19! Many who have the good fortune to look through the Yerkes refractor have reported alarming amounts of color around bright planets, but under good conditions, its superlative resolution and great contrast ensures viewers always come away impressed!

Chromatic aberration is just one of a group of optical aberrations to keep under control when building a good object glass. These aberrations are known as the Seidel aberrations, after an 1857 paper by Ludwig von Seidel; the other four are spherical aberration, coma, astigmatism, distortion, and field curvature.

Fraunhofer was the first person to systematically eliminate two Seidel aberrations that can plague an image, spherical aberration and coma. Let's tackle spherical aberration first.

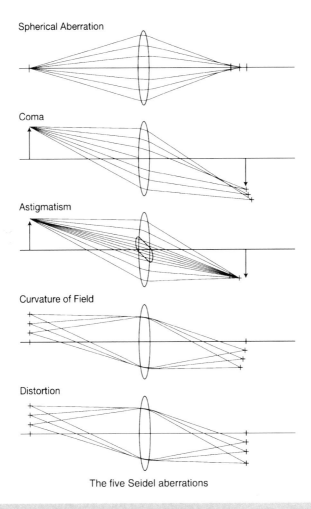

Spherical Aberration

Coma

Astigmatism

Curvature of Field

Distortion

The five Seidel aberrations

The five Seidel aberrations. Redrawn from a diagram first produced by John J. G. Savard

A perfect lens focuses all incoming light to a sharp point on the optical axis, which is usually along the center of the telescope tube. However, a real lens focuses rays more tightly if they enter it far from the optical axis than if they enter it close to the optical axis. This defect is called spherical aberration. A single spherical lens, of course, suffers from spherical aberration. However, a refractor eliminates spherical aberration by combining two lenses with equal but opposite amounts of spherical aberration. More complex refractor designs may use three or four lenses, but the basic idea is the same. These lenses must also work to eliminate a number of other aberrations, so the design process is tricky, but in the end spherical aberration – and not false color – must be the smallest residual aberration if the telescope is to provide a good image.

So how does spherical aberration impair the image in a refractor? At low magnifications, little or no effects can be seen, but as you crank up the power an instrument displaying significant spherical aberration will be very hard to focus sharply. As a result, high power views of planets and the Moon take on a slightly 'soft,' drowned-out appearance. It might not surprise you that the two aberrations – chromatic and spherical – interlink to create a new hybrid aberration. Spherical aberration actually varies with the color (wavelength) of light considered. Although spherical aberration is normally eliminated in green light (where the human eye is most sensitive), there is a slight under correction in red and a slight over correction in blue. This phenomenon is called spherochromatism and has the effect of blurring the definition of the diffraction rings on one side of focus more than the other. Though usually of only minor concern to the visual observer, spherochromatism may be more of a nuisance to the astrophotographer doing tricolor imaging with filters. Spherochromatism can be reduced by increasing the focal ratio of the objective and by increasing the separation between the crown and flint components. This was, in fact, the method used by the late American astronomer James Gilbert Baker (1914–2005) in the design of his refractors.

Coma is an off-axis aberration. By that we mean that stars in the center of the field are not affected, but the distortion grows stronger towards the edge of the field. Stars affected by pure coma are shaped like little comets (hence the name) pointed toward the center of the field. The effect is particularly common in reflecting telescopes, but, thanks to Fraunhofer, it is rare in modern refractors. That said, there is one type of refractor that can suffer from slightly more amounts of coma compared to the Fraunhofer model described thus far. The majority of high quality achromatic objectives manufactured today are air-spaced. But some small aperture scopes have cemented doublets, that is, the lenses are not separated by air but by some kind of transparent adhesive. Because a cemented objective has the same curvature on the inside surfaces of

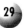

the lenses (the second and third optical surfaces) it eliminates two more degrees of freedom from the design and so makes it more difficult to correct for coma.

Another aberration to look out for is astigmatism. This occurs when a lens is not symmetrically ground around its center or, more usually, by misaligned optics. Most of the time, when such a system is misaligned or badly reassembled, slightly out-of-focus stars take on an oblate appearance. What's more, when you flip from one side of focus to another, the oval flips orientation by 90°. In focus, images appear distorted, too.

Both distortion and field curvature were never hot topics of conversation in the age of the classical achromat. That's because these aberrations only manifest themselves to any appreciable degree in refractors with short focal lengths. Field curvature is easy to spot. First, focus the star at the center of the field and slowly move it to the edge of the field of view. If you have to refocus it slightly to get the sharpest image then your telescope is probably showing some field curvature. Distortion is usually seen when using wide-angle eyepieces on short focal ratio scopes. It comes in two flavors – pincushion (positive distortion) and barrel (negative distortion). These are best seen during daylight hours by pointing your telescope at a flat roof and looking for bending of the image near the edges of the field. Distortion is very hard to correct completely, and only the best (i.e., most expensive) eyepieces seem to be able to correct for it adequately. The good news, especially if you're a dedicated sky gazer, is that it will have little or no effect on the quality of the nighttime images your telescope will throw up and so for the most part can be ignored.

Other Virtues of Focal Length

There is one all-important lesson to be learned from our discussion thus far. All the Seidel aberrations fall off rapidly as focal ratio increases. Below is a table showing the various aberrations in scale with focal ratio.

Aberration	How they scale
Spherical	$1/F^3$
Astigmatism	$1/F$
Coma	$1/F^2$
Distortion	$1/F$
Field curvature	$1/F$
Defocus	$1/F^2$

As the focal ratio decreases, the severity of *all* of the aberrations that affect a refractor have the potential to increase. So even a well-configured 80 mm F/5 achromatic objective will almost always display more in the way of optical defects – particularly false color and spherical aberration – than even a mediocre 80 mm F/10 instrument. That's borne out by ample testament in the field. For instance, if you desire a good, high magnification view of Saturn's rings, the 80 mm F/5 will almost always produce noticeably inferior views to an 80 mm F/10 used under the same conditions.

We have not mentioned the last item on the list – the so-called defocus aberration. This measures how easy it is to find and maintain a sharp focus. This aberration is more commonly referred to as "depth of focus." Depth of focus (ΔF) measures the amount of defocusing that can be tolerated before the image looks noticeably impaired to the eye and is calculated using the following formula;

$\Delta F = \pm 2\lambda F^2$, where λ is the wavelength of light and F is the focal ratio of the telescope.

Note how depth-of-focus scales with the square of focal ratio. Thus, a F/5 refractor will have $(10/5)^2$, or four times less focus depth than an F/10 scope. This means that, using green light (550 nm) for an F/10 telescope, you need only focus within an accuracy of ± 0.11 mm. The F/5 scope, in contrast, exhibits a much lower tolerance (± 0.028 mm).

What this means in practice is that short focal ratio scopes are more difficult to focus accurately compared with longer focal ratio scopes. Photographers, of course, have long been familiar with this effect. Let's illustrate the result here using a digital SLR. The following two images were taken of the view out a front door. The first picture shows an image of when the lens was opened to F/5.6; note that the privet hedge in the foreground is sharply focused but the background is much fuzzier. Next, the lens was stopped down to F/11 and another picture was taken. Notice this time that the foreground hedge and background trees are much more sharply defined.

To see how defocus aberration affects the telescopic image, think of a bout of bad seeing. During such moments, you'll find it very difficult to find the best focus position. Telescopes with a shallower depth of focus will be more affected by this focussing inaccuracy than instruments that enjoy a greater depth of focus. When the bad seeing subsides, the short focus scope will be found to require more corrective focussing than the long scope. So a F/5 refractor will have to work four times harder to 'chase the seeing,' as it were, compared to a F/10 instrument of the same aperture. As will be explained in the final chapter, depth of focus is a

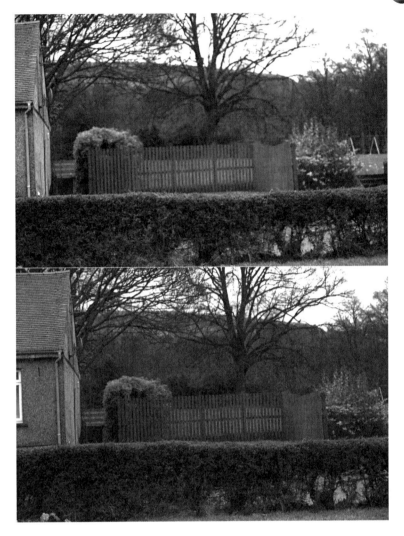

Image captured @F/5.6 (top) and Image captured @F/11(bottom)

greatly overlooked aid to attaining a steady, comfortable viewing experience, especially when observing the Moon, planets, and double stars. We shall have more to say about this interesting result in the last chapter. The downside of having a long focal length refractor is that it becomes less portable and more difficult to mount. Nevertheless, as we shall see, long focus achromats have been championed by an army of loyal fans the world over who savor their clean, crisp views.

Coatings of Many Colors

Take the cap off your telescope objective and examine it in a well-lit room or the great outdoors. Chances are you'll notice a purple, blue, or green tint (or a mixture of these colors) from the surface of the lens. Indeed the color reflected also depends on the angle from which you view the lens. Your binocular and camera lenses will also show this effect. This lens 'bloom' is due to the presence of so-called anti-reflection coatings deposited onto the surface of the lens. What do they do? Uncoated glass surfaces reflect about 4% of the light shining on them. And if light is reflected off a lens surface it can't help but form the image delivered to the eye. By using an ultra thin anti-reflection coating on the surface of the lens, typically only a few millionths of an inch thick, this light loss reduces to less than 1%. Scattered light from an uncoated lens also degrades the daylight image by reducing contrast. On spotting telescopes that have multiple optical surfaces – lenses and prisms included – images would appear noticeably dimmer and lower in contrast if left uncoated.

The simplest anti-reflection coatings take the form of magnesium fluoride (MgF_2), which can reduce reflections at a surface by a factor of four compared to uncoated lenses. Nowadays, multiple layers of different coating materials are used to reduce reflectivity by another factor of four, so total light loss can be reduced to about one quarter of a percent. Multi-coatings can reduce reflections so effectively that they can make the lens almost disappear when viewed from a certain perspective.

It's important to appreciate the terminology behind lenses using anti-reflection coatings. Coated lenses have a single layer, usually magnesium fluoride, deposited on the lens surfaces. Multicoated lenses have multiple layers of coatings deposited on their surfaces. Fully multicoated lenses (now a basic industry standard) have multiple coatings applied to all lens surfaces. An uncoated lens examined in daylight shows a bright white reflection. In contrast, the reflection from a coated lens will be a more subdued, faint blue color. A multicoated lens shows a faint blue, green, or purple tint when looked at from different angles. As we'll see later in the book, multi-coatings are also very important in multi-element eyepieces, especially when observing bright stars. That said, a single MgF_2 coating applied to the objective can improve light transmission very significantly, so much so that other coatings by and large are designed to improve transmission at wavelengths other than visual wavelengths. This will also be welcome news to CCD imagers, of course, but it is still not proven as to the utility of multi-coatings in visual applications. Some of the finest views come from objectives with only a single MgF_2 layer applied. The term fully multicoated

Antireflection coatings can vary dramatically from scope to scope. (Image by the author)

is somewhat misleading and has been abused by unscrupulous marketing hype. Truth be told, there are any number of different coatings that can be used on a newly crafted lens, and in some cases, depending on the type of glass, a single layer coating can actually have a lower reflectivity than a multi-layer. Indeed, let us go so far as to say that a well-executed single layer MgF_2 coating will perform better than a shoddily executed multi-coating.

Baffled by Baffles?

A good refracting telescope is not simply a high quality lens. The tube it's mounted on is equally important. Even the best lens can give poor results if the optical tube is not well designed.

The purpose of a good refracting telescope is to collect as much useful light as possible and prevent extraneous light from reaching the eyepiece. This is why all quality refracting telescopes are baffled. Baffles are not devices used by makers of cheap department store refractors to limit the aperture of their scopes in order to hide the bad quality of their optics. We should really refer to them as 'diameter restrictors.' In fact, properly designed baffles never reduce the useful diameter of the telescope. Quite the contrary: they allow all light from the observed object to reach the eyepiece, but block light coming from other sources to prevent degradation of the image. By increasing image contrast, baffles will give you a feeling that your scope is "bigger" than it was before; fainter objects will be easier to observe and more details will be visible.

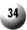
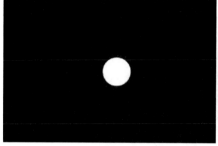

Looking through the tubes of left, a well baffled scope and right, a poorly baffled scope. (Image by the author)

TeleVue telescopes use simple, flocking material to absorb stray light. (Image by the author)

Manufacturers have come up with several different designs to ensure their refractors keep out as much stray light as possible. Most baffles consist of a series of concentric, matte black rings – sometimes called knife-edge baffles – placed at precisely calculated positions along the optical tube and using optical ray tracing. Another approach is to roughen up the inside surface of the telescope tube and dew shield, thereby creating millions of tiny baffles. TeleVue, for example, doesn't really baffle its scopes at all! Its high-performance refractors make do with a simple, dark flocking material that is surprisingly effective at dampening down stray light.

Optical Quality and All That

So how good are the images served up in your telescope? Good? Mediocre? Superlative?

One way of measuring optical quality is to specify how well the objective lens is figured. Because the difference between a good objective and bad objective can be minute, it simply isn't convenient to express errors in everyday units. Instead some opticians prefer to express the error in terms of the fraction of the wavelength of yellow green light the objective deviates from that of a perfect optic. This color of light has a wavelength of 550 nm. One nanometer is one billionth of a meter. A mediocre objective will be figured to an accuracy of ¼ of a wave; that is, the microscopic irregularities in the shape of the lens cannot be more than about 140 nm in order for it to operate satisfactorily under most conditions. Such an objective is said to be diffraction limited, which means that the optics are constrained by the wave nature of light itself and not by any flaws in its optical figuring. Who conjured up this idea? That goes to the nineteenth-century physicist Lord Rayleigh, who reckoned that an image distorted by anything more than ¼ wave of yellow green light would appear obviously degraded to the eye. This is called the Rayleigh limit. Of course, it stands to reason that an objective corrected to an accuracy of say 1/8 of a wave has an even better figure, but would you notice the difference in the field? Careful observers would definitely say yes. A refractor that is corrected to an accuracy of ¼ of a wave will show some nice detail on the planets but not nearly as much as an identical refractor corrected to say 1/6 or 1/8 of a wave. That said, there is a limit to how much the human eye can discern. In typical tests, most people are not likely to see a difference between an objective corrected to 1/8 of a wave and one that is corrected to a 1/10 wave accuracy.

Surface accuracy is all well and good, but it doesn't tell the whole story. Errors in the figure of the lens surfaces making up the objective can lead to increased spherical aberration, coma, distortion, field curvature, and astigmatism (the five Seidel errors), but even a well figured achromatic objective will still display false color, especially at shorter focal ratios. To this end, optical engineers have an even better way of expressing optical quality, which also takes into account how well the objective is color corrected – the Strehl ratio.

To understand this quantity better, picture again the image of a tightly focused star seen at high power through the telescope. The star will not be a perfect point but will instead be spread over a tiny disk of light called the

Airy disc surrounded, in ideal conditions at least, by of series of diffraction rings. This is what opticians call a diffraction pattern. In 1895, the German mathematical physicist Karl Strehl computed what the diffraction pattern of a perfectly corrected lens (or mirror) would look like, with a central peak intensity (representing the Airy disc) surrounded on either side by a series of peaks of progressively less intensity. A *real* lens, on the other hand, will have some optical aberrations that will leave their mark on the diffraction pattern observed. For example, a short focal length achromatic lens will display some false color (chromatic aberration) and so some of the light never gets focused tightly inside the Airy disc, resulting in a decrease in the peak intensity in its diffraction pattern compared to a perfect lens. Other optical errors, such as spherical aberration and astigmatism, for instance, also leave their mark on the diffraction pattern. And yes, it inevitably reduces the peak intensity of the Airy disc.

Strehl suggested that the ratio of the peak diffraction intensity of a real lens (aberrated diffraction pattern) to a perfect lens could accurately predict optical quality. Put even more simply, the Strehl ratio is a measurement of the amount of light put into the peak of the image spot (the Airy disc) in an *actual* telescope, compared to that put in the spot of a *perfect* telescope. It is also noteworthy that the Strehl ratio varies with the wavelength of light used (see figure below). For convenience, most Strehl ratios quoted are measured using green laser light (0.550–0.587 µm). This is called the peak Strehl ratio.

To that effect, some of the higher-end telescope manufacturers routinely quote these ratios as an indicator of how well crafted their optics are. A perfectly corrected telescope has a Strehl ratio of 1.0. A telescope that is diffraction limited (and no better) has a value of 0.8. But some of the best long focal ratio achromatic refractors can have Strehl ratios as high as 0.97 over much of the yellow-green region of the visible spectrum. In contrast, some inexpensive rich field refractors – the short tubes – designed for low magnification observations (such as sweeping the Milky Way at night) can have Strehl values as low as 0.67.

Of course, all of this is merely academic if you already own a telescope and enjoy the views it serves up at the eyepiece. Indeed, it pays to remember that even a 'mediocre' scope used by the modern amateur is optically quite comparable to the very finest available to the nineteenth-century amateur and look where their adventures led them! In the end, it pays to remember that *the eye is the ultimate arbiter of optical quality.*

That brings us to the end of our general discussion on achromatic refractors. Much that has been mentioned in this chapter is generally true of the other type of refracting telescope on the market today – the

Strehl Ratio Vs Wavelength for a 75 mm F/15 Achromat

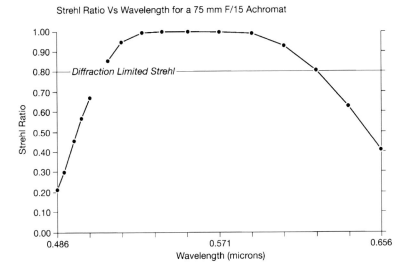

Redrawn from an image produced by Matt Considine

apochromat – which we'll dedicate time to in Part 2 of the book. You can now better understand why your scope behaves as it does and what to look out for in terms of the defects these instruments sometimes carry. For those who wish to dig deeper I can highly recommend Vladimir Sacek's superlative website dedicated to telescope optics: www.telescopeoptics. net. You'll find everything you want and more in there.

Our next port of call is the so-called rich-field achromats – relatively inexpensive instruments that have given thousands of enthusiasts extraordinary views of nature, by day and by night.

Rich-Field Achromats

Are you a casual observer; someone who enjoys a quick look around the landscape during daylight hours, or the river of stars that litter the Milky Way at night? Are you an experienced observer who already owns a large telescope but wishes to have a small portable system that gives decent, low, and moderate power views of the Moon, planets, and brighter deep sky objects? Or are you also a birder on a budget? If your answer is 'yes' to one or more of these questions, then chances are you wouldn't go wrong with a rich-field refractor.

By 'rich field' we mean an achromatic refractor with a relatively small aperture and short focal ratio. Though there are a number of refractors with apertures less than 80 mm on the market, this chapter will concentrate on models with apertures of 80 mm or greater because this is about the minimum aperture most amateur astronomers would be happy using in the field. Of course, you can still see a great deal in the night sky with smaller instruments, especially if you know what you're looking for, and smaller instruments are often used by naturalists and birders during daylight hours. But we'll explore these ultra-small optical wonders in a later chapter.

For many refractor enthusiasts, one telescope above all others has become stereotypical of the genre – the Orion Short Tube 80 ($120 for the new tube assembly). Ever since this telescope was first introduced in the mid-1990s, it has become one of the best-selling portable telescopes of our times.

At the heart of the Orion Short Tube – and many of its clones that have appeared on the market in recent years – is an 80 mm (3.2 in.) achromatic

N. English, *Choosing and Using a Refracting Telescope*, Patrick Moore's Practical Astronomy Series, DOI 10.1007/978-1-4419-6403-8_3, © Springer Science+Business Media, LLC 2011

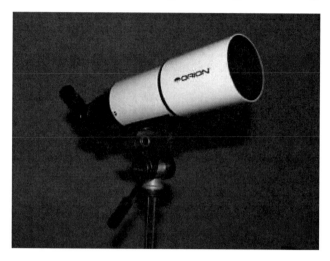

The Orion ShortTube 80 (Image credit: Zeno Sirbu)

doublet with a focal length of 400 mm (F/5). Weighing in at only 3.7 lb, this little telescope is only 16 in. long when the dew shield is removed, making it an ideal grab n' go instrument for both birders and astronomy enthusiasts alike. The lens cell in these models is collimated at the factory and is not user-adjustable, so it's best to make sure the optics are properly aligned before making a purchase, either new or second hand.

The newest incarnation, the Orion Short Tube 80-A Refractor Telescope (A for "Astronomy"), is an upgraded version of the ever-popular Short Tube 80. Now improved with fully multicoated optics and a soft carrying case, 'the little telescope that could' is better than ever! A fantastic 'take anywhere' telescope, it yields bright, wide-field views, whether it's a distant flock of geese or an open cluster of stars thousands of light years away. But it is also fairly good on Solar System targets as well, so long as you don't push the magnification too high. Standard accessories with this telescope typically include an aluminum rack-and-pinion focuser (1.25″), 90° mirror diagonal, a sizeable 8 × 40 finder (a big improvement over the original 24 mm trash finder), tube rings, and two eyepieces of 20 and 9 mm focal length. These deliver powers of 20× and 44× with a field of view of 3.3 and 1.5°, respectively. A convenient mounting block attaches easily to a variety of photographic and telescope mounts, and the entire package comes with 1-year limited warranty.

Powers up to 75× or thereabouts are acceptably crisp, but you'll very soon notice quite a lot of false color around objects such as the Moon, Venus, Jupiter, and bright stars. But used within its limitations, it is a

highly versatile performer. One slightly annoying thing is the almost constant need to refocus when observing planets and double stars. At F/5 you're either in focus or you're not. Only on the calmest nights should you attempt such ventures with this telescope. Still, its modest light-gathering power can just bag 12th magnitude galaxies from a pitch black sky, and it can show you superb details in the daytime landscape even under twilight conditions. The very high powers – up to 50 or 60× per inch of aperture used during good astronomical seeing – are rarely of use during the day, when atmospheric turbulence tends to constrain the upper limit of useful magnification to within the range of the Short Tube 80. If you can live with the chromatic aberration it shows around high-contrast objects at moderate magnifications, then it's definitely worth considering.

Since that time, a plethora of Short Tube 80 clones have come on the market with broadly similar optics and mechanics. The more inexpensive models, for instance, often possess fully coated, as opposed to fully multicoated, optics. That doesn't make a great deal of difference at night, but you're likely to notice the difference during daylight tests. The Orion Short Tube has a single baffle placed midway down the tube and is painted in a matte black, which does an excellent job of extracting stray light. More importantly, though, it is often the accessories that accompany the telescope that limit the usefulness of the more inexpensive clones. Indeed, replacing the stock diagonal and the eyepieces with better quality models can significantly improve their performance in the field. We'll take a closer look at accessorizing your refractor in Part 3 of this book.

One enthusiastic owner of the Celestron version (called the Rich Field 80) indicated how much he liked this refractor: "What a great little telescope! It performs extremely well at low magnifications, providing superb views of the Milky Way, open clusters, and brighter Messier objects. The Pleiades was framed perfectly with the supplied 20 mm Plossl eyepiece. M31 also was a treat under dark skies. M27, M13, M81, and M82 also show up well. I tried the little Celestron on Saturn and was pleasantly surprised. Increasing the magnification to 88× I was able to obtain a fairly sharp view of Saturn. Titan was clearly visible but not Cassini's Division. Not bad, considering Celestron make it clear that this isn't a full blown astronomical telescope, just a spotting telescope. I would recommend this telescope to a newcomer or someone more experienced looking for something small and portable."

Want a high-tech version of the Short Tube 80? Then look no further than the Meade ETX80 refractor. At the heart of this system is an 80 mm F/5 instrument on a GOTO mount powered by an AutoStar computer controller that automatically guides your telescope to over 1,400 objects.

The telescope comes equipped with two quality 9.7 and 26 mm series 4000 Plossl eyepieces and a built-in Barlow lens (that instantly doubles the power of any eyepieces). For an all-in price of $259, it's a bargain.

The old maxim, "You get what you pay for," certainly rings true in the rich-field refractor market, too. If you thought you'd heard the last word on 80 mm F/5 Short Tubes then you haven't looked through a Vixen A80SS (formerly known simply as the 80SS). Like all instruments made by Vixen, this little beauty exudes quality, with no plastic in sight. With the dew cap extended, it's only 14 in. long and weighs in at a mere 4 lb. The optical tube assembly is equipped with two quality eyepieces, a red dot finder, and a dovetail bracket. What's more it's got a lovely 2-in. focuser with a built-in flip mirror for photographic applications, so you can outfit it with all your quality accessories. Visually, it does show chromatic aberration around bright objects, as you might expect, but most units serve up images that remain sharp at powers in excess of 120×. Star testing one unit showed

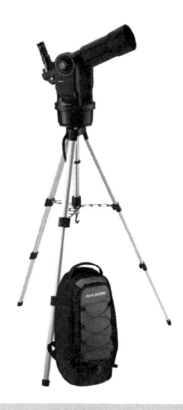

The Meade ETX 80 (Image credit: Telescope House)

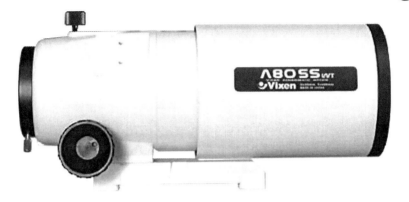

High quality short tube: the Vixen A80SS (Image Credit: Vixen Optics)

very well corrected optics and much less spherical aberration – definitely a step up from the mass-produced Chinese made F/5 Short Tubes discussed so far. What's the catch? Well, they retail for about double the price ($429) of the basic Orion Short Tube 80, but they do come with a 5 year warranty. If you appreciate small, high-quality instruments that can deliver where it counts, this just might be the telescope for you.

Do you want the spirit of the Short Tube 80 in a larger frame? If so, then here's some good news for you: there are rich-field refractors available in a variety of apertures up to 6 in. (150 mm). Sky-Watcher manufactures a nice range of larger rich-field achromats – the StarTravel family – with apertures of 102, 120, and 150 mm. All have F/5 focal ratios. Orion USA produces a similar 120 mm rich-field instrument. Like their smaller siblings, their objectives cannot be adjusted without voiding the warranty, so it's best to try before you buy. Like its smaller sibling, the StarTravel 102 has coated optics in a sky-blue colored aluminum tube. The focuser is a simple rack and pinion and can accommodate 2-in. accessories. Heavily greased, the focuser works well enough under most observing conditions but tends to stiffen up on the coldest winter nights or where temperatures often plummet below zero. Daytime views at low power with a quality eyepiece are delightfully crisp and bright with a very well-corrected field of view.

As you might expect, this is not a telescope to look at the Moon and planets with high power. Like its smaller sibling, it executes its job as a rich-field telescope very well indeed. After the stock 1.25″ diagonal is replaced with a high-quality 2-in. dielectric diagonal and a 27 mm TeleVue Panoptic eyepiece inserted, the telescope serves up a power of 19× and a generous 3.6° field of view. Pointing the telescope towards the autumn Milky

Way through Cygnus, you will be treated to pleasant, crisp, and bright star fields against a very dark background sky. This is what a telescope like this is meant to do! There's a noticeable jump in light-gathering power, too – 36% may not look like much on paper, but it translates into 'pulling out' many hundreds of fainter stars. Stars remain tiny pinpoints out to perhaps 70% of the way from the edge, then get progressively less well defined as one moves towards the edge of the field of view.

Only in the outer 10% of the field do the distortions – astigmatism and coma, mostly – become objectionable. The view of the Andromeda Galaxy (M31) from a dark October sky can be unforgettable. You can trace the faint spiral arms of the galaxy out to about 3° and its two satellite galaxies are unmistakable. Turning the instrument on the famous Double Cluster in Perseus, the StarTravel 102 reveals two distinct sprinklings of pure starlight with plenty of dark sky separating them. Inserting a quality 9 mm Nagler eyepiece giving 57×, you can clearly make out some older red giant stars between the clusters, the members of which are almost uniformly white in comparison. At this moderate magnification at least, chromatic aberration seems to be very well controlled. On brilliant Vega, a star test showed up well-defined concentric Fresnel rings inside and outside focus, but there was definitely a touch of spherical aberration, judging by slight differences in the brightness of the outer ring inside and outside best focus. The "Double-double," Epsilon Lyrae, normally an easy split in fairly small telescopes, does not disappoint. It resolves into four well-defined and sharp discs at 114×. The stars are not pure white, however – more a greenish-yellow cast.

The much-more-difficult Epsilon Bootes (Izar) does show glimpses of its blue-green companion using the 9 mm Nagler eyepiece and a 2.5× Powermate yielding 143×, though the false color from the second-magnitude primary makes for quite a challenging split.

By turning the telescope towards Saturn you can make out the rings and planet quite well, but the image is, well, unexciting? Banding on the planet's globe is quite washed out and subdued, and the Cassini division is visible but not what you'd call obvious. But so what? This is not a planetary telescope! If you use the StarTravel 102 at powers below 40× or 50×, the views are absolutely stunning. And, as an added bonus, this is a telescope that can be upgraded at modest cost. First off, if you get this telescope be sure and buy a 2″ diagonal for it and invest in a quality 2-in. eyepiece for those 'space walk' views. You won't be disappointed. Incidentally, if you still want to look at the Moon you can get very sharp view by using the aperture stop provided on the dust cover. This takes you down to around 53 mm, but the improvement of the images is striking. Indeed, stopped down – which increases the focal ratio – this telescope

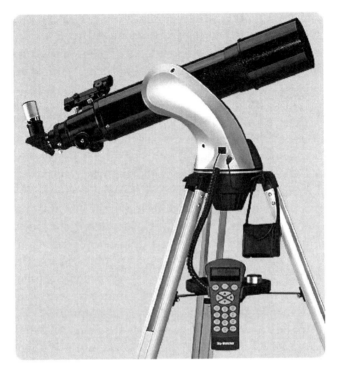

The Sky Watcher Light Chariot (Image credit: Optical Vision Limited)

star tests quite well. Considering what it costs (about £190 UK) and the kind of low power views of the night sky it can provide, this telescope is a wonderful bargain. Recently, Sky Watcher has revamped the original StarTravel 102 and replaced it with the slightly longer focal length Light Chariot ($379), a 4-in. F/6 rich-field achromat that comes complete with a motorized Alt-Az mount.

Both Sky-Watcher and Orion (USA) still sell a 120 mm (4.7 in.) F/5 Short Tube. The optical tube assembly is fairly light – about 11 lb when stripped down – and is a great telescope for deep sky observing. One enthusiast described how he loves touring the Virgo cluster with his ShortTube 120, since its decent aperture can bag a fair number of galaxies from a dark sky site. Moreover, he added that being able to view both the Lagoon and Trifid nebulae in the same field with room to spare was especially neat. Many globular clusters are well resolved with this telescope, too.

Sky-Watcher has manufactured an even larger rich-field telescope, the StarTravel 150 mm (6-in.) F/5 refractor, for a number of years now. Perceptions of this telescope vary depending on who you talk to. Weighing

in at 15 lb, it's not exactly in the size range that you'd call grab n' go. Its large objective lens makes this telescope decidedly front heavy, so it could present some balancing issues when attached to a mount. But you do get a lot of light-gathering power – 225% more than a 4-in. aperture – and with a 30 mm 82° field eyepiece you can enjoy a lovely 3° field of view with a 25× magnification. A 6-in. aperture goes deep, really deep – 14th magnitude is just about attainable. Ron Laeski from Long Island, New York, wrote about this telescope. "The lens on this telescope provides excellent wide field resolution of stars and clusters," he says, "particularly, while using 2″ eyepieces. It has adequate coatings, internal baffling, and a lens hood which provides adequate protection from outside glare. I did not notice any dew build up on the objective while viewing during humid New York summer nights. Owners of this telescope should take advantage of any masking offered by the manufacturer for astrophotography. Though I didn't use this telescope for digital photography, the telescope could make for a powerful CCD objective with decent IR filters. This is a telescope that an amateur astronomer can improve upon with dramatic results! For example, after 2003, commercial companies began selling various chromatic reduction filters such as the Sirius MV-1 filter. Alternatively, a Wratten yellow #8 filter does a good job subduing the purple chromatic aberration generated by this telescope. However, I think these rich-field telescopes generally provide better views than Newtonians and catadioptric telescopes of the same aperture or more."

Short Tube King?

Thus far, we have focused almost entirely on rich-field refractors with focal ratios of F/5. As explained in the previous chapter, it's possible to get decidedly better images with less false color by increasing the focal ratio of the telescope. Even relatively small changes can have very perceptible effects. By extending the focal ratio to F/6 or so, a number of manufacturers have managed to produce higher quality rich-field achromats that still retain an acceptable level of portability. The first instrument in this category is the Stellarvue AT1010 – alias Nighthawk – which is an 80 mm F/6 achromat. Now discontinued in its original form, this telescope enjoyed a fair amount of success when first launched by Stellarvue founder Vic Marris back in 2002 and still show up on the used market fairly regularly. Since then, Stellarvue has re-launched them in several formats.

A few years back this author had the good fortune to put one of the earlier Nighthawks (sometimes referred to as the AT 1010) through its

paces during several weeks of cold winter observing. The model I received came as a black optical tube assembly. Weighing in at about 6 lb, the telescope is built like a proverbial tank, with a retractable dew shield, a lovely screw-on lens cap, and a silky smooth 2-in. rack and pinion focuser with oversized focus knobs. An 80 mm air-spaced objective lies at the heart of the instrument, mounted in a collimatible lens cell. After mounting the telescope to a Tele Vue Gibraltar mount and inserting a good quality diagonal and 24 mm Panoptic eyepiece, I was ready to observe. My first port of call was the great Orion nebula (M42), which was crossing the meridian. I wasn't disappointed. The Nighthawk served up a beautiful cloud of luminous green gas set against a velvet black sky. Cranking up the magnification to 60×, I could clearly discern the quartet of neonatal suns in its core – the famous Trapezium. This little 3.1 in. refractor showed a wealth of high-contrast details within the nebula. This was no amorphous cloud; it had lots of structure.

When I examined the bright star Capella at 120× with the Nighthawk, the image served up was very encouraging – a nice sharp Airy disc surrounded by a single diffraction ring. This telescope definitely shows some false color, as evidenced by a halo of unfocused violet around the star. But what was immediately striking was how much cleaner the focused star images were in comparison to those served up by the Short Tube 80. A more detailed star test showed nice concentric rings (an indicator of good collimation) both inside and outside focus. There was a touch of spherical aberration and astigmatism, but definitely less than with a typical F/5 Short Tube 80. This was borne out when the Nighthawk was turned on Jupiter. At 80×, the image of Jove had a warm, yellowish cast, with a small amount of unfocused violet light surrounding it. In moments of good seeing, you could count three or four bands and the Great Red Spot – not bad at all and

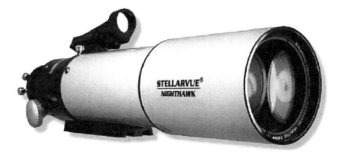

The Stellarvue Nighthawk Refractor (Image credit: Altair Astro)

certainly better than you could routinely achieve with an F/5 Short Tube 80. In short, this telescope is a well corrected achromat. More careful matching of the objective lenses, a slightly slower focal ratio, and more attention to the telescope's tube design – particularly internal baffling – all contribute to its good performance. A little loving care can go a long way for a telescope and it shows with the Stellarvue Nighthawk. No wonder *Sky & Telescope's* contributing editor Alan Dyer crowned it the king of short tubes!

In the last few years, the Nighthawk has undergone a number of changes – all in the right direction. Its most recent incarnation has a slightly longer focal ratio (F/7), promising better color correction. The objective has an aplanatic design, ensuring that coma and astigmatism are minimized. Couple this to its sleek, single-speed Crayford focuser and a red dot finder and you have a highly portable observing instrument. All that for $498!

Want a decent rich-field refractor that really looks the business? Then you might want to get your hands on the William Optics Zenithstar 80. Now discontinued by William Optics, enough of these – and their many clones – are still available either new or second hand. Some come with a custom padded soft case. The telescope is a beautiful, glossy black with gold trimmings. The tube is a shiny, anodized black, so there's no chance of chipping off paint. That said, it's very easy to smudge with fingerprints! The objective (480 mm F/6) is a cemented doublet with deep green multi-coatings. The telescope has a fully retractable dew shield and comes equipped with a very nice Crayford focuser, but you'll have to supply your own diagonal and eyepieces. Another neat feature of the tube is that it is

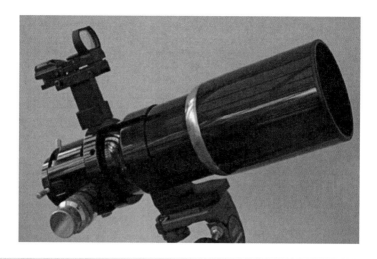

The William Optics Zenithstar 80 (Image credit: Dennis Boon)

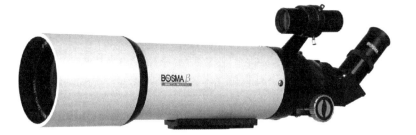

A new player in town, the Bosma Beta 80mm F/6.3 doublet (Image credit: Bosma)

fully rotatable – not a feature you're likely to appreciate if you're a purely visual observer, but it's very useful if you have astrophotography in mind.

Like the Stellarvue Nighthawk, it serves up nice, high-contrast views at low powers. The 15 internal baffles do an excellent job suppressing any stray light. But when you charge this telescope with an old 4.8 mm Nagler eyepiece yielding 100×, you can detect a very small amount of spherical aberration and moderate astigmatism. Then, there's the color. After turning the telescope on Jupiter, you will see a prominent yellow planet surrounded by a prominent crimson halo. Details on the Jovian disc were there, but it is hard to reach a precise focus. This telescope would also benefit from a minus violet filter.

That said, the Zenithstar 80 has better optics than a typical 80 mm F/5 Short Tube, but it is a notch below that of the Nighthawk. The lesson is clear. This is a fine telescope, especially for its modest price tag ($399 new and a good bargain on the used market), for daylight observing and casual stargazing, and it is beautifully finished; but if pushed to extremes, it's more likely to disappoint than delight. Since the launch of the William Optics Zenithstar 80, a few other clones have emerged, most notably the Orion (USA) Express 80, the Antares Sentinel, the Revelation 80, and, most recently, the Bosma refractor. They seem to all display similar optics in very similarly designed anodized tubes.

Going Larger

A number of other companies market rich-field larger instruments in the F/6 range but with considerably more light-gathering power. Orion Telescope and Binocular sell a very popular 4-in. (102 mm) F/6 refractor – the Astroview rich-field telescope.

Similar to the Sky Watcher Light Chariot described earlier, its decent light grasp and relatively short focal length makes it very suitable for bagging many deep sky objects, and its performance on the Moon and planets is also a step up from the shorter focal ratio short tubes. Apogee also market a similar-sized telescope – the 4-in. Widestar refractor – finished in black with a focal length of 640 mm, and the Canadian company Antares (Sky Instruments) offers two similar models – a 90 mm F/5.6 and a 152 mm F/6. The latter has a rather nice Crayford focuser and retractable dew shield.

Keen to try out one of these rich-field instruments, you might stumble across a German-based company called Teleskop-Service (TS) which offers a 102 mm air-spaced doublet achromat with a focal length of 660 mm (F/6.5). The company advertises these telescopes as being solid performers on both Solar System objects and the deep sky. Occasionally, an instrument might come up on the second-hand market. Over a period of a few weeks this author spent countless hours evaluating its optical and mechanical performance in the field. When the telescope finally arrived, I was delighted to see how sturdy it was. The white, aluminum optical tube assembly weighs in at 11 lb. That's significantly heavier than imagined. If there's one word to describe this instrument it has to be 'overbuilt.'

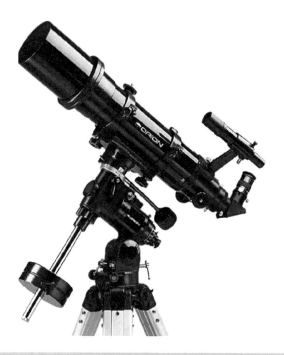

The Orion Astroview 4-inch F/6 refractor (Image credit: OPT)

The Telescope Service 102mm F/6.5 achromat (Image by the author)

Even though the objective lens was only 4 in., it came with a massive dew shield nearly 6 in. in diameter. The objective lens had nice, smooth multicoatings, which give it a deep green daylight tint.

Three baffles helped to dampen any stray light, and the interior was painted an even matte black. Turning my attention to the 'business end' of the telescope, I was delighted to find a very high quality rack-and-pinion focuser, which moved very smoothly with a fair amount of tension. It could also accommodate a 2-in. diagonal and had provision for the attachment of a DSLR. The tube assembly is also graced by a high quality 8×50 mm finder, which was mounted securely on the main telescope. Placing the optical tube (which came with tube rings and a dovetail plate) on my LXD75 mount, I was immediately thrilled by how good-looking the whole set up was.

So, how well does it perform? Overall, very well indeed! During day-light hours, set the telescope up to look at the leaves of some distant trees.

Insert a good quality 26 mm Plossl eyepiece and the TS102 will snap into focus, serving up very bright, crisp views with little distortion – even at the edge of the field. The slower focal ratio (F/6.5) compared to the ultra-fast F/5 short tubes is a definite plus here. Then crank up the power. With a 9 mm eyepiece yielding 74×, the image remains very sharp, with only the merest hint of blue fringing caused by chromatic aberration. It's only when you insert eyepieces yielding powers over 100× that the chromatic aberration becomes prominent enough to notice easily, but in no way does it otherwise compromise the quality of the image.

So far, so good. But how does it perform under the stars? First insert a 26 mm Plossl eyepiece yielding 25× and examine a whole host of objects, including star clusters, galaxies, and nebulae. First stop should be the Perseus double cluster. The view is superb, with mounds of star dust defined as sharp pinpoints nearly all the way to the edge of the field. The Andromeda galaxy (M31) is simply breathtaking, with its spiral arms filling the field of view either side of its bright, condensed nucleus. This is where the telescope really excels. Next up – a star test. Looking at Vega in focus using a 4 mm orthoscopic eyepiece yielding 165×, the TS102 shows a nice tight stellar image. It is surrounded by a faint 'purplish' halo, which is quite unobtrusive. Racking the image *just* inside and outside focus, you can pick up a trace of astigmatism. Moving further away from focus on either side, you can make out a fairly clean set of diffraction rings. There are no obvious signs of spherical aberration. If there are no bright planets or the Moon in the sky, you can try splitting some closely separated doubles. Both Epsilon Bootis (Izar) and the Epsilon Lyrae (the famous double double) are easily resolved with this telescope with magnifications of 200× and 100×, respectively.

When you can, look at the Moon at low and high magnifications. Inserting a 26 mm Plossl and aiming the telescope at a first quarter Moon should serve up a wonderful amount of detail. Yes, the lunar edge has a blue fringe, but one can easily forget about it given the sheer splendor of the image. The eye has an amazing propensity for cleaning up images, and you can, to some extent, learn to 'unsee' the unobtrusive color fringes this telescope throws up. That said, a 1.25 in. Baader semi-apo filter (which cuts off shorter wavelengths of light where false color is most prevalent) inserted ahead of the diagonal effectively removes the glare and much of the blue fringing without significantly shifting the color of the lunar surface. Cranking the magnification up to 205× yields very good images, but no finer details could be seen beyond about 165×. Those interested in doing a bit of photography will find lots about this telescope that's good. For one thing, its solid, over-built construction easily handled the additional weight of a DSLR camera body and off-axis guider. Short

exposures of 30 s or so confirmed what is noticed visually: stars remains pinpoints of light almost to the edge of the field. You can improve the situation still further by attaching a focal reducer to reduce the focal ratio and flatten the field some more.

Bright stars show faint purple halos, but these can be effectively cut down by using a number of filters. A light yellow filter (Wratten #8) does a fairly good job cleaning up the image. All in all, the optical and mechanical quality of the TS 102 mm short tube achromat is impressive. The company sells these telescopes as optical tube assemblies complete with a 50 mm finder and tube rings. Alternatively, you can choose to purchase the instrument with a mount at additional cost. If you're after extreme portability, you might find this telescope too heavy to handle. On the other hand, if you're after a budget-priced telescope with decent light grasp that can do a good (or even very good) job on most celestial targets, then this could well be the telescope for you. Recently Telescope Service has launched an even sleeker version of the TSA 102. Called the TS RFT 1007 (299 Euro for the tube assembly), it has the same aperture but a slightly longer focal length (700 mm), making it a promising contender as a great all around telescope. The focuser has also been upgraded to a single-speed Crayford.

Another German-based company Astro-Professional has also recently introduced a similarly designed version of the TS RFT 1007 achromat but in a 6-in. F/6 format! Simply called the Achromat 152, this telescope sure looks snazzy, sporting a retractable dew shield, excellent baffling, a 2-in. Crayford focuser, and tube rings complete with a nifty carrying handle for easy transport. As you'd expect, this quality is also reflected in the price – £675 UK for the package. A similar instrument – Astro Telescopes 6-in. (152 mm) f/5.9 ($795) – is now being produced by Kunming United Optics in China.

If you're after a rich-field telescope with decent aperture on a fully computerized mount, then Celestron's NexStar 102 SLT package ($419) might just float your boat. At the heart of this system is a neat little 102 mm F/6.5 achromatic refractor, with a fully coated objective, a smooth 2-in. rack and pinion focuser with a 1.25 in. diagonal, and two eyepieces to get you started. The telescope comes complete with a fully computerized (GOTO) alt-azimuth mount with a 4,000 object data base.

Before leaving this section, we should mention an unusual 6-in. F/5 refractor manufactured by Bresser. Called the Bresser Messier R152S, it is actually a four-element design, with a full aperture doublet objective up front and a sub-aperture 'correcting' doublet further back in the tube. Such a configuration is called a Petzval, after the nineteenth-century portrait photographer who invented it. We'll have much to say about this

The Astro-Professional 6-inch F/6 achromat (Image credit: Star Telescopes)

design in Part 2. Suffice it to say at this stage that the Petzval design should have better correction of chromatic aberration and a flatter field (useful for photography) than a simple doublet of the same focal ratio. Gaz O' Connor from Wales gave me his take on this instrument.

"I've had my new (to me) 152 mm F/5 Petzval refractor out for the last three nights, once on a side by side plate with a Sky-Watcher 150 mm F/5 refractor. It's collimatible, stands at just over 3 ft tall (about the same length as a 150 mm F/6), weighs in at around 10 kg (22 lb), and comes with a smooth and solid 4″ focuser. The front lens is F/10 with a reducing doublet in the focuser to give a final figure of F/5 for the telescope. It's a damn sight bigger than the Sky-Watcher 150 mm F/5 in every respect and that means it needs a very beefy mount to do it justice. As the Moon was gibbous and washing out most of the sky I restricted myself to a quick star test, the Moon and Saturn. The star test showed the optics were well aligned, which was quite a relief after receiving such a complex telescope as this through the post. It also showed very slight astigmatism, which isn't enough to be a concern at the moment. In comparison with the Sky-Watcher, the views where pretty similar on Saturn up to around 150×, but after that the Petzval stood up a lot better, right up to 400×, although it was 'empty magnification' after 350×, which is still pretty impressive. The false color is slightly better controlled than the Sky-Watcher but still

The Celestron NexStar 102 SLT (Image credit: Star Telescopes)

very obviously there. At high magnifications on Saturn the image was a lot brighter and crisper in the Petzval than the Sky-Watcher, although I'm not sure why. At first look I'm pretty happy with the telescope. It's a marked improvement over my Sky-Watcher. The only real downside is its size – the Bresser is heavier than a 6″ F/8 and longer than a 6″ F/5, but as it combines the best attributes of the two telescopes maybe that's understandable?"

The Bressier Messier R152S retails for £766 (UK) and comes complete with equatorial mount, three eyepieces, and a nice 8 × 50 mm finder.

Recently Vixen, Japan, has revamped an older refractor called the Neoachromat (NA)140 (UK, £1, 295). Like the Bresser, it sports a Petzval like four-element objective to reduce spurious color and flatten the field. With an aperture of 5.6 in. (140 mm) and a focal length of 800 mm, it tips the scales at just over 14 lb (6.5 kg) and has a length of just over 40 in. Vixen touts this instrument as an excellent astrograph, but its color correction isn't in the same league as true Apos, which have special dispersion glasses

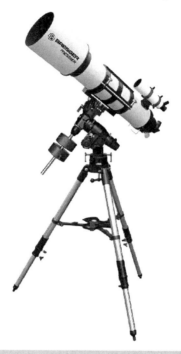

The Bresser Messier R152S (Image credit: Telescope House)

(see Part 2 for details). However, the Vixen will certainly excel as a visual instrument, particularly for low and medium power views of deep sky objects and for Milky Way sweeps.

In summary, rich-field achromatic refractors offer a lot of bang for your buck, combining decent light-gathering power with great portability. Though these instruments throw up a fair amount of false color around bright objects by day or night, the F/6 models are an especially good compromise between portability and optical quality. Although primarily designed as low power, wide-field instruments, they can also serve up good images of the Moon and planets when used in combination with a minus violet filter.

In the next chapter, we'll take a close look at longer focal length achromatic refractors and their great versatility in the hands of amateur astronomers.

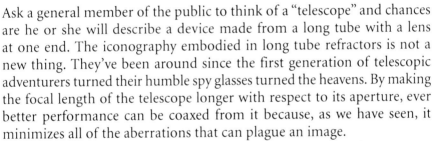

Long Focus Achromats

Ask a general member of the public to think of a "telescope" and chances are he or she will describe a device made from a long tube with a lens at one end. The iconography embodied in long tube refractors is not a new thing. They've been around since the first generation of telescopic adventurers turned their humble spy glasses turned the heavens. By making the focal length of the telescope longer with respect to its aperture, ever better performance can be coaxed from it because, as we have seen, it minimizes all of the aberrations that can plague an image.

Even today, many discerning observers return to these instruments again and again as they rediscover their sharp, high-contrast views of the Moon, planets, and double stars with little in the way of false color. Yet, as we shall see, these instruments – relics from the halcyon days of the refracting telescope – have attributes that have largely been forgotten by a generation whose observing experiences have been shaped by using instruments with shorter focal lengths.

In this chapter we'll be concentrating on achromatic refractors that have focal ratios greater than F/8 and in apertures ranging from 3.2 to 6 in. Without a shadow of a doubt, some of the sharpest images ever obtained were through refractors of this genre. There's a lot of ground to cover here, but we'll be describing some surprisingly good performers that can be acquired at modest cost.

N. English, *Choosing and Using a Refracting Telescope*, Patrick Moore's
Practical Astronomy Series, DOI 10.1007/978-1-4419-6403-8_4,
© Springer Science+Business Media, LLC 2011

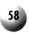

The 80 mm Brigade

If you're after a fairly portable scope that still delivers wide fields of view but can also take magnification well, then an 80 mm (3.2-in.) long focus refractor may just be the scope for you. Many of these instruments have come and gone over the years, but they are still proving popular with amateur astronomers. Typically, they have focal ratios between F/10 and F/12, so the appearance of false color is really a non-issue with these telescopes. One good example of this refractor genre is the Vixen A80MF, which sports a fully multicoated objective with an aperture of 3.2 in. (80 mm) and a focal length of 910 mm (F/11.4). The telescope comes with a pair of eyepieces, a 6×30 finder, and even a prism diagonal so you can begin observing almost as soon as you unpack it. The simple rack-and-pinion focuser found on the telescope may not look all that fancy, especially compared with many shorter focal length telescopes on the market, but at F/11.4, obtaining sharp focus is a breeze.

The telescope's long focal length ensures that even budget wide-angle eye-pieces will work well, serving up fields of view spanning several degrees. On the other hand, if high-power viewing of the Moon, planets, and double stars is your thing, this telescope will not disappoint. All in all, it's a solid bargain at $229 for the package. The newly minted Chinese optical company Bosma also produces its own version of this telescope; the Beta RE 80 mm F/11.3.

California-based Stellarvue has received high praise for its version of the high-performance 80 mm achromat. The 80/9D ($499 for the optical tube)

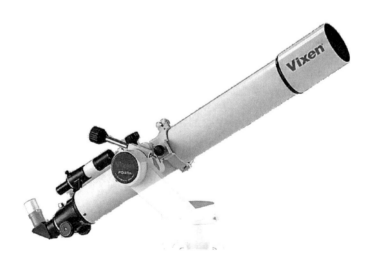

The Vixen A80MF (Image credit: OPT)

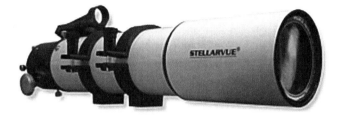

The "sexy" Stellarvue 80/9D (Image credit: Altair Astro)

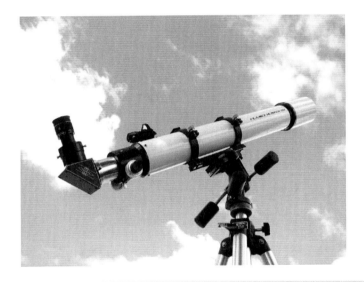

The 80 mm TMB/Burgess Planet Hunter (Image credit: Burgess Optical)

uses the company's proprietary 80 mm F-9.4 hand-figured achromatic objective. The earlier versions of this telescope had a matte-black tube similar in design to the first generation Stellarvue Nighthawk, only longer. And like the Nighthawk, it came with a very smooth rack-and-pinion focuser with oversized rubber knobs. The newer incarnations of this telescope were sold with single-speed Crayford focusers in a beautiful stardust white finished tube and retractable dew shield. The objective is housed in a beautifully machined adjustable lens cell. Now sadly discontinued, these pop up every now and again on the used market and can be had for a bargain. One enthusiastic owner described its performance – a view that seems to be typical of those expressed by owners:

"Under good seeing conditions," he said, "I get very minimal to no color fringing even on the Moon and bright stars at low and medium powers. Under typical atmospheric conditions, color would come and go around bright stars but still was minimal. With good eyepieces, it always serves up excellent contrast and pitch black skies in the field of view. Using a 40 mm Erfle, I can get a 3.3° field of view from the 80/9D for low powering scanning of star fields. Under steady skies, I can consistently use powers up to 180–200× without the image breaking down. It does a very decent job splitting some close double stars too."

Want an 80 mm achromat that has the potential to provide even better images than the 80/9D? Then check out the TMB/Burgess Planet Hunter. With a focal length of 900 mm(F/11.4), the Planet Hunter is designed with the specialists in mind – those that enjoy high-power views of the Moon, bright planets, and double stars. The fit and finish of this telescope is first rate, maybe even a notch up from the Stellarvue 80/9D. The lens cell is beautifully designed with deep green multicoatings, and the silky

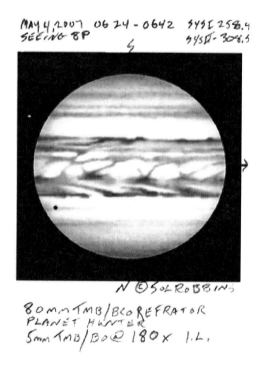

Jupiter using the TMB/Burgess Planet Hunter (Image Credit: Sol Robbins)

smooth Crayford focuser is a joy to use. Yes, it's an achromat – you can see that by subjecting a bright star to a high-power test – but false color is exceptionally well suppressed. The sample this author looked through gave an excellent star test, reducing stars to tight Airy discs and had little in the way of spherical aberration, coma, or astigmatism.

The American amateur astronomer Sol Robbins, known to many planetary observers as a first rate astronomical artist, sent me some extraordinary sketches of Jupiter he made with the TMB/Burgess Planet Hunter using a power of 180×. The drawing speaks for itself! Recently, Burgess Optical has discontinued the sale of their Planet Hunter, but luckily it's still on offer from the Germany-based company Astro-Professional. The optical tube comes complete with a silky smooth 2-in. Crayford focuser, tube rings, and a red dot finder.

All of the telescopes described thus far are still eminently portable. Most can even be mounted on a heavy-duty camera tripod. But if your only telescope has an aperture of 3.2 in. (80 mm), you'll eventually run out of things to see. By moving up to the 4-in. class of long focus achromats you get what many experienced observers feel is the optimal compromise between performance and portability.

The 4-in. Glass

There's something truly magical about a 4-in. aperture. On the one hand, it's got enough light-gathering power to pull 13th magnitude galaxies in the Virgo Cluster from a dark sky. On the other hand, it can resolve details as small as one arc second. Small wonder then that 4-in. refractors have been the instrument of choice for some of the keenest observers of the sky, including the late Walter Scott Houston from Kansas, John Mallas from California, and Steve O' Meara in Hawaii.

A good 4-in. refractor will show you enough to keep you happy for many years, if not a lifetime if you like to return to your favorite objects again and again. By far the most popular models in this aperture class, are those with a focal ratio of F/10. Such a telescope typically weighs about 11 or 12 pounds, so it's still very portable. With a low-power, wide-angle eyepiece you can still coax a 3° field from such an instrument, and because the focal length is quite long, even inexpensive eyepieces serve up nice images.

The great virtue of these telescopes, though, is their ability to take high powers (up to 300× in a good model) to study fine lunar details, difficult planetary features and difficult binary stars. It's just a great all-round telescope. Like everything else, quality varies somewhat from model to

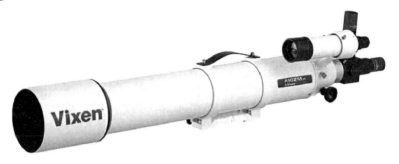

The Vixen 102M achromat (Image credit: Vixen Optics)

model so, where possible, caveat emptor. All of the instruments discussed in this section are 4-in. air-spaced Fraunhofer achromats, featuring multi-coated optics with focal lengths of about 1,000 mm (F/10). The objectives are mounted in well-baffled aluminum tubes with basic 2-in. rack-and-pinion focusers.

A flagship telescope in this category has got to be the Vixen 102 M. Most owners report crisp, high-contrast views on all objects. The best samples show very little spherical aberration, allowing powers in excess of 200× to be pressed into service when required. Quality control seems to be good with these telescopes, too, so I wouldn't expect very much variation between individual samples. Low- and medium-power views of deep sky objects are sensibly indistinguishable from more expensive apochromats of similar aperture. Only when subjected to very high powers can one detect a slight advantage in the latter. One enthusiastic Vixen 102 M owner quipped that you'd have to spend between three and five times as much money on any other 4-in. refractor to get even a barely detectable improvement in the view. It's a pity Vixen has recently discontinued this classy telescope. Luckily, however, other manufacturers have taken up the gauntlet.

Celestron, for example, has maintained its interest in making and selling its own version of the Vixen 102 M. The original Celestron C-4R enjoyed a very loyal following due to its nice views. Recently, however, the company has revamped its 4-in. F/10 refractor in the form of the Celestron Omni 102 XLT. You get a lot of gear for the asking price ($499). The optical tube is one of the lightest in the industry – just 9.5 pounds. The objective features the excellent StarBright XLT multicoatings for maximum light transmission. The telescope also comes with a nice 25 mm Plossl eyepiece and a good 1.25-in. mirror diagonal giving 40× and 1.25° field of view. The 102 XLT also comes with a fairly sturdy CG-4 German equatorial mount, with setting circles and slow motion controls. The telescope and

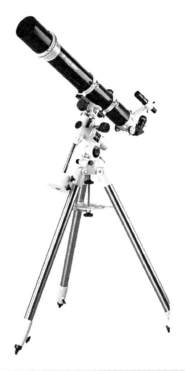

The Celestron Omni 102 XLT (Image credit: Star Telescopes)

mount sit on a heavy-duty pre-assembled stainless steel tripod featuring 1.75″ legs for extra stability.

Owner reports are generally very good and speak of their well-corrected optics and sharp views at low and high power. These telescopes are often touted as a good telescope for a discerning beginner. That's certainly true. You can do a lot with this size instrument. A case in point comes from one enthusiastic Celestron 102 XLT owner who said: "I had the old version, the C-4R," he said, "but you've got to remember that the Japanese (Vixen) version of this achromat used to go for nearly $2,000. This is the refractor that resurrected my interest in astronomy. It is optically sound and with the improved tripod and aesthetics I couldn't say enough good things about it. It could keep a lunar/planetary enthusiast happy for a long time and is no slouch on the brighter deep sky objects, either."

Sky-Watcher has also marketed a few incarnations of this telescope over the years. Bizarrely named the BK1021EQ3-2, this telescope ($355) appears to gaining a well-respected reputation among owners. Like the Celestron Omni XLT, it comes as a nicely finished optical tube atop a

well-designed equatorial mount and a fully collimatible lens cell so the user can tweak optimum sharpness. Ted Moran, an amateur based in the American Midwest described his experiences with this instrument: "Overall, I'm very, very happy with the Sky-Watcher 102," he said. "My harshest criticism would be that the telescope does produce some chromatic aberration, most annoyingly in the form of a very faint, pale blue color tone cast to large scale, bright images – notably those of the Moon. It's made somewhat worse by eyepieces that have "warm" color tones of their own. But even in worst case scenarios, to me the overall negative effect is more than acceptable. I do a lot of lunar observing, and the effect doesn't trouble me very much at all. Venus shows distinct violet fringing, as well – but it is fairly minimal and well controlled for a telescope of this aperture."

Ted is also impressed with the Sky-Watcher's resolution. "I'm not really a double star chaser," he added, "but the telescope appears to have excellent resolving power. I have no trouble seeing details down to 3 miles and less on the Moon under even poor conditions. Saturn's rings are dramatically presented, even with the planet's rings edge-on, as they are now.

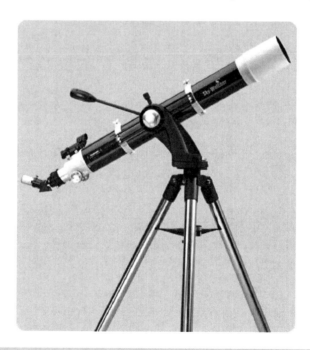

The Sky-Watcher 102 on a sturdy alt-azimuth mount (Image credit: Star Telescopes)

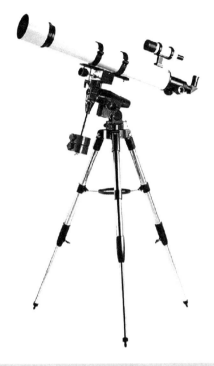

The Bosma 4-inch F/10 achromat (Image credit: Bosma)

Jupiter's north and south equatorial belts are well shown, perfectly separated, and even showing hints of detail. On good nights I've seen three or four other northern belts and two or three southern belts." And Ted has also praised the Sky-Watcher's wide field views. "I remain impressed with the telescope's performance on brighter deep sky objects and open clusters. Its decent light grasp and low-power, wide-angle performance continue to impress me. Nebulosity is visually apparent, even striking on many deep sky objects. I wasn't expecting this from a long focal length, non-APO refractor, and it continues to surprise me. I purchased a 40 mm 2-in. eyepiece for this application. The supplied draw tube didn't have enough extension length to come to focus with this eyepiece, but I have since obtained a high-quality 2-in. mirror type star diagonal, and this has cured all my focus problems." Ted's comments are typical of those heard about this versatile telescope. And at a typical street price of $355, the Sky-Watcher 102 looks like a very good bargain indeed. Most recently, another Chinese made refractor with the same specifications has been launched by Bosma.

If you thought you've heard the last word on 4-in. achromatic refractors, think again! A personal favorite comes all the way from Russia – the

Tal 100R. Introduced in the late 1990s by the Novosibirsk Instrument making plant in Russia, the now discontinued Tal 100R enjoyed a lot of success, especially in Europe, owing to its razor-sharp images with minimal false color and little in the way of other aberrations that can ruin an image. They're built like tanks, tested in sub zero conditions, and have a fit and feel that is reassuringly old school. In fact, the Tal 100R is how a classical 4-in. F/10 Fraunhofer achromat ought to look. In recent years, the Tal 100R has been given a makeover. Now called the Tal 100RS, the new version has a much better 2-in. focuser (which has recently been revamped from the focusers found on older Synta telescopes) and inner tube baffling that is vastly superior to some of the older 100R models.

This author has looked through several examples of the 100R, and each one of them performed like a champ. The telescope presents exquisite low-power views of the summer Milky Way in rich contrast. Using a 20 mm Pentax XW eyepiece giving 50×, the 1.4° field of view is perfectly flat, with stars remaining pinpoint right to the edge. The bright summer star Vega threw up the merest halo of unfocused violet light at this low power. Astigmatism and coma were below the detection threshold. Contrast is lovely in a well-baffled Tal 100R.

One can test the mettle of this Russian telescope, affectionately called "Vladimir," by attempting to split some close doubles visible in the sky. Charging the telescope with a power of 250×, Epsilon Bootis (Izar) will

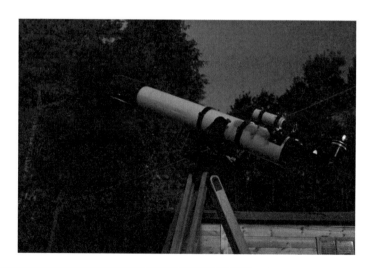

The Tal 100RS ready for a night under the stars (Image by the author)

The intense purplish anti-reflection coatings on the Tal 100R objective (Image by the author)

present easy pickings for this telescope, and a close examination of the double double in Lyra rendered a nicely resolved quartet in both telescopes. On average nights "Vlad" resolved the components of δ Cygni well. I could also split μ Cygni (1.9 arc seconds separation). That's not bad going considering there's a 1.5 magnitude difference between the stars in this pair! In earlier tests, the view through a Tal 100R was compared with an expensive, first generation 4-in. TeleVue Genesis refractor. Although the Genesis operated at F/5, it had a fluorite correcting element at the rear of the telescope to reduce false color. The test object on this occasion was Mars. Remarkably, both telescopes presented broadly similar levels of unfocused purple light – with the edge going to the Genesis. But the surface detail, such as the polar cap and dark markings etched into the Red Planet's surface, were noticeably sharper and better defined than in the longer focal length Tal. So, as one other Tal enthusiast put it, "this is a high end refractor for those of us on a burger and fry budget."

Canadian-based Sky Instruments distribute a trio of very high-quality 4.1-in. (105 mm) achromats that really put the shine into observing. Marketed as Elite achromats, these come in three focal lengths: 1,000, 1,300 and 1,500 mm ($699, $749, and $799 for the optical tubes, respectively). Combining the classical with the conventional, the Antares series boasts a fully multicoated, air-spaced Fraunhofer objective originating from the same stock used by Vixen. The lens is mounted inside a nicely finished white aluminum tube. Bought as an optical tube assembly only, you'll get

a handy 8×50 finder and tube rings to attach the telescope to your mount. The basic model comes with an excellent rack-and-pinion focuser. Alternatively, one can also purchase models with a two-speed Crayford focuser.

The 1,300 and 1,500 mm instruments, in particular, offer superlative views owing to their very high focal ratios. One avid double star observer from Germany says his favorite instrument is the Antares 105/1500. "This instrument has amazing contrast," he said, "and can take powers of up to 500× (that's 120× per inch!) to split some amazingly tight doubles on good nights."

This is very believable. A well-executed long focus achromat, as well as showing almost no false color, has near perfect correction for all the five Seidel aberrations. Even mediocre eyepieces will perform like superstars in these instruments, too, as astigmatism and field curvature will be at an absolute minimum. The Antares Elite achromats also have a relatively

The Antares 4-inch F/15 Elite achromat (Image credit Richard Day)

unsung virtue – great depth of focus – which will help maintain a sharp and well-defined image without the constant need to re-focus and that translates to a more enjoyable experience.

These telescopes star test very well. The lesson is clear. Quality optics are much easier to achieve if you keep the focal length long. One thing you'll notice about these telescopes is the "huge" stellar Airy discs they throw up at high magnification; observing the famous Gemini binary star Castor through one of these instruments at 300× reveals the individual components to be more like mini-eggs than pinpoints – a natural consequence of their large focal ratios.

Brass and Glass

Some telescope makers have resisted modernization and continued to make high-quality achromats using materials that are more at home in the nineteenth century than in the twenty-first century. I.R. Poyser, of Ceredigion Wales, offers beautifully designed long focus achromats using British-made objectives mounted inside finely crafted, solid brass optical tubes. These telescopes are purposefully contrived to recreate the experience of observing Victorian style. The lens cell is machined from thick-walled brass and provides a secure housing for the air-spaced objective lens. Conveniently, the lens cell is detachable and so can be transported separately from the rest of the telescope. The lens cell is threaded at its outer end and is provided with a screw-on polished brass dust cap. Poyser was asked how he evaluated the optical quality of the objective lenses he fits to his brass tubes. "We do all our testing the traditional way, by conducting a high-power star test. If it doesn't make the grade we won't use it," Poyser insisted.

Currently Poyser offers two brass refractors for sale; a 3-in. F/14 and a 4.7-in. (120 mm) F/15. The drawtube of the telescope is moved by the rack-and-pinion mechanism similar to old Cooke refractors and which is completely contained within the body of the telescope. The drawtube has a diameter of 50 mm, so you'll be able to use 2-in. and 1.25-in. eyepieces (with an appropriate adaptor) and a total travel of 100 mm. Each telescope is supplied as standard with your choice a brass finder telescope (either 7×50 or 10×50). A pair of adjustable brass rings attaches the finder telescope to the main instrument. Each ring has three adjustment screws (polished brass, of course!) that bear on the finder telescope by means of soft-lined pressure pads. Each telescope is supplied, as standard, with a brass, 35 mm Plossl eyepiece.

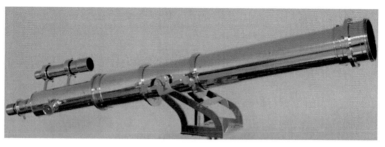

A classic, all brass 3-inch F/13 achromat with optics and tube assembly made in Britain (Image credit: I.R. Poyser)

What's there to criticize? As you might expect, these telescopes don't come cheap. The 3-in. model starts at £3,575 and the 4.7-in. sets you back £4,535. Oh, and how about their weight? A long, solid brass refractor is going to be heavy. The 4.7-in. tips the scales at 38 pounds (17 k), so they'll need a substantial (and equally expensive) mount. Judging by the lack of literature on these instruments on the astronomy forums, they must enjoy a loyal but unusually quiet following.

Go Large

If 4 in. doesn't sate your aperture fever, then you'll be glad to know that a number of larger achromats are available in the medium focal length range. Two low-cost Chinese refractors appeared on the market in the late 1990s with impressive specifications – a 4.7-in. F/8.3 and a 6-in. F/8 achromat made in the far East but marketed by several companies such as Bresser, Sky-Watcher, Orion (USA) and Celestron. The earliest versions of these telescopes appear to have had a number of quality control issues, with some owners being very happy with the views they provided and others being less than impressed. Some telescopes had objectives that were apparently misaligned with wobbly focusers. Others reported razor-sharp views with minimal false color but complained about the inadequate mounting the telescopes came with. Here's the author's take on their performance. Though not exactly grab n' go, they are light enough (the CR-150HD tube assembly, for example, weighs about 18 pounds) to set up in minutes, but they need at least a 45 minute cooldown time to work at their best. Both require a very strong alt-azimuth or equatorial mount to use them comfortably. Both are built like tanks and

have a basic, no-nonsense feel to them. And both are quite front heavy, so you'll have to push the tube back to achieve good balance, which makes them look a bit silly when mounted, but we're after performance here, right?

With good eyepieces, these telescopes are great deep sky tools. The 6-in., in particular, behaves like a veritable light bucket, fishing out stars fainter than 14th magnitude. Low-power views of the Double Cluster in Perseus are exquisite through both instruments, with stars remaining tightly focused pinpoints across most the field of view. Cranking the power up to 150× delivered breathtaking views of the Hercules globular cluster, particularly in the 6-in. The lunar regolith was very sharp and surprisingly color free for such large aperture telescopes. The smaller 4.7-in. telescope seemed to have the edge on its larger sibling on Luna, purely in terms of aesthetics. Both telescopes throw up "gobs" of color around very bright objects such as Jupiter, Sirius, and bright stars. But if you get over the shock of seeing some unfocused haze, their superior resolving power to a 4-in. telescope can show you some breathtaking views of the planets. Jupiter through the 6-in. was almost overwhelmingly bright at low powers (~50×). At 150×, You can glimpse detail in the Jovian atmosphere that a 4-in., however good, could never unravel.

The Sky-Watcher BK15012 achromat (Image credit OVL)

Even without filters, the giant planet threw up a strange yellowish-green cast but you could still clearly make out amazing structure in and around the planet's Great Red Spot. You really can believe this amazing structure is a gargantuan storm with the 6-in. and not just a "spot" while observing with smaller instruments. The 4.7-in. telescope was good at splitting double stars. The 6-in. is slightly less satisfying in this regard. Bright pairs had a tad too much unfocused haze around them, which detracted a little from their aesthetic appeal as compared to a longer focal length telescope.

British amateur John Currie, who regularly puts his Helios 6-in. through its paces, reckons these telescopes are very underrated. "Their contrast on deep sky objects is amazing – much better than any reflecting telescope of the same aperture," he says, "but they can also deliver razor-sharp images of the Moon and planets if I use a contrast booster or minus violet filter."

If you're after a big refractor with a longer focal length on a limited budget, then why not consider the Bresser Messier R127 refractor? The heart of this instrument is a 5-in. multicoated achromatic doublet with a focal length of 1,200 mm (F/9). For £520 (UK) you get the telescope complete with an equatorial mount, three Plossl eyepieces, and an 8 × 50 finder.

The Helios 6-inch F/8 refractor (Image credit: John Currie)

The 5-inch F/9 Bresser Messier R127L refractor(Image credit: Telescope House)

Does this package sound too good to be true? Well, yes and no, depending on who you talk to. The guys at *BBC Sky at Night* magazine found it to be the best in a group test. Dave Tinning, a keen amateur astronomer and refractor enthusiast from Bosworth, England, compared the view of Jupiter low in the sky through his 4-in. F/10 Tal 100R and the 5-in. Bresser. Although the image was brighter through the Bresser, he says, "the Tal was definitely sharper with far less in the way of false color compared to the bigger telescope." On deep sky objects, it was a different matter, though. Examining the Double Cluster showed off the clear superiority of the Bresser over the smaller Tal. The Bresser is probably not giving 100%, though; either it is slightly out of collimation or there is some very slight, but real, aberration in the lens itself. "But it is a nice telescope nevertheless," he says, "and does bring fainter objects into view – just not perfect where the sharpest definition is needed." An Internet

search reveals that this telescope – or something very like it – is also sold under a number of other brand names, including Phenix, Photon, and Astronomica.

Meade also manufactures two large achromatic refractors sold with their LXD75 GoTo German equatorial mount; the AR5 and AR6 ($999 and $1,199, respectively). These are two classical achromatic refractors, a 5-in. F/9 and a 6-in. F/8, respectively. The AR6 gives a performance broadly similar to the Celestron CR-150HD discussed above. We'll concentrate here on the 5-in. model. These refractors are impressive looking telescopes and are much bigger than you'd think they are, judging by the images posted on retailer websites. The mechanics of the telescope have a no-nonsense feel about them. The focuser is a pretty basic 2-in. rack-and-pinion similar to those found on early Synta telescopes, but it gets there in the end. The LXD75 mount is just barely adequate to support the weight of the optical tube, though. A heavier mount is needed to coax the best performance from this instrument.

At low powers, there is little in the way of false color in the Meade AR5, either by day or night. High-power images of bright stars were clean and crisp, with a prominent halo of purple light around bright objects. A star

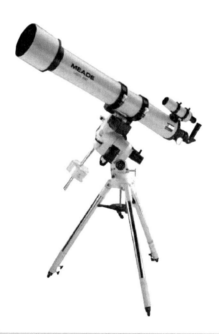

The Meade AR5 achromatic refractor (Image credit: Telescope House)

test gave quite good results, though some samples show mild spherical aberration – not enough to affect low- and medium-power views but enough nonetheless to impart a soft tone to lunar and planetary features when scrutinized at the highest powers. Despite this, a look at Saturn in a twilight summer sky at 200× was marvelous. Though the rings were closing fast, this telescope clearly showed the Cassini division appearing as a jet black "ink line" etched into the icy rings. Variegated cloud structures were also easy to see on the Saturnian globe with the AR5. A first rate 4-in. refractor set up alongside it also showed the majority of these features, but many of them were more subtle, even subdued.

Jupiter was an awe-inspiring sight, too, despite its very low altitude (10°) in the sky from a northerly vantage (56° north). Charging this telescope with powers greater than 100× in such adverse observing conditions was an exercise in futility. Though significantly more detail could be seen through the AR5, the better corrected 4-in. had a much better snap to focus to it than the Meade. Indeed the planet was displaying so much false color – due in part to the atmosphere and also the inherent chromatic aberration caused by the objective – it was difficult to achieve a sharp focus point. This is one telescope that would benefit from a violet-reducing filter.

The Meade AR5 is no slouch on double stars and faint deep sky objects, either. The excellent light transmission of the objective lens allows one to divine subtle details from faint celestial real estate. Indeed, you should get a memorable views of the Veil nebula in Cygnus with this telescope and be able to split 44 Bootis. It was just so easy to zip around the night sky using the mount's Autostar controller – minutes can turn into hours under the stars. This is a great telescope for the price, though, it's more of a general purpose telescope rather than a specialized performer. You get decent optics that will satisfy the majority of novice and seasoned observers alike for many years.

Medium-sized achromatic refractors offer endless opportunity for the enthusiast of nature. When well made, these telescopes are eminently capable of serving up lovely nighttime and daylight views and are easily manageable. They're big enough to be genuinely useful and small enough you won't have to spend a fortune mounting them adequately. What's more, their relatively long focal ratios mean that you needn't spend a fortune on eyepieces, either. A well-chosen model could keep you happy for a lifetime. But if you thought you've heard the last word on achromatic refractors, spare a thought for the mammoth telescopes that are in the hands of amateurs across the world – big guns ablazin!

CHAPTER FIVE

Big Guns

A 6-in. F/8 scope is quite manageable, but how does a 6-in. F/15 instrument grab you? The issue with an F/15 scope is not so much its heaviness as its sheer unwieldiness, like a giant pencil turned on the sky. Such an instrument requires a very beefy mount, and it's got to be raised quite high off the ground so that you can comfortably look through it, especially when pointed high overhead. The reward for such effort is exquisite images, perfectly corrected for all of the aberrations that can plague a refractor and almost devoid of false color. For some enthusiasts, super-long focus achromats provide the best planetary images of *any* telescope, period. They are adored by refractor fans the world over.

The Pennsylvania-based company D&G Optical gives you a real taste of this refractor high life. Founded in 1987, the company is dedicated to providing some of the finest achromatic doublet objectives – either as lens cells or fully assembled optical tubes – to the discerning amateur astronomer. The D&G lenses range in size from 5 to 12 in. with large focal ratios ranging from F/12 to F/30. So, even a 5-in. is a monster! Due to their gentler curves, long focal length lenses are easier to make well, but the extra time dedicated to them by a master optician can result in an objective that can take stupendously high magnifications – as much as 100× per inch of aperture. The company takes pride in the fact that its objectives are not mass produced. Each lens is individually hand figured, and each is guaranteed to reach the theoretical limit of resolution for its size. All lenses are fully coated to increase light transmission and are color

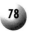

corrected for the C-F visual range between 500 and 650 nm. These giant eyes on the sky have a singular ability to invoke the halcyon days of the nineteenth century, when the great visual observers mapped and measured the heavens.

Long focus achromats, as we have seen in Chap. 2, have numerous advantages over shorter focal length scopes (apochromats included). For one thing, your favorite eyepieces will work even better with these scopes, as there will be less eyepiece astigmatism at longer focal ratios. In addition, there will be noticeably less field curvature with long focus achromats, too, so stars should remain sharp and pinpoint right to the edge of the field. The most important advantage, however, is a much greater increase in the depth of focus, which allows you to more comfortably hold planets and double stars in sharp focus at high powers.

New Zealand amateur astronomer Phil Barker has owned a few of the smaller D&G refractors and enthusiastically shared his experiences of the 5-in. F/15: "In terms of spherical aberration this instrument was the best I've used," he said, "having essentially perfect identical diffraction patterns both inside and outside focus. It is also in a different league to scopes like the 4.7-in. F/8 Synta refractor when it comes to suppressing false color. The 5-in. D&G is superb on Jupiter, showing fine, low-contrast detail. Clusters like the Jewell box (NGC4755) are quite simply

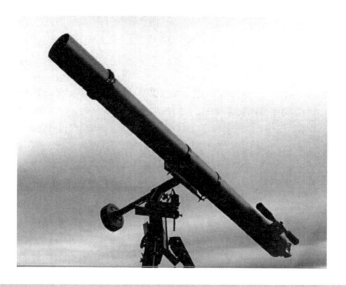

A 5-in. F/15 D&G achromat (Image credit: Phil Barker)

divine through this instrument. The 5-in. made up for a lot in terms of aperture and I preferred it to a 6-in. F/12 with a D&G lens, which had a lot more false color."

The D&G powder-coated optical tubes have a beautiful fit and finish. What's more, they come equipped with a top-rated 2.7-in. Astrophysics focuser for effortless focusing. The 5-in. models retail at $1,695 plus shipping; add a couple of thousand more for the 8-in. D&G tube assembly. That's still a bargain, especially when you consider the quality views these instruments deliver. But any prospective buyer of these super-long instruments needs to spend at least the same amount (if not more) on a mount stable enough to use them comfortably. To their credit, D&G have posted some mounting suggestions for their most popular scopes in the FAQ section of their website. Because these are not off-the-shelf scopes, expect a wait of a several months to over a year months for the smaller D&Gs and over to a year for their largest instruments. Rest assured, it'll be well worth it, though!

Rich Field Nirvana

The D&G long focus achromats, fine as they are, are specialized telescopes. Even medium focal length eyepieces deliver very high magnifications, which is great if you have a good steady night and you like looking at the Moon, planets, or double stars. But they're not exactly "rich-field" telescopes despite the fact that you can coax a fairly wide, 2-degree field from the smallest D&G (the 5-in. F/12 instrument) using a 55-mm Plossl eyepiece. Luckily though, there are a number of truly enormous rich-field refractors on the market and we'll discuss a few of them here.

Bob Ayers wrote an article on an ingenious, folded 6-in. F/5 refractor appeared in the December 2006 issue of *Sky & Telescope* magazine. Starting with a relatively inexpensive Synta style 6-in. F/5 refractor, Bob modified it by incorporating a highly reflective flat mirror to direct the light collected by the objective lens to a more comfortable eyepiece position. Indeed, this folded design enables Bob to point the telescope anywhere in the sky without changing the eyepiece height very much – a very convenient modification indeed. Typically you can aim at any object in the sky while maintaining the same posture at the eyepiece, that is, by dipping your head ever so slightly while in a seated position.

Recently, Ayers said that he had modified an even bigger scope in the same way – an 8-in. F/6 rich-field instrument supplied to him by Markes Ludes of Germany's APM. The basic instrument, weighing in at about

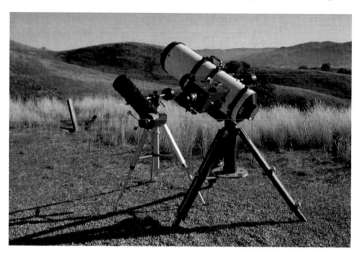

Bob Ayer's folded 6-in. F/5 and 8-in. F/6 rich-field refractors ready for action (Image credit: Bob Ayers)

40 pounds, is an air-spaced Fraunhofer doublet, with multi-coatings applied to all four lens surfaces. The importance of being comfortable at the eyepiece is something Ayer knows well: "The observing position with both scopes – seated and looking slightly down at an adjustable angle – is a delight." Further, "When you are using a narrow-band filter and spending a long time studying a field looking for faint nebulosity, a comfortable observing position is more than a boon, it's a necessity."

By now you'll have probably guessed that an 8-in. F/6, like the 6-in. rich-field telescope discussed in Chap. 4, will throw up lots of false color. Bob is under no illusions as to where the real strength of his 8-in. APM light bucket lies. "I consider the 8″ F/6 to be special purpose instrument," he insisted. "They're not planetary 'scopes: they will not take high powers, no short-focus doublet will. Nor are they 'deep space' scopes – for that you should buy a large Dobsonian. But they are excellent rich-field telescopes. Even with the 8-in. you can get low powers and fairly wide fields with real-world eyepieces. Try doing that with an 8-in. F/15 instrument! Ninety percent of the time, I use the scope with nebula filters. That's why I've permanently installed a filter slide in the diagonal." If you can live with the eyepiece locations thrown up by the conventional APM 8-in. F/6 telescope, then such an instrument won't cost you the Earth. The complete 8-in. F/6 optical tube assembly set me back about $5,000 [it has since increased to $6,290] including shipping and customs," says Ayers, "and that's a bargain in my books!"

A close up of the focuser on Bob Ayer's 8-in. F/6 refractor with a mated filter slide attached to the diagonal

Labor of Love

The large APM achromat doesn't sound like an airline portable telescope and, as described above, it isn't. But one man's passion for large, rich-field refractors that can be transported easily across states and continents impelled him to design his own. Toronto-based amateur astronomer and professional artist Joseph Drapell bought up some of Markus Ludes' large achromatic objective cells and designed his own optical tubes, so that it could be rendered airline portable.

Instead of mounting the objective in a large, aluminum tube, Drapell fashioned a beautiful mahogany housing for the giant lens. The tube is light – only 25 pounds – yet retains its rigidity and alignment. Moreover, the scopes can be taken apart into smaller sections for easier transport.

After assembling the telescopes many times for travel, the collimation remains good. As an added bonus, the wooden tube is a pleasure to handle in cold weather, with little in the way of tube currents. He's only made four, but those who own them are delighted with their performance. The 11-in. F/5 Travel Star, in particular, suffers from prominent false color, as you'd expect, but used with a low power eyepiece, it makes a smashing rich-field instrument. The lenses on these large, short focal ratio achromats have a strong bluish tint and thus may act as a weak

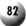

Joseph Drapell's 8-in. F/5 "Travel Star" rich-field achromat with Toronto's CN tower in the foreground (Image credit: Joe Drapell)

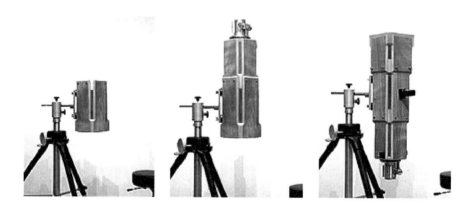

The Travel Star can be broken down into three parts for easy storage and transport (Image credit: Joe Drapell)

minus violet filter. These are specialist telescopes though – they were never intended to be good lunar and planetary performers.

Is there such a thing as a "compromise" instrument in this size class, between the specialist niches of the D&G achromats and the large, rich-field refractors just described? There may be! The late Thomas M. Back designed a good candidate – the TMB 8-in. F/9 refractor. It has

a multicoated doublet Fraunhofer objective in a tube some 50-in. long. Weighing in at 40 pounds, it'll require a substantial mount. One nice feature of this scope is the focuser, a 2-in. Starlight Feather Touch with an internal brake and compression ring. Certainly its specifications alone would suggest that as well as delivering jaw-dropping deep sky views, it might also serve up decent planetary images, too. Amateur astronomer Karl Krasley, from Limerick, Pennsylvania, is a proud owner of a TMB 8-in. F/9 and describe its overall performance. "I was expecting more false color," he says, "but it really is not that bad. In deep space you don't see it. For instance the Double Cluster shows quite true color. I've only noticed false color around bright stars and Jupiter. I must say, though, it doesn't seem to be smeared, but just a violet circle around the object."

Krasley explained how this lens takes magnification well: "Jupiter, even at 515×, shows a clearly defined disc (no fuzz out)," he says, "and detail within the cloud belts themselves. If I were more of a planetary observer, I would use a filter system for the planets. Saturn seems to do quite well on many of these 'scopes, too. The 8-in. certainly shows the planet in all its glory." Karl explains why his big TMB telescope delivers both on planetary and deep sky targets. "I certainly believe the overall quality of this lens tremendously outweighs any of the issues of chromatic aberration. It's well figured, with top-quality coatings applied. Star images even at over 300× snap right into focus."

An 8-in. aperture coupled to a low power, wide-angle eyepiece makes sweeping through the autumn Milky Way an awe-inspiring activity. Even a large Dobsonian reflector couldn't match the sharp, high-contrast views from the unobstructed optics of this lens. Some owners have reported mild astigmatism and spherical aberration in these instruments, but that's quite acceptable given the kind of job they were designed to do.

Big refractors are, for many, the dream ticket. They offer superlative views of the deep sky, with contrast to die for. The D&G instruments, though long and a little awkward, produce some of the finest planetary images a telescope can deliver, while large short-focus achromats such as those designed by APM provide the ultimate in rich-field optics.

Before leaving the classical achromat behind, let's explore the virtues of old, high-quality glass; you know the ones – the instruments you might have drooled over when you were first starting out in astronomy all those years ago. In the next chapter, we'll be looking at some classic models from the 1950s, 1960s and 1970s, as well as taking a trip back in time to explore instruments that saw first light in the halcyon days of the long focus refractor, when names such as Alvan Clark, Brashear, and Cooke were all the rage.

The APM 8-in. F/9 achromat ready for a night under the stars (Image credit: Karl Krasley)

Going Retro

You have to hand it to the refractor. Its unobstructed optics produce the sharpest, highest contrast images of any telescopic design contrived by the artful mind. The earliest varieties, those erected by Hevelius and Huygens in the seventeenth century, for example, had enormous focal lengths ($F > 60$) to remedy the many flaws inherent in a single convex lens. Yet, with such unwieldy "contraptions," Saturn's rings were clearly discerned, and the first recognizable Martian surface feature was recorded. In the eighteenth century, the doublet achromatic objective made its first appearance and was slowly perfected over a period of another century, where it reached its quintessentially modern form in the innovations introduced by the genius of Joseph Fraunhofer. The superior optics of the achromatic doublet allowed the focal length of the refractor to be greatly shortened, and for the next 150 years it has retained its iconic form, typically embodied in a F/15 format. Much of the foundation of modern stellar astrophysics were elucidated with such old, high-quality glass.

These imposing instruments that continue to decorate our observatories and museums pay testament to the great skill and ingenuity of our telescopic forebears. But in a world full of shiny CNC tubes, broadband multicoatings, and dual-speed Crayford focusers, it's nice to take a walk down memory lane and re-experience the simple pleasures of a well-made refractor from yesterday. And we're not just talking about taking a visit to your local public observatory. Sadly, hundreds of thousands of dusty old refractors lie forgotten in our dank and dark basements, attics,

N. English, *Choosing and Using a Refracting Telescope*, Patrick Moore's
Practical Astronomy Series, DOI 10.1007/978-1-4419-6403-8_6,
© Springer Science+Business Media, LLC 2011

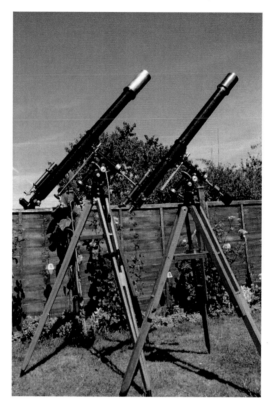

Two classical refractors, one is ultra-modern, the other dates back to the 1930s. Can you tell the difference? (Image credit: Skylight Telescopes)

and outdoor sheds. Yours truly got to plough his first telescopic furrow with a brazen red Tasco 60 mm F/12 refractor. Back then, I couldn't pronounce chromatic aberration or astigmatism, let alone understand them. But I didn't need to, either. That simple refractor changed my life for the better and set me on a path that I've yet to tire of.

Classic refractors are making a comeback. Not only are some being built commercially, some of the finer models produced in the 1950s, 1960s, and 1970s are also proving very popular with collectors and observers alike, as more and more amateurs are re-discovering the surprisingly good views these scopes can serve up. And, as if it weren't of the sign of the times we're heading for, more of these classic scopes are popping up for sale on the leading online astronomy forums and eBay.

I decided to let nostalgia get the better of me by testing out three small telescopes that were in their heyday during the 1960s and 1970s. The telescopes, kindly loaned to me by Richard Day of Skylight Telescopes, London, included a Japanese 2.4 in. (60 mm) F/16.7 Tasco, an East German 2.5-in. (63 mm) F/14 Zeiss Telementor, and an American 3-in. (77 mm) F/13 Model #831 Swift refractor (which is rumored to have a Takahashi-designed objective lens). After figuring out how to mount the telescopes, I used the best modern eyepieces I had at my disposal. Not that I especially needed to. The eyepieces supplied with these telescopes – mostly Kellners, Huygenians, and orthoscopics – often served up crisp, high-contrast views that were very well corrected across most of their small fields of view. Star testing over several cold but steady February nights, using a 6 mm Televue Radian eyepiece, confirmed what I had suspected about all three telescopes during my daylight observations. The optics in all three were all aligned well, despite their 600-mile road trip to my home, each coming to a sharp, snappy focus.

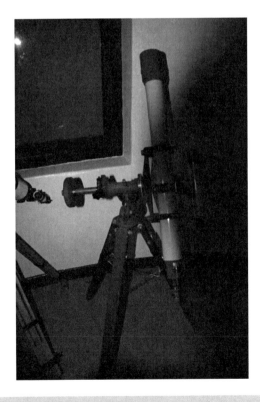

A 3-in. Swift refractor on a sturdy equatorial mount

If you've become accustomed to looking through apochromatic refractors (discussed in Part 2), you'll be pleasantly surprised by the color correction in all these modern classics. Technically speaking, all these telescopes have a CA index well under 5, so daylight subjects will be presented in their faithful colors even at high magnification. More telling tests, performed at night, resonated well with my daylight adventures. Charging the instruments with a power of about 50× per inch of aperture, I could detect no appreciable false color around any bright star with the Tasco and Zeiss telescopes and only the merest trace was seen with the Swift. All three refractors served up nice, pinpoint Airy discs. Both the Swift and Zeiss Telementor rendered well-defined, symmetric diffraction rings both inside and outside focus, a testament to the excellent figuring of these old

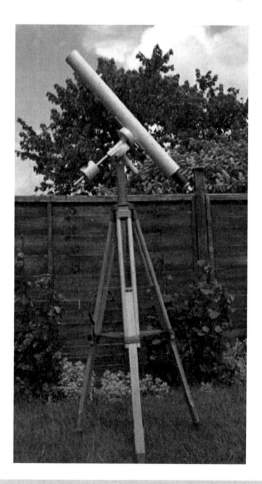

The legendary Zeiss Telementor (Image credit: Skylight Telescopes)

objective lenses. Indeed, the Zeiss star test was textbook perfect. The Tasco showed evidence of a small amount of astigmatism that didn't compromise low and medium power views but did take the edge off images at high powers (×100 and above). The mostly likely source of this astigmatism was a slight misalignment of the optics that could easily be remedied by tweaking its collimation. When the Swift and Telementor was carefully tested in a side-by-side comparison with the view delivered by a modern 80 mm F/11 refractor from a leading Chinese manufacturer, it became clear that the retro scopes had a noticeably smoother figure, with less surface roughness. But how would they firm up on the Moon and planets?

As luck would have it, these telescopes were put through their paces over an unusually long period of steady seeing. As you might expect, they all gave sharp, high contrast (and surprisingly color-free) images of Mars, Saturn, and Luna.

The extra aperture of the Swift made it the clear winner though. But the Tasco and Telementor were no slouches, either, their tack sharp optics constrained only by their diminutive aperture. The views of the first quarter Moon were a revelation with the Zeiss. Despite its 2.4-in. aperture it could easily hold powers of 250× with no image breakdown. Indeed, it really was striking how well each of these telescopes took high magnification. There's no getting away from it – these are splendid little telescopes for lunar and double star observers!

When you hold one of these instruments in your hand you can't help but appreciate just how sturdily built these retro telescopes were. Although the Tasco and Swift are intuitively built, you'll get a surprise when you reach to focus the Telementor. Instead of moving a focuser draw-tube at the eyepiece end of the telescope, the Cold War beauty brings things into perfect clarity by moving the objective lens using a single, oversized focus knob situated mid-way up the optical tube! It sounds crazy, but it worked remarkably well, with zero wobble or backlash – a marvel of German engineering. What's more, the heavily built telescope (the optical tube weighs 5.4 kg) has its own ingenious 1× finder using two sighting holes protruding from the side of the tube. Simplicity itself!

Having myself enjoyed many hours with these instruments, it's hard to believe why anyone wouldn't be thrilled to own one. And there's a lot of quality brands to explore. Other companies that acquired a fine reputation for their optics include Towa, Sears, Jason, Carton, and Jaeger, to name but a few. That said, any discussion on classic refractors would not be complete without mentioning the name of Unitron. Founded in 1952 in Bohemia, New York, Unitron sold beautiful, high-specification long focus achromats in apertures ranging from 2.4 in. (60 mm) to 8 in.

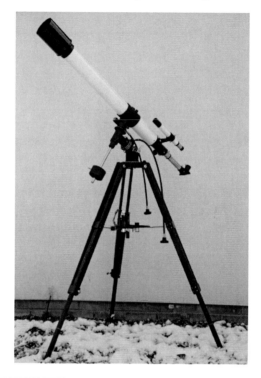

A classic Towa 80 mm F/15 (Image credit: Dennis Boon)

(200 mm). Although it no longer sell telescopes, it still sells replacement parts. Many of us remember seeing the ads in magazines such as *Sky & Telescope, Scientific American,* and others.

These telescopes typically had a long f-ratio, usually around f/15, and were considered to be the one refractor to own if you were a serious amateur astronomer. Many schools across North America purchased these instruments for educational purposes. Since the model numbers remained unchanged through the years, it is easier to evaluate them. Unitron (or Polarex if you live in Europe) refractors continue to command a high price and a high number of bidders on eBay. But they're not just a sound investment. Optically, they are all very good performers. With their very long focal lengths, even the glass from the bottom of a Coke bottle would probably give you a decent image. Some of the earlier models had uncoated objectives, while later models employed a simple, single-layer of magnesium fluoride. Some Unitrons from the 1980s even had greenish anti-reflection coatings.

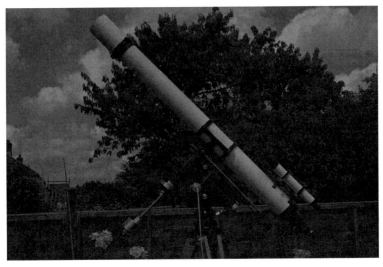

A classic Unitron 4-in. F/15 refractor on its legendary German equatorial mount (Image credit: Skylight Telescopes)

Brian Grider from Clinton, Michigan, is an avid collector of all things Unitron and regularly uses these classic refractors to observe the Sun, Moon, and brighter planets. "I'm especially proud of the Unitron model 160 with its weight-driven clock drive (one of the rarest here in the United States with the 4-in. model). What I like about the Unitron brand is the quality and craftsmanship that went into these long focal ratio refractors. In addition, as a collector's item they are great looking if you want to put one on display. The optics on these refractors were very well regarded, especially on the older 1950s and 1960s models, and the mounts they came with were superior to most others for stability. The only drawback, as far as I can see, is that they can sometimes be a bit pricey, especially now since it's getting harder to find said telescopes in complete and good condition. A big Unitron will always draw a crowd at your local star party, though. They are great telescopes for the collector or backyard astronomer; a vintage telescope that can enjoyed by all."

The Unitrons are renowned performers when it comes to lunar, planetary, and double star observing. Users generally report good correction for spherical aberration and coma, but a small number of more critical users have reported a trace of astigmatism in some models during high magnification work. That said, it's never enough to put you off observing. Their only drawback is possibly their 1.25-in. format, which is unable to accept low power, 2-in. eyepieces for wide-field viewing. Not that this is

The beautiful objective of a Unitron refractor (image credit: Richard Day)

a real issue. You wouldn't think of these as a natural rich-field telescopes, would you?

Buying an antique telescope is another option – one that hails from the early twentieth or late nineteenth century. As it happens, collecting antique astronomical telescopes has become a hobby and even a profession for some people. In the UK Patrick Lindfield, who collects Cooke refractors with apertures ranging from 2.3 to 6 in. and dating from the 1850s to the 1930s, is also the proud owner of a "late" American 3-in. F/15 Alvan Clark refractor. As well as owning large, modern telescopes, Lindfield enjoys looking through his Cooke refractors as often as possible and believes there's something truly magical about observing with these finely crafted instruments. "When equipped with suitable adaptors that can accommodate modern 1.25-in. eyepieces, the images of the Moon, planets, and double stars are very sharp through these instruments."

Then there's the remarkable story of Utah amateur astronomer Siegfried Jachmann, who serendipitously acquired a later model 9-in. Clark refractor. "My interest in astronomy started some 40 years ago, when I was mystified by a fuzzy patch in the winter sky that I had 'discovered,'" he said. Since that time I have observed the great nebula in Orion many times. My interest in astronomy has since shifted from the deep sky objects more to the Solar System and double stars. This is no doubt due in large part to

the wonderful telescope that came my way by pure chance one day. I was, as it were, in the right place at the right time. The telescope is a 9-in. 1915 Alvan Clark refractor. And it just goes to show that one man's problem may be another man's treasure. During a public solar eclipse party at the Hansen Planetarium in Utah during late 1970s, I began a conversation with one of the spectators. I had just acquired a Quantum 4 (Maksutov) and was talking about its performance. The subject turned to an 80-mm Nikon refractor purchased by John Mosely, now the assistant director at Griffith Observatory, and the textbook images it gave. For some reason I made the remark, "I wonder whatever happened to the old refractor that used to be at the University of Utah." To my utter astonishment, he answered that he had the telescope. I still remember the first thought that went through my mind – "How come he has it instead of me?" Now I chuckle at that. He informed me that he had received it from the college, which in turn had received it from the University of Utah. I thought I would inquire why this telescope was given to an individual instead of an institution or tax-free organization. He had given me the name of the geology professor in charge of the astronomy department. After all, this was government property, purchased with tax dollars.

The ultimate personal telescope? A 9-in. Clark refractor (Image credit: Siegfried Jachmann)

I contacted the college and was directed to the man who had given this telescope away and was ready to make a legal challenge of the gift to an individual. I introduced myself and stated that I was associated with the Salt Lake Astronomical Society and the Hansen Planetarium. I stated that I had met the person who stated that he had been given the telescope. Fortunately, before I could put my foot in my mouth he offered that the man had returned the instrument because it was too big for him to do anything with. So out of the blue I blurted out, "Can I have it?" Then the shock of shocks, the Mother of all shocks, he said something I couldn't believe. He said, "Let me see if it's still here, we have loaded it on a truck to take to the dump." He left me on hold while he went downstairs to see if the truck was still there. Of course it was, otherwise this wouldn't be a story. He then invited me to come on down to pick it up.

A friend and I arranged for a 1-ton truck and made the drive to Price, Utah. The cast iron pier, tapered and riveted steel tube assembly, and bits and pieces of the mount were still on the truck. With a lot of effort we loaded the truck. The lens and focuser were in the professor's office. But, had the tube with the retaining ring been discarded it would probably never have been made into an operable telescope again. Its destiny would have been that of a paper weight.

Instead of mounting and using this telescope, the college decided to build an observatory on top of the geography building for a 12 in. Cassegrain inside a 10 in. dome. In all fairness to the college, the refractor would have been very expensive for them to restore. They did not get all of the mounting from the University of Utah. They would have had to build a 15–18-foot observatory, remount it on an adequate mount, and they simply didn't have the budget. Besides that, a refractor doesn't suit the research requirements of modern institutions. A mirror telescope with no chromatic aberration is much more suitable for research work. But, for sheer image quality, used visually, this telescope leaves nothing to be desired.

In its present configuration I am using only the lens, the finder, the focuser, and the retaining rings for the lens and focuser. The retaining ring for the focuser has the familiar Alvan Clark script, in this case, "The Alvan Clark & Sons Corp, Cambridge, Mass 1915." Of course, that plate, attached to the steel tube, was on the garbage truck. I have mounted the assembly in a 117-in. long, 10-in. diameter aluminum irrigation pipe; the focuser increases the total length to 128 in. The instrument is an F/14.8, making the focal length some 133.2 in. It is mounted on a Byers 812 mount with extra counter weights added. This allows this telescope to be portable, with a very liberal definition of "portable." With the help

of some special gadgets, including a "third hand" and a porta Meyer, I usually assemble it by myself in 45 min. The components assemble and disassemble into manageable size components. I transport it on a light weight trailer.

The performance of this telescope is everything one would expect from a telescope of this size and pedigree. It performs to the limit the seeing will permit. With it I have, for example, split Sirius and the B–C component of Gamma Andromedae. I have seen Encke's division in Saturn's rings. I observed the shadow of Europa cross the disc of Ganymede, making it look like Pac-Man. I saw incredible detail during the Shoemaker-Levy 9 impacts with Jupiter in July 1994, the first view of which looked as though Dracula had sunk his fangs into the Giant planet, leaving toothmarks. Most known double stars present little challenge with this telescope. It has delighted thousands, perhaps even tens of thousands at the many public Star Parties I have attended. What makes this even more special for me is that this was the telescope I grew up with. When my interest in astronomy first surfaced and after I acquired an Edmund 4 1/4 reflector, I began going to the University to look through the great refractor. In my high school days I made dozens of trips to the University. At first I was driven, later I would ride my bike. This was the telescope of my dreams, and I consider it completely fair that it should have fallen into my hands. The telescope is listed among the known Clark telescopes in the book, "Alvan Clark & Sons, Artists in Optics, by Bob Ariail and Deborah Jean Warner, (p. 170 and 171) along with a very short version of the above story."

Siegfried's story is incredible; you could call it a dream come true! If anything, it testifies to the powerful emotions classic telescopes can produce in people who appreciate them. But seriously, from a pragmatic point of view, older scopes can be surprisingly good performers and will more often delight than disappoint. Do some research, check out the pedigree, and cautiously, make plans to make that killer purchase.

We've now reached the end of our exploration of the achromatic refractor. It has served the amateur and professional astronomer well for three and half centuries. But slowly, behind the scenes, advances in optical glass design led the way to a new era of refractor building, a movement that has culminated in instruments that are well nigh optically perfect. We speak, of course, of the apochromatic refractor, and its remarkable radiation into a plethora of weird and wonderful forms. That's the subject matter of Part 2 of this book.

The Apochromatic Refractor

CHAPTER SEVEN

The APO Revolution

If you've faithfully read some or all of the material on achromatic refractors presented thus far, you'll have noted I've used the terms "chromatic aberration," "secondary spectrum," and "false color" an awful lot. As we have seen, all achromatic refractors show it to a greater or lesser degree, and even the finest long-focus achromatic refractors cannot completely eliminate this optical defect. Harold Suiter, in his book *Star Testing Astronomical Telescopes*, provides an excellent analogy to describe the essence of a classical achromat: "Achromatism can be compared to tying the spectrum in a knot. The brightest parts of the visible spectrum are deliberately folded into the tightest bundle, with the deep red and violet ends hanging out like shoelaces."

You'll recognize Suiter's "shoelaces" as the origin of the purple fringes seen around high-contrast objects by day and by night. But such color fringing, however slight, takes information away from an image. During daylight use, color fringing robs the viewer of seeing high-contrast detail at the boundary between dark and light zones. Just have a look at some green leaves through an achromat at high power against a bright background sky to see what is meant. Now, recall the image of a star at high power again with its central bright spot, the Airy disc, surrounded by a luminous halo of unfocused purple. Light that doesn't end up inside the Airy disc cannot add information to the in-focus image. The only way to reduce false color beyond that of a long-focus achromat is to bring more

N. English, *Choosing and Using a Refracting Telescope*, Patrick Moore's
Practical Astronomy Series, DOI 10.1007/978-1-4419-6403-8_7,
© Springer Science+Business Media, LLC 2011

than two colors of light to a common focus, while retaining a sharp image. Such an instrument is called an *apochromat* (Apo), and the first models were put together over a century ago by the hands of a brilliant Briton.

Early Promise

H. Denis Taylor, master optician to Cooke & Sons, York, England, was the first to develop, using comprehensive optical theory, the first truly apochromatic objective – that is, an objective that reduced false color by an order of magnitude or so around bright stars at high powers as compared to a good achromatic lens of the same focal length. The outer element was biconvex and of Schott baryta light flint. The center element was biconcave, of a new Schott borosilicate flint. The inner element was a meniscus of a light silicate crown glass of lower dispersion than standard crown. Both pairs of inner surfaces had matching profiles. The rear surface had a radius of curvature roughly equal to twice the focal length. Dispersion was corrected by controlling the radii of the elements. The air space between the second and third elements was critical and used to correct spherochromatism. The image plane was flat and free of coma over a few degrees.

As an added bonus, Taylor's apochromatic objective brought violet light to focus close enough to the green end of the spectrum to allow the instrument to be used for photographic as well as visual use. Thus was created the world's first photo-visual refractor. Taylor's marvelous triplet objectives (more often referred to as the Cooke triplets) entered the world stage at the end of the nineteenth century, just as reflecting telescopes were coming into favor with professional astronomers. "Cooke Triplet" photographic lenses were extensively used by astrophotographers and were modified by Taylor for the specific projects of various noted astronomers. To see how good these early apochromats are, have a look through the 6-in. F/18 Taylor-Cooke at Calton Hill Observatory, Edinburgh, Scotland. If you think a 6-in. D & G achromat is good, the views through this instrument will blow you away. Indeed if the optical analysis of this antique refractor with hand-figured glass are to be believed, it could well be the best color and coma corrected refractor on the planet!

The Taylor photo-visual triplets had to be made with large focal ratios to work at their best. However, if new optical glasses could be developed with the right refractive and dispersive properties, it would allow designers to coax apochromatic performance at much smaller focal ratios, that is, with shorter tubes. That approach was made possible by the genius of

a young philosophy student-turned optical guru, Ernst Abbe, who was hired by Carl Zeiss, proprietor of a small optical firm based in Jena, Switzerland, to improve their line of optical products.

Working first on the microscope, Abbe realized that he needed to find improved glass types if he was going to make progress in correcting the chromatic aberration found in the achromatic doublet objectives. In 1879, Abbe met Otto Schott. Together they introduced the first abnormal dispersion glasses under the name of Schott & Sons. Abbe discovered that by using optically clear, polished, natural fluorite in a microscope objective, all traces of false color could be removed.

When the academic world first learned of them, the first true apochromatic microscope objectives sold like hot cakes, with Zeiss, naturally, absorbing nearly all of the high-end market. So secret was the use of fluorite that Abbe marked an "X" on the data sheet for the fluorite element, so as to hide its remarkable optical properties from the prying eyes of other optical companies.

Zeiss first introduced their so-called semi-apochromatic "B" objective, which was followed soon after by a full Apo lens, dubbed the "A" objective, but the glass was apparently unstable and tended to accumulate large amounts of fungus. Indeed some have speculated that it is doubtful whether any useable "A" objectives are still in existence. The "B" objective came in focal lengths of between F/11 and F/19. Indeed, the longer focal lengths were considered to be fully apochromatic.

Early fluorite objectives were carved from natural sources, so supplies of the crystal were limited. But as a result of technologies developed during World War II, advances in Apo lens design got a big boost, when ways were discovered to grow the crystal artificially using calcium fluoride (CaF_2) solutions.

What's so great about fluorite? Well, for one thing, it displays exceptionally good optical qualities across the visible spectrum. Specifically, it displays a remarkably small variation of index of refraction with wavelength, that is, fluorite has "low dispersion." This makes it easier for the designer to reduce chromatic aberration. If lenses could be manufactured from this material, apochromatic refractors could be designed in much shorter – and more convenient – formats and could operate well using fewer elements.

The problem with early fluorite optical systems was the difficulty in obtaining pure fluorite crystals of sufficient size. For decades, only small fluorite elements could be fabricated, but these yielded impressive results in microscope objectives. Finally, in 1977, Takahashi Seisakusho Ltd. of Japan introduced the world's first astronomical telescope with

a fluorite objective. By working closely with optical experts at Canon Inc., the technology for making fluorite lenses as large as 150 mm (6″) in diameter was developed. The remarkable performance of the fluorite element allowed the production of F/8 telescopes with only two elements in the objective. Fluorite, however, remained very difficult to work with. Because it has a low refractive index, fluorite requires steeper lens curvatures, which tends to throw up greater spherical aberration. Fluorite also suffers from poor shape retention and is very fragile.

New Glass on the Block

The Abbe number, also known as the *V*-number or constringence of a glass material, is a measure of the glass's dispersion (variation of light bending with wavelength) in relation to the refractive index. The Abbe number *V* of a material is defined as

$$V = \frac{n_D - 1}{n_F - n_C}$$

where n_D, n_F and n_C are the refractive indices of the material at the wavelengths of the Fraunhofer D (yellow), F (blue), and C (red) – spectral lines (589, 486, and 656 nm respectively). When the calculations are made – in this case measuring how much red, blue, and yellow light bend while passing through the lens – fluorite turns out to have a very high Abbe number of 95. Over the last few decades advances in materials science has enabled optical firms to develop their own brands of "synthetic fluorite." Japanese Ohara glass, for example, known also as FPL-53, has effectively the same Abbe number as Fluorite (94.99), and there are lower grades of the same glass known as FPL-52 and FPL-51 with Abbe numbers of 90 and 81.5, respectively. Other scopes are made with low-dispersion Hoya glass (FCD1), which has the same optical properties as Ohara FPL-51 glass. Russian and German Apo manufacturers often employ so-called OK4 glass, which has an Abbe number slightly less than Ohara FPL-53 glass.

Typically, only one element from a doublet or a triplet needs be used to achieve an apochromatic effect. All Apo refractors containing these new glass types are branded as extra dispersion (ED) or, more rarely, special dispersion (SD). These terms were invented in the 1970s by the photographic industry, and the buyer can take them to mean the same thing. Less common, fluorite containing Apos are not normally branded

as either ED or SD, perhaps to emphasize the esteem in which fluorite is held by the amateur astronomy community.

What is apparent from an examination of the online forums is the anxiety people feel if they discover that their new scope doesn't have Ohara FPL-53 glass or its equivalent, turning their nose up at anything less. But a lot depends on the mating glass used, that is, how well matched the other elements are. A poorly made FPL-53 scope will do worse than a well-made FPL-51 instrument. If you can bear the thought of extending the focal length, an FPL-51 doublet would be a great performer. Although most companies in the business of manufacturing Apo refractors now make public the glass types used in the design, others, particularly TeleVue, prefer not to. That's not to say that TeleVue is dodging the issue; it merely says that their objectives are made from special dispersion (SD) glass. Their performance, as we shall see, leaves you in no doubt that they are functionally apochromatic.

In Search of Definitions

You'll notice that we've not yet offered a rigorous definition of what qualifies as an apochromatic lens. If you check on the Internet, you'll find that there are many different definitions, including:

- A lens that brings three colors of light to the same focus.
- A lens that acts like a mirror, focusing all colors equally.
- An objective lens that tries to bring all visual spectra to a tighter point of focus.
- A lens with absolutely no false color!
- A telescope that bundles three colors – red, blue, and green – together better.
- A lens that brings three different frequencies of light to a common focus. Such a lens will therefore be a triplet.
- A telescope that shows less color than other telescopes that were supposed to be Apos!

What are we to make of these definitions? Well, it's obvious that all the people that came up with them have a fairly good idea of what to expect from an Apo. Now for some first-class irony; if we are to define apochromatism in the tradition of the man who invented the term, then scarcely any contemporary Apo is truly apochromatic! Ernst Abbe defined an

apochromatic lens as follows: *an objective that brings three widely spaced wavelengths to the same focus and is corrected for spherical aberration and coma for two widely separated wavelengths. Additionally, one of the crossing points for color correction should also coincide with one of the crossing points for spherical aberration and coma. Furthermore, that crossing point should lie as close as possible to the Fraunhofer yellow, e-line if it is to be optimized for visual use.*

Now, coaxing an objective lens to fulfill all these criteria is very difficult, and truth be told, not a single modern so-called apochromatic objective being manufactured comes anywhere close to meeting it! Yet perhaps there is one that does. The superlative 6-in. Taylor F/18 triplet just an hour's drive from this author's home at Calton Hill Observatory, overlooking the medieval city of Edinburgh.

The late refractor builder Thomas M. Back, founder of TMB Optical, apparently thought the Abbe definition of Apo was too stringent and suggested that from a visual point of view a lens will perform apochromatically if it displays the following characteristics:

- Peak Strehl at 550 nm of >0.95
- Diffraction limited (>0.8) over the entire C (red) to F (blue) range
- Has at most one-fourth wave spherical error over the C–F range and achieves at least one-half wave correction of the violet (g) wavelength.

Such a lens, Back claimed, "would not satisfy the Abbe definition, but for all intents and purposes, would be color free and give extremely sharp and contrasting images." You'll notice that Back included the phrase, "to all intents and purposes," with the implication that perfect visual color correction is not achieved.

So the two definitions of APO – the old and the new – are different. But does it matter? They say the proof of the pudding is in the eating, but isn't there more than one way of baking a nice cake? As Es Reid, an optical engineer based in Cambridge, England, commented, the Abbe criterion is more rigorously held to in the microscope world, where measurements are easier because of the lack of atmospheric and heat effects.

How does the Strehl ratio, discussed in the context of the achromatic refractor in Chap. 3, hold for an Apo? The 3-in. F/15 featured had a peak Strehl value in the 0.95 ballpark at 555 nm (green), and it is diffraction limited (or better) between 500 and 600 nm. But at the ends of the visible spectrum (the red and blue "shoelaces" in Suiter's analogy) the curve dips below the diffraction limited (0.8 Strehl) line (drawn horizontally)

while still in the C–F range (their positions are marked under the diagram in bold). Specifically, deep red and violet wavelengths don't make the grade. A TMB defined Apo would bring those extra wavelengths (below 500 and above 600 nm) above the diffraction limit. Thus, for a 3″ F/15 achromat the diffraction limited wavelength range is fairly large, and the problem comes when ones goes to larger apertures and/or faster F ratios. Achromatic refractors larger than 5 in. and faster than F/15 have a much smaller diffraction limited range, centered on green wavelengths with the image swimming in a huge violet halo. The human eye is able to focus on some part of the diffraction limited image, but the violet halo is blurring it.

All this is rather technical, of course, and few (if any) companies certify that their telescopes meet either Abbe's or Back's definition. You can go to great lengths, usually at considerable additional expense, to have your optics tested in a professional laboratory, but would that really make you happy? It pays to remember that most telescopes designed by opticians today have not been rigorously tested under the stars. As a result, they optimize their designs for the maximum theoretical optical performance as measured under lab conditions. Freed from its laboratory test bed, the new telescope is exposed to the vagaries of the nighttime environment, with its sudden temperature changes that ever so slightly warp the curvature of the lenses. Worse still, the mount it sits on jolts the telescope up and down, testing the rigor with which the objective elements are aligned. The cold night air is a thoroughly nasty environment for a newly minted refractor. But if it is thoughtfully designed, it'll cope and provide you with exquisite images.

Having looked through many scopes that tout the title Apo over the years, this author has concluded that the term is more a description of performance than it is a design blueprint. If your refractor exhibits less than a 0.03% color shift over the entire visible range (from 405 to 706 nm) and is well corrected (at least one-fourth wave) for spherical aberration over the same range, then it will perform apochromatically to the eye. What's more, as we'll explore in Part 3, you can perform your own "backyard tests" to establish how well your instrument meets this definition. This is very much the minimum requirements for a telescope to perform like an Apo, and the very best (read, most expensive) do significantly better than that. You will note, however, that the more "relaxed" definition does not insist on three color crossings. Indeed, you don't have to have any color crossings for an objective to perform apochromatically, so long as the colors are sufficiently tightly bundled together.

Who's Who in the APO Zoo?

There are many ways to create an Apo, but the less optical elements you have the work with, the more difficult it is to execute, particularly if you wish to keep the focal length short. With a doublet objective, you simply can't make the curves very steep and still bring the different colors close to the same focus. For this reason to get "Apo-like" performance, the doublet usually needs to be a rather "slow" focal ratio. Most amateurs, however, for reasons of convenience, prefer faster focal ratios. That's because, for visual use, it keeps the optical tube shorter and lighter, and for photographic applications, it gives you a faster exposure time. If you shorten the focal length too much it becomes almost impossible to keep the difference between the focal points of the different colors pretty close together. The light from different colors will bend at different angles, and the sharper the curve of the glass, the more the different colors will diverge.

When you go to a triplet, you are spreading the bending over more lenses, so you can make sharper curves and give the light rays more – but relatively shallower – bends, or use the center element to bend some colors back together. The implication of all this is that triplet Apos can be made with even shorter focal ratios than doublets of the same aperture. And yes, you've guessed it, adding another element (four in all) gives the designer even more freedom to correct some aberrations – particularly field curvature – that triplets can't do as well.

So, as you'd expect, commercial Apo refractors come in a rich variety of forms. The simplest have a doublet objective with typically one element made from ED or fluorite glass and come in focal ratios in the range of F/5.5 to F/9 and in apertures ranging from 60 (2.2 in.) up to 120 mm (4.7 in.). Despite their simplicity, they can vary enormously in price. Doublets tend to be highly favored by visual observers because of their relatively light weight, exceptional light throughput, and contrast. In the longer focal ratios, they have reduced Seidel errors and good depth of focus, and so make exceptionally powerful lunar and planetary scopes. That said, doublet Apos often show some color when pushed out of focus or when subjected to the scrutinizing eyes of the CCD camera, where long exposures throw up faint purplish haloes around brighter stars. Small ultraportable ED doublets are all the rage in sports optics and are now gaining great popularity with wildlife enthusiasts, birders, and folk who like to travel to far off lands with small high-quality refractors. That's why there's a later chapter dedicated to some of these little beauties.

Triplet Apos also have a least one ED glass element and usually come in shorter focal ratios (typically F/5.5 to F/7) than doublets. When properly designed and executed, they have even better control of both spherical and chromatic aberration (typically 1.5 times better) compared to a doublet Apo of similar specification. Triplets also display less field curvature than doublets, but it is not completely eliminated. That's not much of an issue for the visual observer, but it's a real nuisance if you're a photographer. To remedy the problem, the leading refractor manufacturers now make auxiliary optics, known as "field flatteners." Despite their shorter focal lengths, though, the triplet objective tends to make them heavier than doublets of the same aperture, which reduces their portability. Because of their greater number of glass lenses, triplets also take significantly longer to cool down than their two-element counterparts.

Other designers have adopted four elements in their Apo refractors. The most common is a so-called Petzval design, which consists of two doublets – a full aperture one up front and a sub-aperture doublet located further back in the tube. Even when used with conventional crown and flint glasses, Petzvals do achieve modest reductions in false color compared to a conventional achromatic doublet of the same specification. Indeed, some companies such as Vixen have produced so-called "Neoachromats" that are based on this design. By introducing exotic glasses, however, exceptional suppression of false color and other aberrations can be achieved. The Petzval design also produces very flat fields across a wide area, which makes them a dream to use with large-format CCD cameras and digital cameras. As we'll see, Petzval-type Apos are considered dream instruments for ambitious astro-imagers and visual observers around the world.

We're now ready to survey the exciting Apo market in all its glorious forms. We'll begin with the simplest form; the doublet Apo.

Doublet Apos

Times, they are a changing! Just a decade ago, apochromats of any genre were prohibitively expensive to all but the wealthiest of us. That changed forever in 2004, when Orion USA launched its revolutionary new low cost Apo, the ED80, which, for the first time, brought a taste of the color free to many amateur astronomers. The telescope boasts a doublet objective with one element made from FPL-53 ED glass. Its 600 mm (F/7.5) focal length makes it a versatile telescope for visual and photographic applications. If you've only ever used achromats, you'll immediately know that you're looking through an Apo when you first look through this telescope.

The original ED80 (made by Synta for Orion USA, Celestron, and Sky-Watcher) is chunky for a 3.2 in. telescope. Measuring in at 24 in. long and tipping the scales at over 6 pounds when used with a diagonal, this doublet Apo packs a satisfying optical punch. Star fields are variegated in vivid detail. Contrast at low to moderate powers is noticeably better than achromats of the same specification. And it takes magnification really well – 200× on a good night. I took my blue-tube Sky-Watcher ED80 with me on vacation to a dark sky site in southern Portugal a few years back and set it to work over several sultry August evenings. Despite some overlying haze, Jupiter was brighter than I had ever seen it before. Conditions were perfect for testing the mettle of this telescope, but I wanted to enjoy myself, too! The ED80 delivered razor-sharp views of the giant planet at 120× with four of five bands clearly discernible at a glance. The planet's image at 200× was still very well defined, but some false color was beginning to

N. English, *Choosing and Using a Refracting Telescope*, Patrick Moore's
Practical Astronomy Series, DOI 10.1007/978-1-4419-6403-8_8,
© Springer Science+Business Media, LLC 2011

creep in, washing out the most subtle atmospheric features. That said, I could clearly make out the tiny disks of Europa and Ganymede against an ink-black sky – a magical moment for me! Color correction is very impressive in this telescope. Gems such as Albireo in Cygnus and Almaak in Andromeda presented in their most beautiful, contrasted pastels.

The ED80 was a best-selling telescope, and it's not hard to see why; at $499, it still represents excellent value for money. But things were about to get a whole lot better when a 4-in. F/9 ED doublet appeared, followed fast on its heels by a 120 mm ED F/7.5 instrument. The 100 mm F/9 ED model, in particular, has received rave reviews by many people. These revolutionary telescopes have done more than just introduce an army of amateur astronomers to the Apo high life; they have irrevocably changed the high-end refractor commercial landscape.

To see what we mean, let's take a look at an instrument from the "high-end" of the doublet Apo market – two TeleVue doublets. There will be more about the TeleVue 76 in a later chapter dedicated to sports optics.

The TeleVue 102 instrument retails for over $2,000 for the tube assembly, 2-in. Everbrite diagonal, clam shell, 20 mm Plossl eyepiece, and carrying

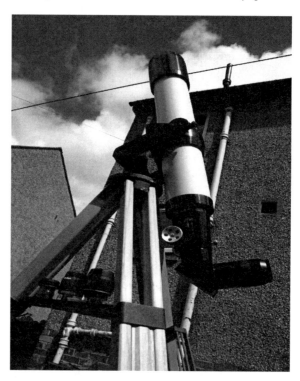

Ready for action: the TV 102 atop the Gibraltar mount (Image by the author)

case. First off, you should know that it's a great all-around instrument and a joy to use. It's a two-element, air-spaced doublet with one element made from an unspecified special dispersion (SD) glass. Like all TeleVue refractors, it's equipped with one of the smoothest rack and pinion focusers in the industry. Everything about this telescope exudes quality. Bright stars display almost no false color in focus, and star testing revealed a very smooth figure to the lens. It's also a first-rate lunar and planetary performer. But how does it compare with a less expensive ED100 F/9, or for that matter, the more "souped up" versions of the same telescope offered in the form the Sky-Watcher Equinox, the Vixen EDSF, and Orion (USA) EON series, which still retail for about half the price of the TeleVue 102?

Based on several samples of the original 100ED from Sky-Watcher, Orion, and Celestron, there is no doubt as to the uniformity of the quality images that can be enjoyed with these telescopes. In terms of optics, there is little difference between them and the top-rated TeleVue 102. Not even an experienced observer could distinguish a top-rated TeleVue 102 from a less expensive but optimally performing ED100 marketed by Sky-Watcher, Orion (USA), Vixen, or Celestron. But that's true only if you're interested in the optics. The TeleVue 102 prides itself in the heirloom quality of the tube assembly and focuser, which frankly, is light years ahead of the cheaper competitors – even the slick EONs and Equinoxes.

It's especially instructive to recount the story of a very experienced observer, Antony McEwan, based in Cromarty, Scotland, who has owned a premium TeleVue 85 (another heirloom quality instrument) but who was gradually won over to the new, cost-effective Sky-Watcher line. Here's McEwan's story.

"I used to own a TeleVue 85 apochromatic refractor," he said. "I loved that 'scope!' I had hankered after a quality telescope that would be perfect from day 1 and would remain utterly dependable every time I used it." The build quality was rugged and tough, the mechanical tolerances were very high, and the views were just gorgeous. There was only the tiniest little bit of false color, and I only ever saw that when viewing the limb of the Moon. Gradually, though, the TeleVue became my holiday telescope. I would only use it a couple of times per year, and I began to resent the fact that my most expensive astronomical purchase was the one I used least often. Finally, I resolved to sell it and buy a cheaper Apo of similar aperture to replace it. The plan was acted upon, and I sold the TeleVue 85 for £1,000, replacing it with a Sky-Watcher (blue tube) ED80, with tube rings, dovetail, and aluminum case, bought for £175 (including postage) on eBay! Initial testing of the telescope showed that the optics were

perfectly aligned, and the first few viewing sessions showed views that were, to me, very similar to those I had experienced through the TV85!

I had read that the simple Crayford focusers on these cheap Sky-Watcher ED telescopes were sometimes rough and might need adjustment. On the model I bought, this wasn't required, and although I still own that telescope after several years and have used it a lot, I have never needed to dismantle it or adjust it at all. OK, the tube doesn't look as good as the TV85, and there are some battle-scars in the form of scratches on the tube, possibly from bits of grit that have lodged between the tube rings and the tube at some point, but that's irrelevant. The fact that I can own a 80 mm apochromatic refractor with a smooth focuser and nearly color-free optics for less than £200 (albeit second hand) is a real joy for me, as I can remember the time when there simply were no cheap Apos!

"I'm sometimes asked if I miss my TeleVue 85," he said. "In terms of what a lovely instrument it was and how proud I was to own and use it, yes, sometimes I do. But not so much in terms of the images the ED80 delivers in comparison to the TV85. I'm quite sure that the TeleVue had much more time and effort spent in its creation, and definitely had a much higher, almost tangible, air of quality about it, but I don't think the ED80's glass is far behind it in terms of night to night performance. It certainly wasn't a night and day difference when I first looked through the ED80 after selling the TV85. If I had the money to spare I would probably buy the TV85 again, but in the meantime I am never disappointed by the ED80's performance."

The ED80 (retail price $595 for the Equinox model) is a great little telescope, but it's lacking a bit in terms of aperture, especially if you want to resolve fainter deep sky objects and very close doubles. Antony also gave the other larger Sky-Watcher telescopes a closer look.

"Thrilled with the performance of the ED80, I eventually acquired its bigger brother, the ED100," he told me. "This came in a longer F/9 tube, gold painted this time, along with the ubiquitous 2″ Crayford focuser. I got this as an ex-demo model from one of the main astronomical retailers, and an aluminum case was included, along with tube rings and dovetail, for the princely sum of £475. OK, so that's a 4-in. class Apo with accessories for less than £500. This is Heaven, yes? It was. The optics again were perfectly aligned, and on my first viewing session with the telescope I observed the Veil nebula in some detail. I was very impressed by the transmission level of the telescope, showing such a faint and nebulous object, through a relatively small aperture, to such a beautiful extent. Planetary and lunar views almost shocked me through this 'scope,' with particularly fond memories of a night spent in my back garden observing Saturn with a handful

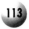

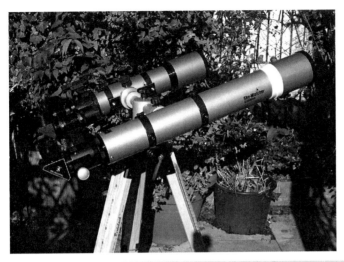

The Sky-Watcher's ED 80 (blue tube) mounted side by side with the ED 100 (Image credit: A. McEwan)

of orthoscopic eyepieces. The detail, clarity, and sharpness were breathtaking, and the subtle color variations and shadows revealed are etched in my memory. Nebulae, open clusters, and galaxies also presented very well through the telescope. The group of M31, M32, and M110 was easily framed within the field of a 22 mm 68° eyepiece (Vixen 22 mm LVW), and the Double Cluster in Perseus was a regular target for showing off pinpoint star images across a wide field of view. Touring Orion with this telescope was a revelation, as the optics showed the nebulous regions with a very high level of contrast. It was simply an outstanding performer."

One of the other things Antony loved about the ED100 (retail price $795 for the basic PRO model) was its performance to price ratio.

"The fact that this was a sub-£500 purchase and yet gave such a high number of grins per view always gave me a warm glow inside. However, on my particular model, I did feel the need to replace the focuser. I found that that particular telescope's Crayford was not as reliable or sturdy as on my ED80, and so I replaced it with a rotatable Crayford made by Baader Planetarium. Whereas before the telescope had been a good optic in an 'OK' body, the new focuser made it feel much more complete and well rounded. The focuser cost about £100, bringing the total purchase cost up to just under £600."

Antony McEwan reserved his most exciting comments for the Sky-Watcher's flagship Apo refractor, the Equinox 120 (retail price for the

optical tube $1,495). "I grew very excited indeed when Sky-Watcher announced an even bigger refractor in the same line," he said. "The ED100 had operated at F/9, but initial reviews of the Equinox 120ED seemed to show that it performed to a similar level, but at only F/7.5 as it had the same focal length as the ED100 (900 mm). I was intrigued, as I am always interested in new refractor developments, and the thought of a 120 mm Apo being used as my main telescope really appealed! It was not just the extra 20 mm of aperture that tempted me, but also the tube mechanics. Sky-Watcher ED's had long been thought of as telescopes with good optics in average tubes. The Equinox line changed all that. Gone was the gold paint job and clunky Crayford focuser, and in its place was a sleek black tube with silver trim. A retractable dew shield replaced the fixed one on earlier incarnations, and a two-speed rotating Crayford focuser took its place at the 'fiddly end.' The 120 also came with very sturdy CNC style tube rings and a foam-lined aluminum case. I took the plunge."

Had Antony considered other Apo designs over these doublets?

"I wanted to stick with a doublet because of the speedier cool-down time," he said, "and my (perhaps mistaken) belief that it would be easier to build a very good two-element Apo than a three-element one. I set myself some goals, too. The views would have to be at least as good as the ones the ED100 delivered and must show no greater amount of false color. Once I had received the Equinox 120 and used it for a few nights, I realized I had made the right decision. The difference in build quality seemed like night and day when compared with my trusty old ED100. The 'scope *looked* great,' and the views through it were brighter and just as sharp as through the ED100. Optical alignment was spot-on, and some of my earliest observations with the telescope are very memorable ones. Like counting craterlets in Plato on a nearly full Moon, or resolving M13 to an extent I never imagined would be possible with a sub-5-in. aperture refractor. Or the view of the Pleiades with the Pentax XW30 – absolutely the best view of them I have ever enjoyed! I was slightly surprised at how the 120ED can soak up magnification to a much greater extent than the ED100. With the ED100 I regularly used 230× and sometimes 270× or so, but on one night after I received the Equinox, I was able to view Saturn as I'd never seen it before. With the rings at a very nearly edge-on angle to us, I was using 240× and getting a great view. That was the most magnification I could use without using a Barlow lens. As the seeing was extremely steady, I decided to go for it and put in the Celestron Ultima 2× Barlow I've had for years. The resulting image at 480× was just as sharp as at 240×, and the amount of detail resolved was amazing! It was harder to achieve focus, but once I had it, it stayed sharp."

Antony was obviously well smitten by the optics of the Sky-Watcher Equinox 120. Did he have any quibbles about the ED120?

"I did have an issue with the Equinox's focuser," he said. "It was not as smooth as I expected, having some rough spots in the drawtube travel. Also, rotating the focuser resulted in a coarse metal-on-metal screeching noise as though it was not lubricated. When I dismantled it, that was the case, so I greased it slightly and adjusted everything I could to get rid of the coarseness. My tweaks did not help much. I was disappointed as the optics and tube assembly were first class, but the focuser did not live up to the same high standard. So I ordered a hand-built Moonlite two-speed rotatable Crayford. It added a hefty £300 onto the purchase price but was worth every penny. There is no comparison between it and the Sky-Watcher Crayford. The Moonlite will hold anything, anywhere, with no slip, and the drawtube motion is perfectly smooth all the time. So now I have the Equinox 120ED – a 120 mm-aperture Apo with a classy tube assembly and good-quality looks, fitted with a Moonlite focuser. In my eyes, that qualifies as a 'premium' telescope, and it cost a lot less than one of the same type made by one of the elite manufacturers. It gives fantastic views and can go from low power, wide field (F/7.5) to very high power for planetary and lunar viewing. I am very, very pleased with it. Also, please note that I haven't heard of anyone else experiencing the problem that I had with my Sky-Watcher Equinox focuser. Maybe I'm too fussy or maybe it really was literally a one-off!"

Finally, Antony was asked how he would sum up the experiences he has had with the new line of Sky-Watcher ED doublets.

"The Sky-Watcher ED line has come a long way," he told me. "The original models brought Apo class refractors to the masses for an affordable price, and the Equinox range is the latest step in the evolution of the Sky-Watcher ED's classy and well thought-out telescopes to be proud of, and at very cost-effective prices. However, it's worth remembering that to get the very best out of a Sky-Watcher ED 'scope,' you may need to be a little proactive. Some tinkering (lubricating and adjusting focusers, etc.) may be required. Some accessorizing will definitely be rewarded: dump the supplied diagonal and buy a good-quality mirror type with high reflectivity and then invest in some very good-quality eyepieces to allow the superb optics to perform at their very best!"

Antony McEwan's assessment of the Sky-Watcher line of doublet APOs concords with others experiences with these telescopes. Remember Orion (USA) does a similar line, too. They represent great value for money and will provide a lifetime of high-quality views. Choose the model that best suits your needs.

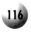
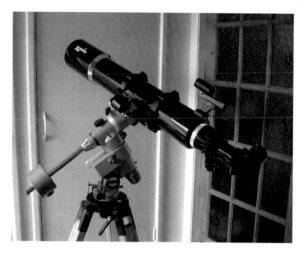

The Sky-Watcher Equinox 120 (Image courtesy A. Mc Ewan)

Japanese Magic

If you think the new ED doublet refractors from China are good, there are two performers from the Japanese company Takahashi that are widely regarded to be even better. Arguably the best 4-in. Apo sold in recent years is the Takahashi FS 102. Unlike its competitors, who invariably employs modern ED glass in its telescopes, one of the elements in the "Tak" is composed of true fluorite, while the other is made from low dispersion glasses (unspecified). Its decent focal length of 820 mm (F/8) serves up razor-sharp images that really have to be experienced to be believed. Put another way, these instruments have polychromatic Strehl ratios of the order of 0.95, and to get any higher you'll need to buy a more expensive triplet (discussed in Chap. 11).

At a trip to Kelling Heath star party in Norfolk, England, some years ago, this author observed through one for a 20 min spell. It left an indelible mark on my psyche. The FS 102 had the best contrast I've ever experienced in a telescope of this aperture. Running through the star fields of Cygnus on that cool September evening, the North American nebula (NGC 7000) stood out so much it seemed to pollute the light of myriad stars with its glare. Stars focused down the tiniest pinpoints, more minute than any ED100 could. False color was not visible under calm conditions, and only the merest flicker of color appeared intermittently during unsteady atmospheric bouts. The figure on these Takahashi lenses makes

soaking up magnification look easy, even ridiculous. Under normal conditions, 200× can be comfortably maintained, but you can push this telescope to over 300× on steady nights to split close doubles and enjoy fine lunar detail. If you're in the market for a finest 4-in. refractor in its focal length class, then you won't be disappointed with the Takahashi FS 102. Now sadly discontinued, the telescope occasionally appears on the used markets and can be had for about the $1,500 mark. Incidentally, Takahashi also made a larger fluorite doublet, the FS 128, which has now also been discontinued, to be replaced by their new line of triplet Apos.

Will Borg Assimilate You?

California-based company Hutech Corporation has enjoyed a solid reputation for producing extremely versatile, modular refractors that can be disassembled for airline travel. In recent years, Hutech has teamed up with Pentax to produce a new range of dual-purpose doublet Apos that can be used both visually and photographically. The Borg range includes 3- and 4-in. ED doublets (77EDII, 101ED) as well as their new flagship instrument, the 5-in. Borg 125SD ($3,995 for the optical tube). All of these refractors can be fitted with focal reducers and field flatteners for photographic applications.

Canadian amateur Chris Beckett, a night-hardened visual observer, explained his motivations for choosing the Borg 125SD.

After viewing through a friend's 5-in. F/8 Astro-Physics over the years, I quested after the ultra-portable 5-in. refractor. The 5-in. Astro-Physics is beautiful, but large and heavy, requiring a big equatorial mount. I really enjoy the Borg 125 SD, and it is the ideal combination of light weight and quality. At about 8 pounds with a Feathertouch focuser, it weighs little more than my William optics 80 mm triplet. I mount it on a Tak-Lapides modified Alt-azimuth mount, which works beautifully and is rock solid at over 300×. Does the telescope perform as well optically as the Astro-Physics 5-in.? No, but I would not expect it to, since it is less expensive and built out of lighter materials. But the Borg is much better than the five Sky-Watcher 120EDs I've looked through in terms of correction for colors and other errors.

"To be upfront, I went through a couple of lenses from Borg, and the first two lenses were pinched. Since I'm in Canada (Ontario at the time, Saskatchewan now) we felt it could be due to much colder temperatures than the testing environment. The third lens was adjusted for this and it works exactly how I expect a telescope in this price range to work optically. Speaking

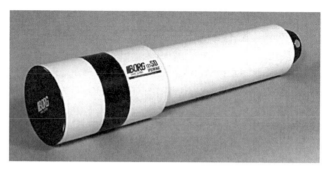

with other refractor owners near my location in Ontario – a TeleVue NP101 owner and Tak TOA130 owner – both showed me images of pinched optics that resembled what I had in the first lenses, so this does not seem a problem isolated to Borg, and considering the attention I got from Hutech and Borg/Pentax itself, I only confess positive things about my experience with these companies. I also did a side by side shootout with a Takahashi FS 128 and could detect no optical differences between the two."

Portability Plus

If portability is especially important to you, then why not consider the Takahashi Sky 90. This is another fluorite doublet with slightly less aperture (90 mm) than the FS 102 and a significantly shorter focal length (500 mm). The tube weighs just 7 pounds and can be contracted to an incredible length of only 20 in., making this telescope highly desirable for airline travel to a dark sky site. The oversize rack and pinion focuser – smooth as silk – has an adapter for both 2- and 1.25-in. diagonals, and it also accepts the FS series photographic adapters. With a focal ratio of F/5.6, you'd expect this telescope to show a fair amount of false color (even with low dispersion glasses), but owners report very low levels of chromatic aberration even around tough objects such as Sirius and Venus. This telescope really excels as a rich-field telescope with contrast that is every bit as good as the FS 102.

Getting high powers for planetary viewing isn't easy with the Sky 90's very fast F/ratio, but the company also supplies a piece of auxiliary optics called the Extender Q, which boosts the focal length to 800 mm and greatly improves high power views of the Moon, double stars, and planets. Some folk think it's overpriced (the tube assembly alone retails for

The Sky 90 objective (Image credit: Kevin Berwick)

$2,000) for what it delivers, but if you're after an exceptionally compact telescope with excellent apochromatic optics that you can take anywhere, then the Takahashi Sky 90 may well be the instrument for you.

More recently William Optics has launched the Megrez 88FD F/5.6 doublet. On paper, this telescope has a very similar specification to the Takahashi Sky 90 but retails for less than half the price. How do these compare? Well, for one thing, there's something a little nefarious about the name given to this telescope. The letters "FD" might trip off the tongue as "Fluorite Doublet," but you won't find any fluorite in this refractor. Instead one element is made from low dispersion FLP-51 ED glass to reduce false color, but side by side tests reveal that the fluorite-containing Takahashi delivers noticeably better color correction. Canadian amateur Clive Gibbons, who has used a number of William Optics refractors, believes he has the answer. "From my observing experience," he says, "the Megrez 88FD appears to use Ohara FPL-51 ED glass, or a similar type by another glass supplier. The telescope's color correction is good, but not quite what you'd see with an FPL-53 or fluorite doublet of its size and aperture."

In recent years, a number of telescope companies have produced a line of affordable short focal length and portable Apo telescopes designed for amateurs who need to make the most of the limited time they have to observe. One of the best doublets in this category is the SV 102ED, produced by California-based company Stellarvue. This telescope is a 4-in. F/7 ED doublet ($995 just for the optical tube and clamshell mounting ring). Unlike other companies who tout this refractor as fully apochromatic, Stellarvue

Takahashi Sky 90 on TeleVue Telepod Mount (Image credit: Kevin Berwick)

The 'cute' William Optics Megrez 88FD (Image credit: Clive Gibbons)

founder Vic Maris deserves credit for making no such claims. Despite this, most owners report near Apo-like color correction and almost identical diffraction rings both inside and outside focus. This is due in part to Stellarvue's policy of star testing each unit before it leaves the factory.

Josh Walawender is a postdoctoral scientist based at the Institute of Astronomy in Hawaii and a long-time amateur astronomer who has used this instrument extensively. "I'd definitely recommend the SV102ED," he says. "I think it's an excellent value in the market. I'm quite impressed with how it stacked up against a telescope costing twice as much (the 4-in. F/8 Stellarvue SV102ABV Apo). The ED shows a modest violet halo around bright objects, but it is a very deep violet color, not the bright blue that is thrown up by inexpensive achromats. I haven't done a side by side test with the following telescopes, but to my memory, the halo is substantially fainter and deeper violet than all of the following telescopes that I have looked through: a 152 mm F/8 inexpensive achromat, a Stellarvue 80 mm F/6 AT1010 achromat (the Nighthawk), and a Stellarvue 80 mm F/9.4 SV80/9D achromat. It didn't have the color correction and contrast of the more expensive SV 102ABV. I'm particularly fond of the no nonsense aspect of refractors like this one (no collimation to worry about, minimal cool-down time, simple to mount, etc.). I think it makes a great telescope for people with different levels of experience, from beginners to seasoned observers."

In recent years, these medium focal length models have grown in popularity and are now marketed by a number of companies, including

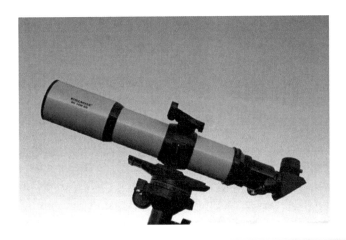

The Stellarvue SV 102 ED (Image credit: Josh Walawender)

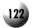

The iOptron Versa 108 F/6 ED doublet

Orion USA (the Orion Premium 102 mm F/7 ED Refractor for $900, as well as a larger model – the 110 mm F/7 ED – for an extra $100), ASTRO-TECH, USA (80 and 102 mm ED F/7 doublets), and Germany's Astro-Professional (80, 102 and 110 mm apertures F/7 ED). Typically, these all come equipped with a retractable dew shield, a dual-speed Crayford focuser, and an adjustable lens cell. The basic package includes the optical tube, tube rings, and a mounting bracket, but for a little extra money you can also get a nice diagonal and carry case. iOptron, who made its debut in the telescope mount market, has recently introduced another variation on the same theme – the iOptron Versa 108. For $1,699 you get the optical tube assembly, a 2-in. photographic field flattener, tube rings, and a hard case.

Now perhaps you are thinking that even with ED glass, the iOptron's large aperture and very short focal ratio is a recipe for throwing up false color. If you shorten the focal length too much with a doublet, it becomes almost impossible to keep the difference between the focal points of the different colors close enough together to be unnoticed during observing sessions (<0.03% color spread). Should you consider a 4-in. F/7 ED telescope to be fully apochromatic? In a word, no. False color is well controlled, but you can see some at high power around bright stars. That's not to say they don't deliver excellent images, though. You really need a triplet objective to go to the next level of color correction at these focal ratios.

Another interesting feature of these fast ED doublets is that some models appear to be optimized to largely eliminate the dreaded "purple haze" at the expense of leaving a touch of unfocused red. Canadian amateur Clive Gibbons has done extensive research in this area and has published some of his results on a well-known on line astronomy website. This is what he has to say. "The manufacturers of these ED refractors have chosen

an optical formula that minimizes the appearance of defocused blue/violet light at the slight expense of red correction. Observers are often sensitive to worse correction at shorter wavelengths and typically look for 'blue/violet' halos around bright objects as an indication of color error. Manufacturers have become increasingly aware of this and realize that the best way to make their optics appear to display less chromatic error is to 'shift' correction slightly. The result is that these lenses generate less visible defocus at shorter (bluer) wavelengths, but more blurring in the red. Unfortunately, this poorer correction at longer wavelengths is more detrimental to performance than many people might imagine. It makes it more difficult to achieve sharp visual focus, especially at higher magnifications. Planetary and lunar detail suffers. Difficult double stars (especially when the brighter component is reddish) are harder to discern."

Gibbons has even discovered a palliative of sorts for this color shift. Instead of using a mirror diagonal, he suggests using a prism diagonal with his eyepieces. As Gibbons explains, "Since light passing through a prism is refracted slightly, image correction is altered. A star diagonal prism shifts color correction. As it happens, this shift is beneficial to a surprising number of today's ED doublet and triplet refractors sourced from Taiwan and China. The lens's red defocus is reduced by the refractive property of the prism. A small amount of blue/violet blur is generated as a result, but that defect is far less damaging to image quality. Another optical characteristic of a diagonal prism is that it's naturally overcorrected for spherical aberration. Many refractors are made slightly undercorrected for spherical aberration. Thus, a prism can neatly (or nearly so) null the spherical correction of these refractors."

Not any old prism will do the trick, though, as Gibbons has pointed out. "It would appear that the optimal type of prism for use in many of today's ED doublet refractors is one that employs BK7 glass. Inexpensive 1.25″ 90° (not the correct orientation 45° prisms popular with birders) star diagonal prisms sold by Celestron, Meade, and Orion all use BK7 glass." My own testing with a number of ED refractors show a real and modest improvement in image quality at high power at the expense of losing some light compared to a high-quality mirror diagonal. Indeed contrast is generally improved by using a prism diagonal with these telescopes.

Gibbons was asked what he thought the motivations were behind the design of these color-shifted ED telescopes. "I think this is something the industry does," he said, "rather than just William Optics. For imaging, it has advantages. For observers, who judge a telescope's correction based on how much blue-violet haloing they see around bright white stars, it is attractive. However, for planetary observers, who more greatly prize

traditional correction – that is, green-yellow-red at best focus – it's not so good. I think it's a bit of a 'trick' the lens makers are using. But it's a trick that can be improved upon by a prism diagonal."

There will be more to say about William Optics' range of super sexy small aperture ED doublets in the next chapter, which is devoted to small aperture instruments for the great outdoors. For now, though, it's time to take stock of our journey through the incredibly fast-moving world that is the doublet Apo market. Doublets are often the instrument of choice used by discriminating visual observers who require the highest contrast levels an Apo can deliver. They are easier to collimate than triplets and other Apo designs, and many experienced observers believe that they have slightly higher light transmission compared to more complex designs. More importantly, there's less chance of ghosting, glare, and other contrast-robbing effects occurring with a simple two-element design compared to those that employ more glass elements.

If there is anything to be learned from this chapter it is this: there is no substitute for focal length. Fast (<F/7) ED doublet refractors have a harder time tying up the colors of the spectrum in an orderly way than their slower (F > 7) counterparts. A 4-in. F/9 ED doublet will show only a hint of false color and present a delightfully sharp image at high powers. A 4-in. F/6 ED instrument, for example, will show noticeably less false color than an achromat, but it will still be more prominent than in the longer focal length ED instrument. High power images are likely to be "softer" in the F/6 telescope, too, owing to small amounts of other errors such as astigmatism and spherical aberration creeping in as the focal length of the objective is shortened. Of course, more expensive models are bound to deliver better correction for these optical errors. Choose a model that suits your needs and enjoy it.

In the next chapter, we'll take a look at the bustling market of small (<80 mm aperture) refractors that have proven incredibly popular among amateur astronomers hell bent on travel and wildlife enthusiasts. Although many of the more inexpensive models are traditional crown-flint achromats, there are now a great many little ED doublets instruments available to the enthusiast who enjoys crisp, color-free views by day and by night.

Sports Optics

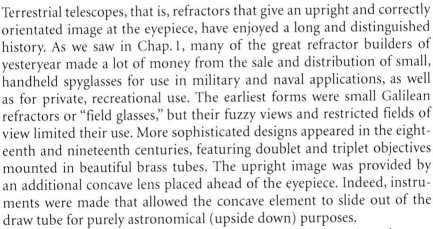

Terrestrial telescopes, that is, refractors that give an upright and correctly orientated image at the eyepiece, have enjoyed a long and distinguished history. As we saw in Chap. 1, many of the great refractor builders of yesteryear made a lot of money from the sale and distribution of small, handheld spyglasses for use in military and naval applications, as well as for private, recreational use. The earliest forms were small Galilean refractors or "field glasses," but their fuzzy views and restricted fields of view limited their use. More sophisticated designs appeared in the eighteenth and nineteenth centuries, featuring doublet and triplet objectives mounted in beautiful brass tubes. The upright image was provided by an additional concave lens placed ahead of the eyepiece. Indeed, instruments were made that allowed the concave element to slide out of the draw tube for purely astronomical (upside down) purposes.

More than any other telescope genre, surveying the spotting telescope market is like hitting a moving target. There are a staggering number of different models available to the consumer, and so it's well nigh impossible to cover each and every instrument. Luckily, many of these refractors can be classified on the basis of their overall design – traditional models that employ prismatic arrays and deliver an eyepiece image (such as binoculars), and what can be called "crossover" telescopes, which are small, short focal length achromatic or ED doublets, originally marketed to star

gazers but now enthusiastically endorsed by birders and other outdoor hobbyists. Before delving into the details of particular models, let's make note of some general points about daylight observing.

Daylight Observing: a Primer

In normal daylight, the eye pupil becomes dilated to between 2 and 3 mm. To get the optimum accommodation for your eyes, it's best to match a quantity called the "exit pupil" of the telescope to the size of your pupil's diameter. The exit pupil is found by dividing the aperture of the objective by the magnification of the eyepiece. For example, a 60 mm aperture telescope delivering 20× has an exit pupil of 60/20 = 3. So, our 60 mm spotter will deliver maximum image brightness of between 20 and 30× magnification. For general daytime viewing, good working magnifications to use a range from 20 to 30× for a 60 mm, 22 to 33× for a 66 mm, and 25 to 40× for an 80 mm. In low light conditions, as occurs at dawn or dusk, the pupil opens up, dilating to between 5 and 7 mm, depending on age. Under these circumstances, optimum performance can be tweaked by using a lower magnification eyepiece or using a larger objective lens.

Of course, larger apertures do produce brighter images, but unless the objective is of very high quality – typically with ED elements – the greater light grasp will also amplify any optical imperfections inherent to the telescope. False color will be easier to pick up, and their higher magnifications will render them more sensitive to atmospheric turbulence, especially over long distances. Big lenses are heavy, too, and so reduce portability. In truth, there is little to be gained in going above 80 mm (3.2 in.) if you only intend using your telescope for daylight projects. Such an instrument will provide excellent light transmission even in low light conditions. Spotters marketed for daylight use usually express the field of view in terms of the width in meters of the image when viewing at a distance of 1,000 yards. Alternatively, they may simply use angular degrees. One degree of angle is equal to 52.5 feet at 1,000 yards.

For recreational daylight observing, viewing comfort is a premium concern, and to that end, the hobbyist should do well to consider the eye relief offered up by the telescope's eyepiece. Eye relief is the distance between the eye lens and the point where the pupil is positioned for the entire field of view to be observed. Eye relief varies from eyepiece to eyepiece. If you don't wear eyeglasses, you can tolerate quite small eye relief (<10 mm). If you do wear glasses, then a minimum of 20 mm eye relief is

usually recommended. If you can't see the full field of view while wearing glasses – even after pulling down the rubber cap on the eyepiece – then you need more eye relief.

The manner in which the eyepiece fits to the telescope body gives rise to their description as either straight telescopes or angled telescopes. The straight eyepiece variety is common and often easier to use because the eyepiece is in line with the body of the telescope and pointing in the direction that you are looking. The great advantage of viewing in the straight-through position is that it allows you to follow fast-moving objects more effectively. Straight telescopes are also better suited to observing birds that are at or below eye level. Angled eyepieces, on the other hand, that is, those fitted at 45° to the body of the telescope, are best suited to observing birds that are high up, for example in trees or in flight. Of course, using an angled spotting telescope also makes astronomical observations much more comfortable, so if you like doing both, it's probably best to avoid straight-through instruments that do not allow you to use interchangeable eyepieces or diagonals.

Most quality spotting telescopes use Porro prisms made from BK-4 optical glass, while cheaper models use the less efficient BK-7. Porro prisms are more wide than long. If you view the light path through the prisms from the side, you'll see that they fold light into a square "S" configuration. If the prisms are made from high-quality glass and aligned correctly, there is very little light loss or degradation of the image. The only real disadvantage is the fact that the prisms are large and bulky and consequently require large housings. The newer designs, using roof prisms, have an advantage here. They are smaller and more compact than Porro prisms, and they actually look like their namesake. Roof prisms can thus be fitted into smaller housings and that makes the telescope lighter. Although you can buy a so-called phase-coated (PC) roof prism model (at extra expense) that gives excellent results, roof prisms generally give inferior optical performance in comparison to the best Porros.

The great advantage of using a "crossover" telescope is that it can be purchased as a so-called optical tube assembly and so you can carefully choose a diagonal and eyepiece combination tailored to your needs. This makes a crossover far more versatile than dedicated spotting telescopes. One can choose either a 1.25-in. diagonal or a 2-in. diagonal, depending on the eyepiece you want to use. Most birders make do with spotting telescopes that use relatively lightweight 1.25-in. eyepieces. The 2-in. eyepieces deliver greater fields of view, which is great for astronomy but normally overkill if you're trying to concentrate on the variegated feathers of a nesting kestrel. By purchasing an optical tube assembly, *you* get

to choose the kind of viewing *you* want to experience. Having observed through traditional spotting telescopes for many years, with their dedicated, non-interchangeable zoom eyepieces, this author finds this new-found freedom a great liberation. If, for example, you wish to experience the prismatic world with its correctly orientated view, a number of companies, including William Optics, produce both 1.25- and 2-in. prismatic diagonals angled for 45° viewing. They were designed to give very good images over typical daylight magnifications for their small ED telescopes such as the Zenithstar 66, but the image quality rapidly degrades if powers above 60× or so are employed.

There is a near perfect palliative, however, and it comes in the form of a high-quality mirror diagonal. In general, its excellent optical flatness and high reflectivity allows you to use much higher magnifications – if your project needs it – than the 45° prismatic diagonals. The best have dielectric coatings that boast 99% reflectivity.

We used the term "near perfect palliative" for a purpose; the only caveat with mirror diagonals is that, although they yield upright images, the view is reversed left to right. What's more, traditional astronomical mirror diagonals are designed for looking high in the sky and thus are designed with 90° angles. One great exception is the 1.25-in. TeleVue 60° Everbrite diagonal. Designed by Al Nagler, this diagonal offers all the comfortable terrestrial viewing of a 45° prismatic diagonal does but delivers noticeably better images, especially during high-power applications. As you

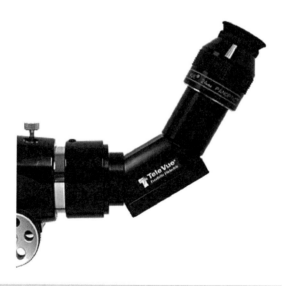

The TeleVue 60° Everbrite Diagonal (Image credit: Venturescope)

might expect, it doesn't come cheap ($210 retail price), either. There is at least one birder who uses one with his inexpensive $100 spotter!

Another issue for spotting telescope users is minimum focus distance. That's the closest distance to an object that your spotting telescope will focus on. If you like using your telescope as a long-distance microscope, you'll need to be able to focus at close range, often within a few meters. If the telescope you purchase doesn't come with this information, you'll need to try before you buy. Most commercial spotters can achieve sharp focus at distances ranging from 3 to 6 m. In general the larger the telescope, the greater the minimum focus distance achieved.

Dedicated spotting telescopes with non-interchangeable eyepieces tend to be significantly lighter than an equivalent aperture crossover telescope. Many of the more expensive models are made from ultra-light metal alloys that can be over 50% lighter than a similar aperture crossover telescope. The extra weight is not much of an issue when it comes to astronomical applications, when the telescope is not hauled about as much. Most spotting telescopes also need to be adequately mounted if a nice steady view is to be enjoyed. We'll be discussing mounting options for these and other telescopes in Part 3 of this book. Buying a decent telescope can be a significant investment. Selecting the right model for your needs and your budget is vitally important. Fortunately, the increased demand for quality optics has led manufacturers to produce a dazzling assortment of telescopes from which to choose, and this has kept their prices from skyrocketing.

We'll now take a look at one highly regarded traditional spotting telescope: the Leica Apo-Televid 82. This 3.2-in. (82 mm) aperture spotter is available in a choice of either straight or 45° angled body but optically they are identical. The focuser can be rotated a full 360° around the mounting collar. On the straight body, this rotation facilitates orienting an attached camera to compose an image as desired. The straight body is a good choice when operating around flat marshy areas devoid of trees or high ground. For some people it's easier to sight through the straight body telescope onto a distant target, too. For quicker sighting when using the camera adapter, or for observing from a car window mount, then here too you might prefer the straight-through view body. That said, a straight body will place the eyepiece and spotting telescope at the same height, so a taller tripod or stand will be required compared to that needed for the angled body.

The angled body is the better choice for most users, since this provides more comfortable eye position, particularly when observing objects higher than the observer, i.e., a bird perched high in tree canopy or a craggy cliff edge, or indeed a celestial object. A noteworthy advantage of the angled body, since it too can rotate in the collar, is that the eyepiece

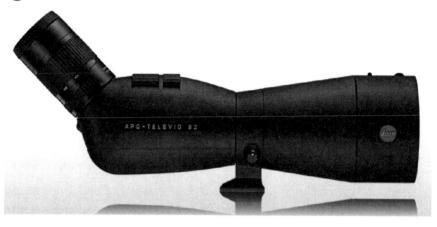

Spotter King: The Leica APO Televid 82 (Image credit: Ace Cameras)

can be positioned up, down, or to the side to allow people of differing heights to view. When target shooting, the telescope barrel can be rotated so that the eyepiece can be seen from a prone position. For surveillance viewing, the observer can remain hidden around a corner or below a ridge while still able to look through the eyepiece. And the view is correct left to right and right side up regardless of the eyepiece position!

The Leica Televid has a special five-element objective (in four groups) containing fluorite for very good color correction. It has a focal length of 440 mm (so it's about F/5), and the supplied zoom eyepiece delivers magnifications from 25 to 50×. The lenses are coated with an innovative antireflection coating called AquaDura that prevents water droplets from adhering, and the surface is also resistant to the formation of fog. Hopefully we will soon see similar stuff applied to the objectives of mainstream astronomical refractors. Furthermore, the entire telescope is nitrogen filled and water resistant to a depth of 5 m. The telescope body is made from die-cast magnesium, making the whole package extremely light – just 3.6 pounds (1.5 kg) – for a telescope of its size. Being less than a foot (30 cm) long, the Leica Televid 82 is superbly designed for the outdoors in temperatures ranging from −25 to +55°C.

Eager to try one out, this author paid a visit to one of the biggest camera stores in Scotland and played with a Leica telescope for a few minutes, which was carefully mounted on a sturdy Manfrotto tripod. By and large, the views were breathtakingly crisp with superb color rendition. The wide field of view was impressive, too. Now you'd expect to get absolute optical

perfection from a telescope that retails for $3,995 ((£2679 UK), but that wasn't the case. When the telescope was pointed at a window located some 20 m across the showroom and the 50× was dialed on the supplied zoom eyepiece, there was a wee bit of false color around areas of high contrast. There was also a hint of field curvature. There's so much glass – lenses and prisms – inside this telescope that it is well nigh impossible to achieve the level of color correction common with simpler, less expensive Apo telescopes designed for the amateur astronomer. So, in the cold light of day, is it worth the astronomically high price tag Leica commands for it?

That's a difficult question to answer. It's stylish, rugged, ultra-light, and has excellent optics. But it has limited latitude in terms of the range of magnifications it can be used with. Sure, Leica also supplies two very nice additional eyepieces for the Televid 82; a 32× wide-angle and a higher power 20–60× zoom – but that's it. Even if it could be charged with higher magnifications, the tiny amounts of color seen that day at 50× in the camera store indicated that it would throw up considerably more under typical astronomical use. Seen in this light the Leica Apo Televid 82 is very much a specialist telescope. It gives bright and delightfully corrected images in daylight but probably would not throw up the finest high power views of the Moon and planets possible for a 3.2 in. aperture. A small, premium telescope really ought be able to do everything superbly! It should be lightweight and compact, have superb, color-free optics, and be able to use interchangeable eyepieces. In short, it should perform equally well by day and by night. To that end, in the last few years, an amazing array of small, ultra-portable crossover telescopes have made their debut, and they have sold by the thousands across Europe and North America. We'll now take a look at some of these models.

The William Optics Mini-scopes

The year 2005 was an exciting one for small refractor lovers. That's the year William Optics launched not one, not two, but *three* sensational little refractors all at the same time. No doubt it was a bit of an experiment on the part of the company to see which one would win out with the consumer.

The first to emerge was a 66 mm F/6 four element Petzval design (which we'll be examining thoroughly in Chap. 11), billed as semi-Apo. Then came the Zenithstar 66 ED F/7 triplet Apo, followed fast on its heels by a 66 mm F/6 SD doublet. All came in a beautifully anodized tube complete with rotating Crayford focuser and logoed soft case. All also came with a retractable dew shield and weighed in at about 5 pounds. As if

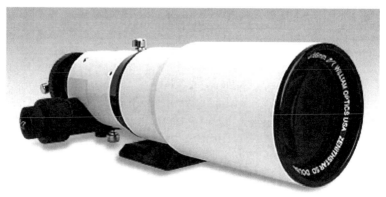

The William Optics Zenithstar 66 SD doublet (Image credit: Ian King Imaging)

that weren't enough, all three came with a ¼-20 L mounting bracket that could be used with nearly any photo-tripod.

The 66 ED Petzval had a nice flat field – a real bonus if you're into photography – but its displayed quite a bit of color in daylight tests at moderate powers (>30×). The single FPL-51 sub-aperture element and Petzval design frankly didn't subdue false color as much as had been hoped. The triplet Zenithstar 66 was much better in this regard. Daylight and night-time testing showed only the merest trace of false color but only when pushed to high magnification or bouts of atmospheric thermal instability. The Zenithstar 66 SD, though, was very impressive with its level of color correction. The full aperture FPL-51 element did a superb job at wringing out any chromatic aberration from all but the most testing of objects.

Within a few months of the launch of the Zenithstar 66 F/5.9 SD doublet ($395), the Petzval and triplet models were discontinued. That was probably a wise move on the part of William Optics, as both are more complex and thus harder to manufacture than the SD doublet. Since 2005, the Zenithstar 66 SD has gone on to become one of the best-selling small telescopes in the world. This little telescope certainly seems to offer excellent optics for its modest price tag ($329 for the optical tube, 1.25-in. diagonal, and hard case). Although the latest models sold have black and white anodized tubes, William Optics cashed in on the incredible popularity of these telescopes as "luxury" finders mounted atop larger telescopes. To this end, they produced both "Celestron" orange and "Meade" blue tubes to delight an army of Schmidt Cassegrain fans.

Weighing in at just over 2 kg with a 1.25-in. diagonal and eyepiece inserted, this little telescope serves up sharp, high-contrast, and color-free views at low and moderate powers. Even high powers (>100×) reveal only a trace of color fringing around high-contrast objects. Star testing a few of these telescopes showed pretty good results with only minor spherical aberration and a trace of astigmatism detected when pushed to 120× or so. As discussed in Chap. 8, the William Optics Zenithstar 66 SD had a bit of red excess when viewing bright stars at high power, but an inexpensive prism diagonal removes the red excess at the expense of introducing a slight bluish fringe around bright stars and planets at high power.

William Optics also supplies an adaptor that allows the 66SD to be mated to 2-in. diagonals (in fact it is deliberately designed to take popular SCT accessories) to obtain the widest possible views for a telescope with these specifications. Think about it! A 31 mm Nagler eyepiece would yield a field of view near 6.6° wide – that's 13 full Moon diameters.

That said, despite its appeal as an ultra-rich field telescope, its aperture (and limiting magnitude of +10.8) restricts its performance as a serious deep sky instrument.

Because the 66SD is so light, it can easily be mounted on a conventional photo-tripod for terrestrial viewing. The dual-speed Crayford focuser, fitted as standard on these telescopes, is of great benefit when homing in on wildlife constantly on the move. Maybe 66 mm doesn't sound like much aperture, but it's enough for most daylight applications using moderate magnifications. The only scenario in which the Zenithstar 66 SD would probably prove lacking is in low light conditions. That said, if you're after an ultra-portable travel telescope that won't break the bank but nonetheless offers very good, color-free optics, then there is little to go wrong with the William Optics SD doublet.

Since the launch of the Zenithstar 66 back in 2005, the telescope has been a huge success for William Optics. In the autumn of 2009, the company announced it was ceasing production of this popular model – no doubt a reflection of the global economic recession that preceded it. However, a number of other companies have marketed their own version of this telescope, most notably Astronomy Technologies (ASTROTECH). Produced in a wide variety of colored anodized tubes, the AT66 ($359) has essentially identical optics to the William Optics mini-scope. The only significant difference between the two lies with their focusers. The AT66 has a 1.25-in. focuser, while the William Optics telescope has a 2-in. focuser, making it more useful for adding photographic adapters. If you want the widest fields of view with big 2-in. eyepieces the Zenithstar 66 is the better choice. Other than that, choose the model (or color) that's

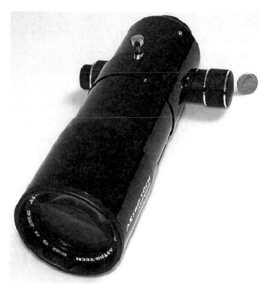

The ASTRO-TECH 72 ED doublet (Image Credit: Altair Astro)

right for you. Alternatively, Sky-Watcher and Kunming United Optics also produce competitively priced clones of the ASTRO-TECH telescope.

William Optics and ASTRO-TECH also market two other ED doublets, slightly larger instruments built around the success of the 66SD. William Optics produces the Zenithstar 70 (F/6.3) and the Megrez 72 FD (F/6). ASTRO-TECH also markets an almost identical 72 mm F/6 ED ($379). Though the images these telescopes serve up are quite comparable to the Zenithstar 66, the Megrez 72 FD and ASTRO-TECH 72 deliver slightly brighter views, especially in low light conditions. Both telescopes when kitted out with a 1.25-in. diagonal and eyepiece still weigh in at or just over 4.4 pounds (2 kg), making them easy to use and transport in the field.

As commented on before, the FD labeling on the 72 mm model is a little annoying, especially since it's an ED doublet (most probably FPL-51). A quick daylight look through one of these telescopes shows that although color correction is very good, it is not as color free as its smaller sibling, the Zenithstar 66 SD. For the record, Stellarvue also offers a 70 mm F/6 ED telescope. Called the SV70ED, it comes with all the features of the William Optics Zenithstar 70 but includes a threaded dust cap with the Stellarvue logo, a Vixen-style mini rail, and a very nice hard case all for $399.

The Borg Mini-scopes

When it comes to having fun with a small portable refractor, no company seems to understand the market better than Hutech Corporation and their series of tiny, high quality ED refractors in the range of 1.8- to 3-in. apertures (45–76 mm). This Mini-Borg series offers a range of finely made telescopes with Japanese optics. They are modular in design and so can be used with other Borg accessories for visual use, wide field imaging, or just for guiding larger telescopes during long-exposure astrophotography. Perhaps the most remarkable of all is the MiniBorg 45ED, the world's smallest Apo refractor. Sporting a high-quality ED doublet objective, this little telescope has a focal length of 300 mm (F/6.6) and can be used in conjunction with a dedicated focal reducer/field flattener. Only 6.6 in. in length, with the focuser racked in and weighing less than a pound, this telescope would get lost in a woman's handbag! It's well designed helical focuser has very generous back focus (up to 6.5 in.), so it'll work well visually or with a CCD or digital camera.

Despite its $349 price tag, it's hard not to like this telescope. Images are crisp, color free, and it's a super little instrument for looking at the Moon

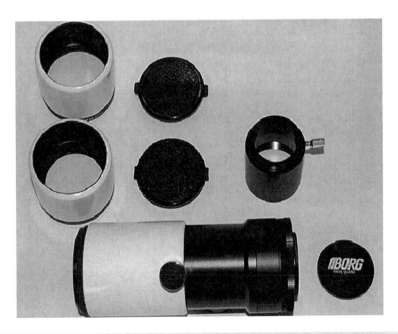

The worlds smallest Apo, the Borg 45ED (imade credit: Stedit Asbury)

at a moment's notice. It'll take magnification well, but it won't break the laws of physics. Hutech Borg also offer a similarly designed 60 mm F/5.8 ED model for significantly greater resolution and light grasp.

Nothing but the Best

The William Optics, ASTRO-TECH, and Borg mini-scopes sure are a tremendous dollar value. They are the Ford KA of small, ultra-portable telescopes. But some aspire to owing a Mercedes A Class, and in the telescope world there are several candidates – the Takahashi FS-60C and two from TeleVue (their 60 and 76 models). All are apochromatic doublets of exquisite optical and mechanical quality. All have rack and pinion focusers that move with the effortless precision of a Rolex timepiece and can be set up at a moment's notice.

Takahashi affectionately calls the FS-60C the "itinerant" telescope par excellence. This tiny 2.4-in (60 mm) refractor weighs virtually nothing (OK, it's 2.9 pounds for the optical tube assembly) and is less than 12-in. long when used in visual mode. Optically, it's a fast F/5.9 doublet with a fluorite front element mated to a low dispersion flint. The little Takahashi excels mechanically as well. Its oversized 2-in. rack-and-pinion focuser is thoughtfully designed for astrophotography and CCD imaging. A thumb screw maintains the focuser in position whatever the direction of pointing is.

You'd expect such a fast doublet to show a bit of color, but a bit of careful testing by day and night shows that views are almost entirely devoid of chromatic aberration. It's one sharp optic. It will handle 200× on a good night before the image begins to go a bit soft. Moreover, by using an adapter called the Extender Q (exclusively designed by Takahashi) the focal length of the native telescope can be extended from 355 mm to 566 m (a 1.6× focal length boost), and it'll be easier to achieve high power for lunar and planetary viewing. However, the expensive Extender Q ($268) is probably a bit of overkill if you only wish to use it on this tiny 60 mm telescope. Better to spend your hard earned money on a high-quality eyepiece that'll do the trick. A 2-4 mm Nagler zoom (discussed in Part 3 of this book) fits the bill perfectly!

Al Nagler, founder of TeleVue Optics, New York, has enjoyed an almost guru-like status among small refractor lovers, especially in the USA. But it's not just the amateur astronomy community who venerate him. Unlike the other high-end refractor makers, Nagler has vigorously marketed his prestigious mini-telescopes in the birding community.

The Takahashi FS-60C (Image credit: Geoffrey Smith)

And it's paid off. TeleVue's two smallest refractors are as now as likely to be used by day as they are by night. The smaller of the two, the TeleVue 60, is arguably the most beautiful mini-telescope in the world! Optically, it's got a very similar specification to the Takahashi FS-60C, but its mechanical design couldn't be more different. This is a telescope designed for the discerning visual observer who wants to extract the very finest images from an ultra-light portable setup. Its focuser is a 1.25-in. format, so you can't use 2-in. eyepieces with it like you can on the mini-Takahashi, but the TeleVue 60 can still deliver a maximum true field of 4.3° a 24 mm Panoptic.

Neither is its focuser a rack and pinion, as you find with the Takashashi FS-60C. Instead, Nagler reverted to the wondrously smooth helical focuser design once used on the now discontinued 70 mm TeleVue Ranger. You do coarse focusing by loosening the knob at the top of the tube and sliding the draw tube in and out. When an approximate focus is achieved, the knob is locked, and the helical focuser takes over to do the fine tuning. It sounds a bit clumsy but it's remarkably efficient. After 5 min in the field, you'll have memorized the approximate distance the draw tube needs to be extended for quick results. Weighing just less than 4 pounds with a diagonal and eyepiece in place and measuring just 10 in. long with its dew cap retracted, it's no wonder Nagler calls it his "briefcase" telescope.

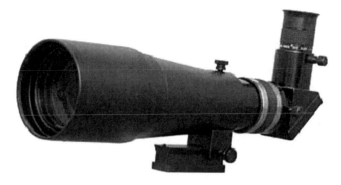

The beautiful tapered tube design of the TeleVue 60 Apo (Image credit: Venture Telescope)

Which one to get? Well, that's hard to answer. They both command a hefty price tag for their size (about $800), but if you're after optical perfection in a tiny package these are the telescopes to own. But that's also their Achilles' heel. Both the TeleVue 60 and the Takahashi FS-60C, despite being optically perfect, are only 60 mm telescopes, and while they handle most daylight projects very well, there are significant advantages to looking for a telescope with a little more aperture. Enter the TeleVue 76 ($1,595).

Introduced in 2002, the TeleVue (TV) 76 was the replacement for their older ED telescopes – the Ranger and Pronto – both of which were splendid 70 mm F/7 doublets with good but not Apo-quality color correction. The TV 76 (F/6.3) has a slightly larger aperture but the same focal length as the older telescopes. Like the TeleVue Pronto, it has a beautiful rack and pinion focuser in a 2-in. format. Bought new, the package includes a custom soft case, a screw-on lens cover and sliding dew shield, a 20 mm TeleVue Plossl eyepiece, a 2-in. Everbrite diagonal, a 1 ¼″ adapter (all with clamp ring fittings), and a manual signed by Uncle Al himself. When outfitted with an eyepiece and diagonal, it tips the scale at just over 6 pounds. That's significantly heavier than some top-of-the-range spotting telescopes but not enough really to present problems in the field. Any loss of portability though is made up for by the TV 76's amazing versatility. A 3-in. aperture is just about large enough to make high resolution visual observing worthwhile, and its short focal length (480 mm) coupled to a big, wide-angled eyepiece means that you get majestic 5.5° views of the night sky.

The optics on these telescopes must be experienced to be believed. Having owned and looked through several lower cost ED doublets of similar specification, this author can say, hand on heart, that the TV 76 bested them all. The difference was more dramatic than those noticed in

The TV 76 goes anywhere at a moment's notice (Image by the author)

comparing the 4-in. TV 102 with the Orion/Sky-Watcher 100ED. Star testing this telescope at 120× shows how superbly crafted the optics are. Vega displays a hard white Airy disk surrounded by a single diffraction ring. No color error was noted. The diffraction patterns both inside and outside focus were the nearest to perfection seen in any telescope. They're cleaner and easier to see compared to the slightly fuzzier patterns usually observe with cheaper ED doublets. Like other two-element Apos, they do display a small amount of color on the rim of the diffraction pattern both inside (magenta) and outside (green) focus, but that's normal behavior for an instrument with an ED doublet objective.

It's easy to test good optics, and you don't need an optical test bench to do it. A well-figured lens ought to able to take very high magnifications before noticeable image breakdown occurs. Daylight and nighttime tests with high-quality eyepieces and image amplifiers show that the TV 76 can take amazingly high powers and this little telescope can hold 100× per in. of aperture. It has very low spherical aberration and is devoid of astigmatism and coma. This is extraordinary for an Apo with such a fast focal ratio (F/6.3). And it's no accident, either. It's down to the excellent figure of the lens and the employment of a large air gap between the objective elements.

The TV 76 really rocks when it comes to resolving double stars, despite its fairly short focal length. Only one problem – like all other short focal

The well-figured doublet objective of the TV 76 (Image by the author)

ratio telescopes, maintaining sharp focus can be a bit fiddly, especially during high-power applications under less than perfect seeing conditions. The instrument's excellent color correction makes seeking out variegated doubles a joyous adventure. Albireo, 61 Cygni, and Almaak unveil their austere beauty at moderate and high powers. Forget Polaris and Rigel: these high-contrast companions usually cited as tests for a 3-in. refractor are too easy for this refractor. More challenging (and more fun) is the lovely triple system of Iota Cassiopeiae and close binaries such as Delta Cygni and Theta Aurigae, all of which the TV 76 manages to resolve. And though it's not the hardest binary system to discern with a good 3-in. refractor, Epsilon Bootes (Izar) is arguably one of the most compelling sights to see in a small telescope in all the heavens. Steady skies and high magnifications are required to elucidate its lovely secret, a magnitude +4.6 blue green companion separated from its primary by just 2.9 arc sec of sky.

Now, this little telescope can resolve pairs as close as 1.5 arc sec *provided* they are of fairly equal brightness. But the near sevenfold difference in brilliance between Izar and its main sequence companion renders the secondary hard to see, overwhelmed as it is by the light of its primary. Optics plays a role with this system too – many 4-in. instruments consistently struggle with this system, but a high quality 60 mm refractor should just do the job under good conditions. And though this author has

looked at Izar with all sorts of telescopes, from small portable telescopes to humongous Dobs measuring fully 2 feet across, it must be said that the finest view of Izar was with this 3-in. refractor.

During a recent vacation to a tiny coastal resort on the northwestern coast of Scotland, I chanced upon some fair weather. Tucked away in a shallow inlet, the early evening winds subsided gradually to a dead calm after midnight, allowing me to take advantage of exceptional observing conditions with dark magnitude +6.5 skies. On two successive nights, I was able to rack up the power on my telescope to 276× to get a razor-sharp separation of the system. Like a budding yeast cell seen under a microscope, the pale blue ball of the secondary sat on an otherwise perfect first diffraction ring of a golden orange primary. it's at moments like this that one can more fully appreciate why the famous double star observer Otto Struve christened it *Pulcherimma*!

That completes our survey of the sports optics section. To summarize, let us say that although traditional spotting telescopes are nice to use and easy to transport, the new line of small ED doublets specifically aimed at the amateur astronomy market are more versatile and provide better value for money, even if they're not exactly waterproof. You can spend a small fortune buying a top-of-the-range spotting telescope only to find out that a less expensive ED doublet from William Optics, Stellarvue, Borg, ASTRO-TECH, or TeleVue will turn out to give you much the same views.

Now, we're ready to take color correction to the next level. It's time to take a closer look at triplet Apos, the subject of the next chapter.

Triplet Apos

We've covered a lot of ground so far, so this might be a good time to take stock on the story to date. Let's talk lenses. First off, a simple lens, like the magnifying glass you fiddle with from time to time, has two curved (spherical) surfaces. No matter how well you figure and polish these surfaces, the lens will never focus red light and blue light at the same point. A doublet lens – such as our classical crown-flint achromat – adds a second element that whips the red and the blue into line, as it were, so they come to a common focus. When we add another element, so creating a triplet, it's possible to bring more than two colors into perfect focus. This naturally reduces the amount of spurious color observed. But you can also harness the refractive muscle of the triplet to bring light entering at the edge of the lens into sharper focus with light entering at its center. That cuts down on spherical aberration. Do you get the idea? Basically, each element you add gives you more ways, more degrees of freedom, to perfect the image by carefully choosing its material properties and shape. Of course, the cost and complexity increases with each new element you add.

So you'd expect a triplet to exhibit sharper, more color-free images compared to a doublet ED or fluorite Apo of similar aperture and focal length. So how do the current line of triplet Apos square up to these expectations? Arguably the finest triplet Apos ever produced came from the factories of the Swiss optical giant Carl Zeiss, in the form of the legendary APQ line. Sadly Zeiss has ceased producing refractors for the amateur market, but other innovators have since reached comparable heights of

N. English, *Choosing and Using a Refracting Telescope*, Patrick Moore's Practical Astronomy Series, DOI 10.1007/978-1-4419-6403-8_10, © Springer Science+Business Media, LLC 2011

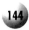

A modern classic: the superlative Astro-Physics Traveler EDFS triplet Apo (Image credit: David Stewart)

optical artistry. Roland Christen is, for example, telescope maker extraordinaire and founder of the Illinois-based company Astro-Physics. In the early 1980s, the company introduced the first high-performance triplet apochromats to the amateur market. These early instruments, though not as entirely color free as their current line, were nonetheless quite revolutionary, being a major influence in the rebirth of refractors in the modern era.

Today, Astro-Physics is synonymous with state-of-the art refractors and equatorial mounts, with a waiting list for their telescopes that extends for years. Without much in the way of advertising, the legendary status of these "all-American" telescopes has continued to grow in the 21 century. Indeed the Astro-Physics refractors have gone where no contemporary telescope manufacturer has gone before. After all, what other telescope company do you know has discontinued products that continue to appreciate in value?

In 1992 Astro-Physics introduced their line of refractor lenses, which incorporated synthetic fluorite ED glass in various optical designs. This optical material, as we have seen, has further revolutionized the modern refractor by all but eliminating the last vestiges of false color in fast refractors. Despite being discontinued, telescopes such as the 90 mm F/5 Stowaway, the 105 mm F/6 Traveler EDFS, and the StarFire EDT refractors (in 5- and 6-in. formats) remain the Apo refractors by which all other

refractors are measured. More care and attention to detail goes into these refractors than any other refractor on the market – and it shows! Astro-Physics currently offer three superlative triplet Apo refractors; the 130 mm (5-in.) F/6.3 StarFire EDT, a 140F/7.5 StarFire EDT, and the overwhelming 160 mm F/7.5 StarFire EDT.

To see the extraordinary time and skill put into each and every one of these instruments just take a look at the specifications (taken directly from the Astro-Physics website) of the smallest of the 5-in. Astro-Physics StarFires, the telescope nicknamed "Grand Turismo":

Color correction: Less than ±0.006 net focus variation from 706 to 430 nm (r to g wavelengths).

Clear aperture: 130 mm (5.12"), Focal length: 819 mm (32.25")

Focal ratio: F/6.3

Theoretical resolution: 0.87 arc seconds

Coatings: Multi-layer, broadband, overall transmission greater than 97% in peak visual wavelengths

Magnification range: 22× to 500×

Tube assembly: White, 4.7" diameter, machined aluminum tube, fully baffled, flat black interior, push-pull lens cell, engraved retaining ring

Focuser type: 2.7" I.D. Focuser with rotating collar, rack and pinion with Feather Touch Micro 9:1 dual-speed reduction, 4.4" travel; 2 and 1.25" adapters

Telescope length: 698 mm (27.5") with dew cap fully retracted

Weight with dew cap: 15 lbs (6.8 kg)

To top it all off, the instrument comes with a wooden case with a gray vinyl covering and foam-lined interior. What does it all mean? In a phrase; near optical perfection! Chris Cook, astrophotographer extraordinaire from Cape Cod, New England, recently acquired the 130 mm EDT after waiting more than 8 years for the privilege! "I would say that the Astro-Physics 130GT refractor is the finest telescope I have ever owned," he told me, "the quality of the craftsmanship is excellent. I have owned numerous other refractors over the years and Astro-Physics is in a whole different league. I will also comment on the fine optical coatings on the main objective lens. I'm not sure what kind of coatings Roland uses, but they basically reflect no light. When you look at the lens the glass almost disappears. Very impressive! The scope also features a new twist lock dew shield design which works very well. One of the wonderful features of an Astro-Physics refractor is the 2.7-in. focuser. It is very robust and buttery smooth, a real work of art!"

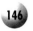

The majority of triplet Apos employ air-spaced objectives, but three companies use oil: TEC, a firm based in Golden, Colorado; Astro-Physics (their 5.5-in. [140 mm] F7.5 StarFire EDF Triplet is oil spaced); and the Hungarian manufacturer, GPU. What's the idea behind using oil? Well, it's actually an old trick borrowed from microscopy. For over a century, microscopists have utilized special oil-immersion objectives that greatly improve the refractive properties of high power (typically 100×) objectives. Introducing oil between the elements in a telescope objective effectively smoothes out any tiny irregularities that occur on the surfaces of the lenses. In addition, the surfaces of oil-spaced objectives don't need to be polished as finely as an air-spaced model. Overall, the oil gives the objective more uniform refractive properties and marginally greater light transmission. Another advantage of oil-spaced objectives is that they cool off more quickly than their air-spaced counterparts because the oil removes the pockets of air that help insulate the lens.

It has been said that the oil can sometimes leak. Maybe that's true of one or two isolated cases, but there are objectives over 20 years old that show no leakage of oil or deterioration. So oil spacing really can be considered a permanent, or at least a very long term, solution. That said, if the oil layer ever clouds over from slow chemical deterioration, all that needs to be

Astrophysics 130 mm EDF Gran Turismo (Image credit: Chris Cook)

done is to separate the lens elements, renew the oil, and re-seal the lens – all without harm to the glass.

TEC produces a number of top-of-the-line oil-spaced triplets, ranging from their most popular model – a 5.5 in. F/7 TEC 140 – to their largest, observatory-class instrument, a 7-in. F/7 TEC 180; these range in price from just over $5,000–$19,000.

Chris Lord, an experienced amateur astronomer based in Lancashire, England, has fastidious tastes when it comes to high-end Apos. His instrument of choice is a 5.7-in. (140 mm) oil-spaced triplet, built to the exacting standards of TEC opticians. Lord, a long-time refractor fan, built his first telescope, a 3-in. f/15 achromatic Littrow refractor, in 1969 and enjoyed using it for 20 years. Here's his take on why he settled on the TEC:

"During 2003, in the run up to the record closest perihelic opposition of Mars in August, I decided to observe from Corfu, overlooking Gouvia Bay, where seeing Antoniadi I or II was assured. Which portable telescope to take, capable of 1 arc second resolution and high image contrast? Having used a Quantum 6 and a Meade ETX90 Maksutov, I wanted an instrument with less cool down time, and no central obstruction. So which short focus refractor to choose?

"The minimum aperture to obtain one arc second resolution at the Rayleigh limit is 140 mm. At the time flight baggage weight limits were 30 kilos plus another 8 kilos hand luggage, which meant an optical tube assembly and mount not exceeding 20 kg. What I was after was the largest aperture barrel assembly not exceeding 10 kilos that could be split into not more than a 2-foot length. I looked at nine different makes of Apo ranging from the William Optics FLT-110 through to the Astro Physics EDFS130 Starfire. My preference was the TMB130, until I saw the TEC140/980 at European Astrofest. What impressed me was the specification: a 1/55 wave RMS (at the mercury e-line) oiled triplet FPL53/ZKN7 objective, Strehl 91% polychromatic Strehl and 99% peak Strehl near the Mercury e-line, a Feathertouch rack mount with 4.5-in. helical rack, and a 3.5-in. I.D. rack tube with very smooth backlash free action and no sag. It had large milled Dural knobs, and milled fine-focus knob. The rack mount could be rotated and locked by means of a large scalloped capstan. The 2-in. eyepiece collet was available either with a PBS or Beryllium-Copper alloy sleeve. The tube was well baffled, finished inside with a true matte black, and outside with a white heat-reflective, high emissivity powder coating, and a retracting, integral dew shield. The rack mount could be withdrawn from the tube to reduce transport length.

"Apo refractors of this class have to be ordered via a subscription list. They are made to order in small production runs. Every optical tube assembly is hand

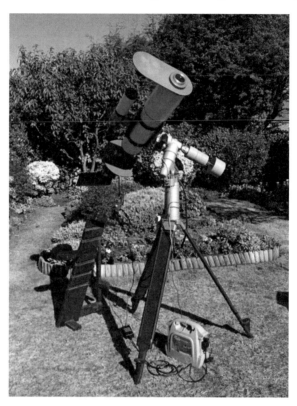

The TEC 140 triplet APO geared up for solar viewing (Credit: Chris Lord)

assembled, and every component, including the objective, tested, and quality assured. The TEC140 Apo I ended up buying was the review model #022 from the first batch, sent to Dennis di Cicco at *Sky & Telescope*. I ordered the OTA, with two eyepiece collets, (PBS & Dural), a 2-in. finder, and the TEC 5-port turret. I also acquired several useful dedicated accessories, including a set of TMB Super-Mono eyepieces, a Vernoscope bino-viewer outfit, with matched pairs of Brandon orthoscopic eyepieces, Vernonscope Zenith & Amici 45° 2-in. prism diagonals, a TeleVue 2-in. Everbrite dielectric mirror diagonal, an APM Herschel wedge and circular polarizer, a Solar Spectrum Å0.25 SO15 passband H-alpha unit, a Schott filter slide unit, and a Vixen 70 S guidescope.

"What impresses me about this telescope, after 6 years of usage, is the objective. The chromatic correction is nigh perfect. Only when the power is pushed beyond ×120 per inch can I detect any tertiary spectrum. Spherochromatic aberration is 0.02% over the C–F wavelength range. It has a 19-layer, mil-spec anti-reflection coating. When you look into the tube, the lens is

difficult to see, so little light reflects off it! Cool down time in the UK is nil. I keep the telescope in its trunk indoors. I can use it by the time it has been set up on my Vixen GP-DX mount (about 20 min). I am not sitting there twiddling my thumbs while tube currents subside, as I was using my Quantum 6. Planetary detail on Mars, Jupiter, and Saturn is excellent. I am primarily a visual observer, and the TEC140 Apo is a superb visual 'scope (but it is also an excellent imaging 'scope when fitted with its dedicated field flattener). For about 3 years, I had it piggybacked off my 10-in. f/10 Calver Newtonian. Only on nights of excellent seeing (Antoniadi I) did the Calver outperform it. I could see the cloud patterns on Venus in daylight clearly, when the Calver showed me nothing but a bland disc."

What can I say? Chris likes his TEC 140. For those who want a less expensive option, the company have recently introduced a very fetching 110mm (4.2-in.) F/5.6 Fluorite triplet model for $4500. Hungary's GPU has a great reputation within the EU for making very fine oil-spaced triplet Apos. This is a small business founded by Andras Papp. Currently the

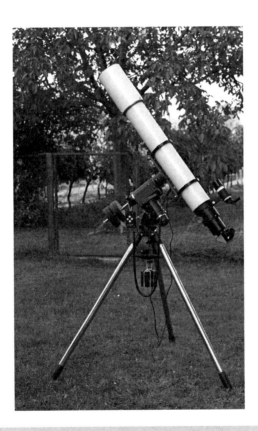

The GPU 5-in. GPU 127/1200 (Image credit: GPU Optical)

company produces 4-, 5-, and 6-in. oil-spaced triplet Apos. The small-est is the GPU 102/640, a 4-in. F/6.4 model (1990 Euro + VAT), designed with portability in mind. The company offer two 5-in. models, the GPU 127/890AS and the GPU 127/1200, which have focal ratios of F/7 and F/9, respectively. The GPU 127/1200 (2790 Euro + VAT) is especially eye catching, as it is the only oil-spaced triplet in its aperture class with such a large focal ratio currently being manufactured. If you fancy putting one together yourself, you can also order the lens cell without the optical tube. GPU scopes sure seem an especially good bargain in today's high-end market, but there's a small catch. You get a "bare bones" optical tube assembly from which you choose your own upgrades, which GPU are happy to install for you at extra cost. That said, judging by the happy cus-tomers who've taken the plunge and bought a GPU triplet, their optical performance in the field will not disappoint. Indeed, it is refreshing to see a company's awareness of the difference between a telescope's certifiable optics and its performance in the field! Check out the GPU website to more details.

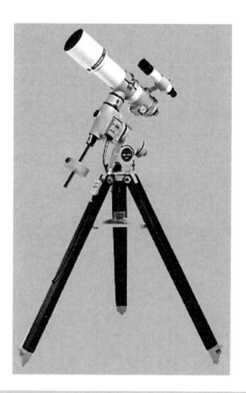

The superlative Takahashi TOA-130 (Image credit: Greenwitch)

Takahashi Triplets

The Japanese have a long and well-earned reputation for producing fine optics, and Takahashi bests them all. The fluorite doublet FS 102, discussed in Chap. 8, is arguably the finest performer in its genre, but the company has been making exquisite triplet Apos for over a decade. The company currently sells three triplets from 4 to 6 in. in aperture and in two forms. The TSA-102 S ($2,695), long considered to be the replacement for the veritable FS 102, has a fairly long focal ratio (F/8) but is still airline portable, weighing just 12 pounds and slimming to just 23 in. with the dew shield contracted. At the heart of the TSA-102 S is a newly developed lens design incorporating ultra-premium FPL-53 ED glass positioned between two low-dispersion crown glass elements to produce images of superlative quality. For those of you who like figures, check out these typical TSA-102 S statistics – color correction over the visible spectrum from 436 to 656 nm is reputedly no more than ±0.01%. That, together with e-line Strehl ratio of 0.99, means that you'll see razor-sharp, high-contrast images completely devoid of spurious color.

Doug Sanqunetti from Cicero, Indiana, is a keen amateur astronomer and astro-imager. Over the years, he has built up quite an arsenal of top-quality Apos to meet his imaging needs. One of the jewels in his crown is the Takahashi TSA 102, which he rates very highly indeed. Doug's own high-power star testing produced, in his words, "extraordinary results," but to elaborate, he says, "there was no trace of astigmatism or spherical aberration. Fresnel rings were beautifully defined and almost identical in and outside of focus. Furthermore, there was no false color in or out of focus. The Airy disc was solid and very sharp with a very delicate and perfectly defined first diffraction ring looking very much like the theoretically "ideal" image of an unobstructed optical system found in textbooks." That said, Doug is not primarily a visual observer. "In the area where I live," he says, "there is considerable light pollution. It is a rural area, so the sky is not too bright, but there are enough lights on neighbors' houses that your eyes can never get adequately dark adapted. Almost all of my time is spent imaging because I can often image an object with the TSA 102 that I cannot see visually at all."

The TOA series is comprised of two larger triplets – a 5.1 in. F/7.7 (130 mm) and a 6-in. F/7.3 (150 mm) instrument. Retailing for $6,395 and $8,795, respectively, they're likely to be prohibitively expensive to the vast majority of us. Rest assured, though, these are dream Apos, and their performance is nothing short of breathtaking.

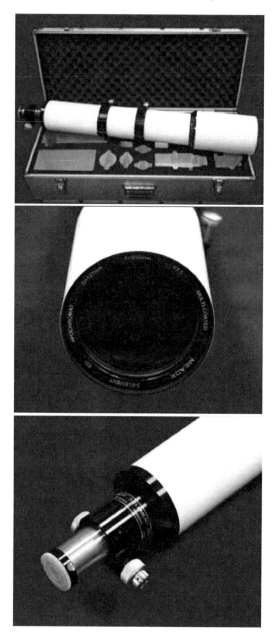

The Meade Series 5000 127ED triplet Apo (Image credit: Telescope House)

So much for the ultra-premium models; a number of other companies are now marketing more attractively priced triplet Apos that are winning the hearts and minds of many visual observers and astro-imagers alike.

Economy-Priced Triplets

Triplet Apos were the preserve of the high-end market until just a few years ago. That all changed when Meade launched their line of Series 5000 triplet refractors, which included a 3.2-in. (80 mm) F/6 instrument, a 4-in. (101 mm) F/7 ($1,295), and a 5-in. (127 mm) F/7.5 model ($1995). With a machined aluminum Crayford focuser, a retractable dew shield, screw-on lens cap, and collimatible objective cell, the Series 5,000 refractors have what are now considered standard features.

Both of the Meade scopes have an air-spaced triplet objective with one element made with FCD1 low dispersion glass. This Hoya glass is equivalent to Ohara FPL-51, which provides less dispersion (and a higher refractive index) than the higher-end FPL-53 glass. Not surprisingly, FCD1 is also cheaper than the FPL-53, but it meets, or slightly exceeds, the color correction of a typical fluorite-based doublet. This was tested on a 80 mm Meade Series 5000 triplet ($649 for the tube, add another $100 for a case and diagonal) against a TeleVue 76, a high-quality ED doublet. Both scopes have the same focal length – 480 mm – and similar F ratios (F/6 ish). During a few mild nights during October 2008, you could see a wide variety of targets under fine seeing conditions. Operationally, the TeleVue was slightly easier to use. Its butter-smooth rack and pinion focuser responds perfectly with no backlash whatsoever. The Crayford focuser on the Meade was less impressive. It's quite coarse, making fine focusing difficult. Indeed when the focus lock was engaged, it knocked the focus off ever so slightly.

Despite this, the Meade delivered very good images. It was not totally devoid of color; it was just about equal in both scopes at moderately high powers. A star test also showed nice smooth rings inside and outside focus with both scopes, but the TeleVue 76 had significantly better spherical correction (as evidenced by nearly identical ring brightnesses inside and outside focus). That was surprising, as the Meade should be at least as well, if not better, corrected for this aberration owing to its triplet design.

In relation to difficult double stars (for a 3-in.) the view of Delta Cygni at 192× was tested. Although both scopes resolved its gray–blue companion, the TeleVue image seemed to be a touch cleaner, despite its slightly smaller

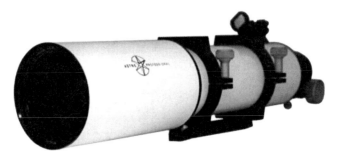

The Astro Professional 115mm ED triplet Apo (Image credit: Star Telescopes)

aperture. All in all, the Meade Series 5,000 triplet can be rated as a good all round performer, but it does have its imperfections as revealed by more stringent tests. And it's really a great value, especially considering the more expensive TeleVue 76 retails for more than twice its price.

Similar 80 mm FPL-51-containing triplets have appeared on the market since Meade launched theirs. California-based company Explore Scientific has launched a very similar product – the ES80 triplet. And Germany's Astro Professional offers a larger aperture, 4.5-in. (115 mm) F/7 ED triplet. Though the company does not state the glass used in this model, the very reasonable price suggests that the less expensive FPL-51 glass is employed in its design. In the world of triplet Apos, as elsewhere in life, you tend to get what you pay for, or do you?

In the last few years, Oklahoma-based company Astronomy Technologies (ATRO-TECH) has introduced a new line of exciting new triplet Apos, including an 80 mm F/6 ($699); a 90 mm f/6.7($1,295); two 4-in. models – the 4.1-in. ASTRO-TECH AT106 106 mm f/6.5 ($1,995) and the 4.2-in. AT111mm F/7 ED triplet ($1,895) – and a 5-in. (130 mm) F/6 instrument. All have higher quality FPL-53 glass with the exception of the AT111, which uses one element made from FPL-51 ED glass. Owner reports consistently reveal very well corrected, razor-sharp optics devoid of any false color. Alan Dyer, a self-confessed refractor nut, astro-photographer, and *Sky & Telescope* contributing editor evidently rates the AT 106 very highly, especially for its modest price tag ($1,995). Dyer noted its total lack of false color but did notice a trace of astigmatism.

As fairly new products, the ASTRO-TECH and Explore Scientific triplets don't have the same pedigree as Germany's APM/TMB, Japan's Takahashi, or America's Astro-Physics, which have been making very fine triplet Apos for many years. That said, these bargain telescopes seem to be making a good name for themselves among astro-imagers.

Astro-Tech's AT 106 triplet Apo (Image credit: Altair Astro)

Triplet Wonders from the William Brothers

In 2005, William Optics teamed up with TMB Optical to produce a superlative 80 mm F/6 triplet Apo. Lee Townend, a British amateur astronomer, spoke about this instrument. "I have used many of the traditional scope designs over the years, but I always end up coming back to a refractor. The Megrez 80 mm F/6 TMB Apo is, in my opinion, one of the best. The 80 mm size is the perfect balance of aperture and ultimate portability. The OTA can be used on a decent camera tripod to great effect. I have done this many times when a gap in the clouds has materialized, and I do not have the time to get out the full kit. The scope obviously shines at wide-field work.

"The clarity of the glass defies belief. It seems to have limitless ability to show objects well beyond its capability. The Great Orion Nebula shines with exquisite wispy detail, with all four trapezium stars visible. M13 shows an incredible amount of stars, and with averted vision you can clearly resolve some of the inner detail. I recently purchased an 8" Maksutov for planetary use. I am finding that on some nights I still

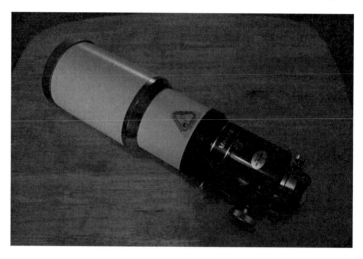

The 80 mm F/6 William Optics/TMB Megrez triplet Apo (Image courtesy: Lee Townend)

prefer the unobstructed view through the Megrez. Although the image is much larger in the Mak, the detail shown in the Megrez is just amazing. The Moon is razor-sharp with breathtaking contrast. Again the 'scope seems to punch well above its weight. I have been able to push the magnification well over 250×. I just love the Megrez. It has to be the most versatile 'scope I have used. It works on so many levels, and if I had to choose just one 'scope it would be this one. There is a vast array of 80 mm APO style 'scopes. Some are good and some not so good; as with most things, you pay for what you get. It's a shame that this 'scope is no longer produced because I believe it to be the best 80 mm scopes about. Color-free, contrasty, unobstructed wide-field views. What more could you ask for?"

William Optics currently markets an extensive range of air-spaced triplet Apos ranging in size from 98 mm (3.9-in.) to huge 158 mm (6.2-in.) models. All have very well designed fit and finish, with a nice powder-painted white CNC-machined aluminum tube, golden finish, retractable dew shield, anodized 360° rotatable focuser, and a dew shield cap engraved with the William Optics logo. Although it did offer some oil-spaced objectives in the past (the FLT 110 TEC, for example) the current line all have air-spaced triplet objectives with one element made with FPL-53 glass for excellent suppression of false color.

Stuart Ross, a keen amateur astronomer from Kirkintilloch, Scotland, let this author try out the jewel of his telescopic collection – the

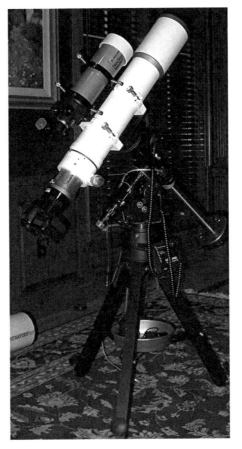

The William Optics FLT 110 (Image courtesy Kurt Friedrich)

William Optics FLT 132. Now it must be said that some folk have had some quality-control issues with this telescope, including sloppy focusers and pinched optics in colder weather caused by a non-temperature compensating lens cell. Others have reported under corrected optics. But I was quite impressed when I looked through it.

Although Stuart lives in light-polluted Glasgow, he enjoys packing up his refractors with a heavy duty equatorial mount and driving some 25 miles north into the Campsie Hills to observe and image the heavens. I arrived at the observing site to discover that Stuart was better attired for the occasion than I was but nonetheless delighted to see the 5.1-in. Apo pointing skyward atop a fully charged GoTo mount. Conditions were far from perfect, but good enough for me to get the measure of this impressive looking instrument.

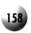

Here's his take on the mechanics of the instrument: "The William Optics 132 FLT is an air-spaced triplet objective designed by TMB, and the telescope can be fitted with an additional TMB designed field flattener for astro-imaging. At the other end is a 4-in. Crayford style focuser that is 360° rotatable and allows the framing of images. The 'scope comes in a sturdy aluminum case and is commonly bundled with a 2-in. quartz dielectric star diagonal but no finder. The focuser collar has mounting points for William Optics' own finder bases that are compatible with both optical and red dot finders. It would be nice if at least one of these was included within the package.

The scope has a nice white paint finish and the matte effect of the white finish along with the gold accents of the lens hood and dew cover make this a striking telescope to look at. It has a nice heavy feel to it when lifted from the case, and the build quality is impressive in this price range. The focuser is smooth and has a nice firm feel to it. With the TMB flattener and a digital SLR camera with added batteries there is still little need to use the focus lock screw. When the lock screw is applied, though, there is a small amount of focus shift, which can be quite frustrating. The rotation mechanism is a little light, too, controlled by a single lock screw. Once loosened the end of the focuser rotates quite freely.

There are numerous points of view on the focuser available on different forums, with some suggesting it is not up to the standard of the rest of the scope and others, like me, quite happy. As with a number of other William Optics 'scopes, the focuser has to racked out quite a bit before best focus is achieved. In fact, used without a diagonal, it is almost impossible to achieve focus without extension tubes. Again, it would be nice if these were supplied in the package or if the tube could just have been a little longer to remove the need altogether. All in all, I am very pleased with this 'scope for this price range. The focuser is probably the weakest point, but with a feathertouch replacement costing another 33% on top, I find it hard to justify for the minor improvement that may be achieved."

I began my testing of Ross's FLT 132 on Vega, riding high in the mid-autumn sky. Using an eyepiece delivering 300×, I examined the star for signs of any optical aberrations. As an F/7 triplet Apo, I was expecting good things from this 'scope, and it certainly delivered. The brilliant white star snapped to a sure and certain focus with a pure white Airy disc. I observed no color, save for the odd sparkle of red and blue during turbulent episodes. Racking the eyepiece inside and outside focus, I confirmed what many others have said about these 'scopes. They have great optics. There was no sign of significant spherical aberration, astigmatism, or coma. Stars at the very edge of the field had to re-focused ever so slightly. That's a sign of a modest amount of field curvature, but all

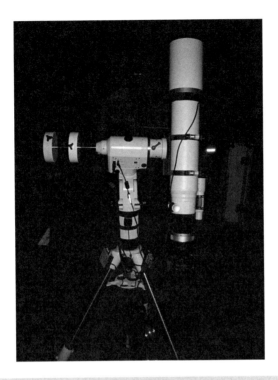

The William Optics FLT 132 triplet Apo (Image credit: Stuart Ross)

normal behavior for a triplet Apo without a field flattener. I also detected a trace of spherochromatism, as evidenced by the appearance of a small amount of color on the rim of out-of-focus star images.

Turning to the double double – Epsilon[1] and Epsilon[2] Lyrae – visible in the scope's color-matched 8×50 mm finder (an optional accessory), I was delighted to see that both stars revealed their companions cleanly at 150× despite deteriorating conditions. Ross then slewed the scope to Jupiter lying low in the southern sky and centered it in the field. The view at 75× was exquisite, despite fairly windy conditions, with five bands being clearly discerned. Increasing the power to 150× showed that we had reached the limits the turbulent atmosphere would allow. Color correction was superb, with only the merest trace of atmospheric refraction rearing its ugly head.

Still, Ross was forthcoming about a couple of things that niggled him about the FLT132. "Despite its stubbiness (over 30 in. when fully retracted), he said, "it's quite heavy – a hefty 20 pounds when kitted out with my William Optics 2-in. quartz diagonal and wide-angle eyepiece. There's a little play in the focuser, especially using heavy accessories.

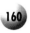

I could probably sort that out myself, but I kind of expected it to be a wee bit better given the caliber of 'scope that this is. Other than that I'm a happy man." It's clear why Stuart feels so pleased with himself and his William Optics triplet Apo. If properly cared for, it will provide him with exceptional views of the night sky and keep a diehard observer happy for a lifetime. Retailing at $4,199 for a package that only includes mounting rings and an aluminum carry case, it's still a good value considering that a 4.7-in. Takahashi TSA 120 will set you back about the same price. If this William Optics triplet scope is anything to go by, then there is nothing "entry level" about the apochromatic performance of this line of refractors. Choose the one that best suits your needs.

American All Stars: The Stellarvue Brigade

California-based company Stellarvue makes and sells a very nice range of triplet Apos from 3.2-in. (80 mm) up to 5.1-in. (130 mm) apertures, for visual observers and astrophotographers alike. Among them, the SV80S ($1,295 with carry case and mounting clamshell) is proving one of the most popular, with its FPL-53-containing triplet objective. With a focal length of 480 mm (F/6), owners report lovely, tack sharp, color-free images. Quality control on these telescopes is exceptional, with each sample tested in bench tests and under the stars before being dispatched to the customer.

The SV80S retails for over twice that of the company's 80 mm ED doublet, so does the extra expenditure translate into a commensurately improved image at the eyepiece? That's a tough one to call. Certainly, many owners seem to suggest that it is. They consistently report very well corrected optics that produce more faithfully rendered images devoid of the residual color error inherent in the short focal length ED doublet design. One thing's for sure, though – the SV80S will be a clear winner from an imaging perspective. The superior color correction and reduced field curvature will reveal tighter star images with less color halo than a doublet designed for visual use.

At the other end of the Stellarvue scale is the SVR 130 "Raptor", the company's flagship triplet Apo ($4,995). The first thing you'll notice about this 5-in. F/6 beauty is the carbon fiber tube housing its high-specification triplet optics. Company founder Vic Maris claims that the objective is "thermally equalized to handle low temperatures and changes

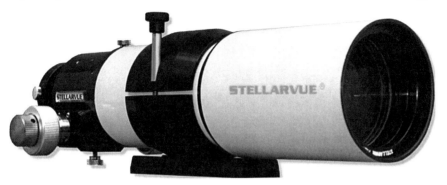

The Stellarvue 80 mm SV80S triplet Apo (Image credit: Altair Astro)

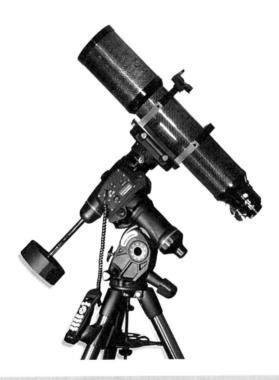

Stellarvue's flagship triplet Apo: the SVR 130 (Image credit: Altair Astro)

in conditions better than other 5-in. class refractors." That's about $800 more than a William Optics FLT 132, but then again it comes in a slightly shorter tube (the William Optics scope is F/7) and weighs considerably less, too. The Stellarvue raptor 130 has a fairly standard 3-in. focuser, though, while the William Optics FLT 132 has a heavier duty 4-in. focuser; an advantage if you plan to use weighty add-ons to your telescope.

Stellarvue could arguably be said to be one the most flexible of all the companies selling premium triplet Apos. A case in point is the SV90T F/7 triplet refractor. The basic package ($1,695) gets you a very nice 90 mm refractor using the FPL-53 as the central element and finished in a pearl white aluminum tube weighing just 8 pounds with an included clam-shell. Want the same optics in a lighter package? No problem. For an extra $300, Stellarvue will make you an SV90T with a carbon fiber tube that cuts the weight to just 4 pounds! Are you one to turn your nose up at synthetic FPL-53 glass? Stellarvue will empathize with you and recom-mend their deluxe SV90T complete with a pure calcium fluoride central element to wring that last drop of false color from the image. Now that's service!

APM Excellence

Equally versatile is Germany's APM with Markus Ludes at the helm, who continues to carry through the innovations instituted by Thomas M. Back before his untimely death in 2007, by producing some magnificent triplet Apos in the 3.2 in. (80 mm) to 20-in. (500 mm) aperture range and featuring optics made by LZOS of Russia. APM Apo refractors have a truly international flavor: air-spaced SD triplets from Russia, tubes made in Germany, and US made Feathertouch focusers from Starlight Instru-ments. Most of the APM triplets under 6 in. in aperture are also offered in a variety of configurations utilizing various tube materials and designs to best suit the idiosyncrasies of the individual. Larger apertures can also be provided in custom made folded tubes by Matthias Wirth. Ludes can rightly be said to be at the cutting edge of customer satisfaction, because he understands better than most the importance of tailoring the tele-scope to the individual. Imagers, for example, have different needs from visual observers.

Let's take a closer look at some of these offerings from Germanys' hot-test telescope maker. First, their tube designs feature so-called CNC II tubes for the entire line. These are considerably lighter than the earlier classic CNC. Other "standard" features that set this line apart include

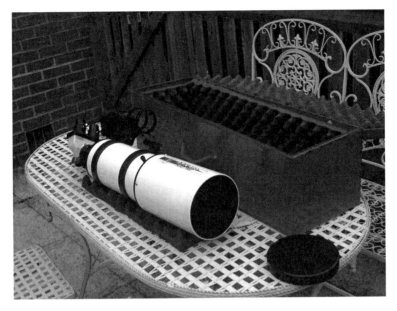

The APM/LZOS 105mm F/6.2 Triplet Apo (Image credit: Phil Gulvins)

the world famous Starlight Instruments Feathertouch 3.5-in. rotatable focuser to handle even the heaviest camera loads, along with CNC rings and an extension tube to accommodate a wide range of visual and imaging applications.

The LW series is more than capable of supporting lighter imaging gear but was designed with the visual observer in mind, too. Major features of the LW line include a sliding drawtube onto which a 2-in. Feathertouch focuser is mounted. The drawtube allows this line to keep weight and transport size to an absolute minimum while offering the added benefit of accommodating any quality bino-viewer without having to use an image amplifier. The LW series is clearly intended to offer the utmost in portability without sacrificing mechanics. The LW tubes allow for light-duty imaging and provide illumination up to around 24–26 mm (DSLR array sizes). Ludes also sells the so-called LW-P models, which are designed and built to meet the needs of the ever-growing number of imagers whose camera array sizes now go up to 35 mm. You'll need 2.5-in. field flattener (also supplied by APM) if you're to avoid vignetting with these arrays.

Phil Gulvins, an amateur astronomer from Tonbridge, England, took some time to describe his experiences with his APM refractor, a beautiful 4.1-in. (105 mm) F/6.2 triplet Apo. "When you first see the telescope it is

both shorter and stubbier than it looks in photographs," he says. "I was told by someone at Telescope House (a leading UK scope importer and dealer) that the same tube diameter is used for the 115 mm F/7 scope. The collapsed tube length is kept short by having a novel drawtube that can be extended as far as required. This means that in-focus can be effectively reduced for use with bino-viewers without any additional Barlow or adaptor needing to be installed in front of a diagonal. The tube is very well made, with a massive temperature-compensated lens cell for the triplet objective and an excellent Feathertouch two-speed focuser. The retractable dew-shield is felt lined. The lens coatings appear smooth, without blemish. The one aspect of the mechanicals that fails to impress is the quality of the tube rings which are, in my opinion, not of adequate quality to match the rest of the telescope. They are plain rings with no holes to attach other accessories.

"It looks from photos on the APM website that some of these telescopes are sold with better quality rings, but not this one. The one accessory I would attach to the rings would be a grab handle to make transferring the scope onto and off a mount a less anxious affair. Handling a slightly damp and slippery tube that currently retails for something over £3,000 ($4,120) does not make for a relaxed beginning or end to an observing session if the telescope/mount has to be assembled and disassembled each session. Having used a variety of focusers over the last eight or nine years the Starlight Crayford is the best I have come across, with those by TeleVue and Moonlite being very close in quality."

Phil then talked about the optics. "In use, I can't imagine a more perfect instrument of this size. Views are completely color free, in or out of focus, and the star test is excellent. It does have a slightly curved field of view, but if you keep the object you are observing in the center-to-75%-to-edge of field, then little or no refocusing is necessary. Stray light is very effectively suppressed by the baffling. The scope handles high magnification well, but I find that the quality of the "seeing" in the south of England usually limits magnification to a maximum of about 150×, which is just over 40× per inch of aperture. This is obviously considerably less than the maximum magnification a lens like this is capable of if observing conditions are better. I leave my telescope in a garden shed so that temperature equalization is as rapid as possible, but I still find that it's necessary to wait 30 min or so to begin observing and nearer an hour to obtain the best views."

Gulvin's optical report of the APM 105/650 is typical of the opinions canvassed from other amateur astronomers. In short, you can't go wrong with an APM. Choose the one that fits your wallet and your observing needs.

That completes this survey of the triplet Apo market. Though some of the less expensive models may have some minor optical and mechanical issues, the majority serve up superlative views of deep sky and Solar System objects and are fantastic instruments to think about if your interests cross over from visual into deep sky astro-imaging. The lower-end models provide color correction on par with the best ED doublets out there, but the better (read, more expensive) models outperform them in nearly all respects.

Triplet Apos may be exceptional performers when it comes to visual observing and astro-imaging with small CCD chips, but, was just mentioned, for ultra-wide field imaging they have one weakness – field curvature. Of course, many of the telescope manufacturers who sell premium triplets offer their own field flatteners, devices that can be mounted in front of the camera which flatten the field and reduce the focal length of the telescope so that shorter exposures can be made.

There is another way to have it all (well nearly anyway!), though. If you're not one for adding auxiliary optics onto your telescope, then why not consider an Apo model that has a field flattener built in? That's where four-element Apos come into their own – the subject of the next chapter.

CHAPTER ELEVEN

Four Element Apos

A well designed triplet Apo, as we have seen, closely approaches optical perfection. Images snap to a focus, have no false color, and have very little in the way of spherical aberration, astigmatism, and coma. Many triplets show traces of spherochromatism, as evidenced by some out-of-focus color, but not enough to seriously affect image quality. Only one Seidel aberration remains in triplets, and, in the scheme of things, it's rarely serious enough to dwell upon if you're a purely visual observer. We're talking, of course, about field curvature.

There are two ways of eliminating this effect. Either you can use an add-on field flattener or you can introduce another optical element into the design. In general, using a dedicated field flattener negates the telescope's use for visual applications. But there are telescopes – all four element designs – that can be enjoyed visually as well as photographically.

While Astro Physics and Takahashi were busy improving their triplet designs, Al Nagler of TeleVue Optics traveled an altogether different road. He set out to create the ultimate portable telescope with enough aperture to keep you going as a visual observer for years, while also delivering the finest flat field astrographs the hobby could yield. TeleVue was the first company to offer telescopes with flat fields to the amateur community. Their revolutionary Genesis refractor – a 4-in. F/5 instrument – was an innovative four-element modified Petzval design and was the first telescope to offer relatively color-free images and have a beautifully flat field.

N. English, *Choosing and Using a Refracting Telescope*, Patrick Moore's
Practical Astronomy Series, DOI 10.1007/978-1-4419-6403-8_11,
© Springer Science+Business Media, LLC 2011

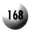

The original TeleVue F/5 Fluorite Genesis (Image by the author)

This author has owned and used an early 1990s Genesis refractor. It's a superbly designed instrument, with a heavy duty, powder-coated aluminum tube and a black retractable dew shield (earlier models had a white dew shield) with a beautifully machined threaded lens cap. At the other end you'll be greeted by a chromed rack and pinion focuser. Up front is a 4-in. crown and flint doublet, with a huge air space between the elements. Further back is a two-element, sub-aperture 'corrector' with one of the elements made from fluorite.

Daylight views deliver crisp, high-contrast images. There's a little color at moderate magnifications (75× and above), so it's definitely not an Apo by modern standards. But the quality high power views of planets and double stars it served up when pushed to magnifications of 150× or so were impressive. Prevailing wisdom attests that a 4-in. aperture ought to take 200× before the image breaks down, but when this scope was pushed to these higher powers the planetary images seemed a wee bit soft. Indeed, as already mentioned, the views of Jupiter through the Genesis and a 4-in. F/10 Tal 100R were quite comparable, but the longer focal-length Russian achromat was the easy winner in terms of sharpness, despite showing more chromatic aberration.

Still, the Genesis could do something the Tal simply couldn't. Stick in a 31 mm Nagler 'hand grenade' eyepiece, and you'll get a whopping 5° field at 16× with pinpoint stars right to the very edge of the field. That's a field area four times bigger than that presented by the Tal with the

same eyepiece! When compared the Genesis to a 4-in. F/9 ED 100, you will perceive a noticeable contrast difference between the instruments. Scrutinizing the Perseus Double Cluster riding high overhead one cold February evening, the ED doublet just seemed better in this respect. Perhaps the better optical coatings and fewer elements in the optical train of the doublet played their part to create such an effect.

Despite these deficiencies, the Genesis approximates the perfect all-around instrument; built to last several lifetimes and ready at a minute's notice to sail the starry archipelago on a simple alt-azimuth mount. The Genesis was a great success for Nagler, especially in the USA, where it has become a deserved modern classic. But Nagler didn't rest on his laurels. He refined the design by introducing improved, low-dispersion glasses into, first the front, then the rear elements, leading first to the Genesis SDF (F/5.4) in 1993, followed fast on its heels by the TeleVue 101 in 1996. Finally, in August 2001, TeleVue unveiled their flagship 4-incher, the venerable Nagler Petzval (NP) 101. Irish amateur astronomer Kevin Berwick was asked to share his experiences of a 1996 vintage TeleVue 101, which he uses as his 'workhorse' instrument on most clear nights.

"I ordered a TV101 telescope from Venturescope in England," he said "very soon after it was introduced by TeleVue as a replacement for the Genesis, and waited about 9 months for delivery. It arrived very well packaged in three boxes: one for the optical tube assembly, one for the tripod, and one for the Sky Tour computer. The 'scope comes in a very impressive molded carrying case that looks as if it's earthquake proof! The rest of the telescope arrived in heavy duty cardboard boxes, and all items had survived the transatlantic trip from New York to Ireland via Venture-scope in England. The documentation was excellent with all items on a checklist inside the boxes with the name of the person in TeleVue who had done the packaging written on the list. The instruction manual for the telescope itself had "Wishing you clear skies – Al Nagler" handwriting on it by Mr. TeleVue himself, a very nice touch in this age of laser printers and impersonal mass production.

The tube assembly is very well built and feels remarkably heavy, about 11 pounds, for its size. The dew shield is retractable, and, when fully retracted, allows you to attach a solid aluminum threaded cap over the optics. The focuser is also very well made, with rubber-coated wheels, presumably to improve grip, but it also keeps the wheels comfortably warm in the winter as well. It has a lock nut, which you have to use most of the time, even with quite light eyepieces. Otherwise, the focuser tube can run out when the telescope is pointed upwards. The focuser tube itself is chrome plated, which looks very nice but which can scratch. Personally, I'd have

preferred it to be aluminum for this reason, but maybe I'll have to start looking after my telescopes better!

The 'scope comes with a set of tube rings for attachment to a mount. A nice feature is that it is very easy to loosen the telescope within these rings for rebalancing the tube 'on the fly,' a very useful feature if you are using long focal length wide-angle eyepieces, such as the TeleVue Naglers. I had couple of gripes. The telescope has no handle. When you remove it from the mount the tube can be quite slippery with dew or ice, and it strikes me that it would be easy enough to drop it. I addressed this in two ways. Firstly by putting the telescope on my household insurance and secondly, by tying a guitar strap to the optical tube using Velcro straps. It's not pretty, but neither is a broken objective! It is possible that the cover could spin in the cell and strike the objective if you were clumsy either removing it or attaching it. This could be remedied by placing the threads on the dew cap and making the cover oversize, for example, but it would lengthen the telescope slightly. It may also adversely impact the aesthetics. The telescope comes with a very sturdy 2-in. Everbrite diagonal, which can accept the supplied 1.25-in. reducer for using smaller diameter eyepieces. I never use the telescope without it, as it makes observing far more comfortable on your neck. The images are exquisite, particularly at low power. You get great images 'tack sharp to the edge of the field' as the ad says. There is a slight bit of astigmatism at the edge of the field in the 32 mm Plossl eyepiece, but this is the eyepiece, not the telescope.

The tube is not baffled, and this surprises me. I know that other Apo manufacturers do put in baffles and plenty of them. Al Nagler has addressed queries on this and assures us that in this design it isn't a problem to see. I have to agree from using the telescope; there seems to be no problem with off-axis light to my eyes. I initially tested the TV101 with Epsilon Lyra. The telescope split this quadruple system beautifully with pitch-black space between the components even at low powers. Furthermore, the system splits easily even in very mediocre seeing. I've looked at this a few degrees above a roof of a house across the road with intermittent smoke wafting across the field and it stayed split. The Moon is a picture with the telescope, framed in a pitch-black sky. Deep sky objects are also surprisingly good, although I have to admit that I sometimes would like more aperture. But this is not a criticism; you can hardly criticize a 4-in. telescope for having a 4-in. lens!

One thing I'd say about the telescope – you must get a good Barlow, preferably the suggested 5× TeleVue Powermate for high power work .The focal length is very short, and what were once your finest high-power eyepieces for the Moon and planets will not deliver high magnification

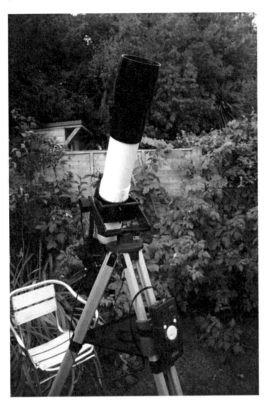

The Televue TV101 on a Gibraltar Mount with Argo Navis setting circles (Image credit: Kevin Berwick)

on the TV101. No finder is supplied, but you can invest in either the Starbeam or Qwikpoint by TeleVue if you want a zero power sight. I only need to point the telescope to a couple of bright stars during the alignment procedure for the computer and I can easily do this simply by looking along the tube. After that, I let the software take the strain! I won't be buying a finder for the telescope.

The Gibraltar mount is very solidly constructed from machined aluminum. It works very well, except near the zenith, where there's a small 'hole.' Presumably, if they had extended the arms further back to allow access to this region, the azimuth bearing would be too sticky due to the weight being so far off the center of the mount. It's surprising how often the object you want to look at is in this area, but it only takes a short wait to allow the object to drift into sight. It's really not a problem. The mount can be supplied factory-installed with encoders, allowing the use

of digital setting circles. The altitude encoder has a metal cover on it to prevent it from getting broken with a bump, but the azimuth one is not covered, which is an oversight in my opinion. I realize that it is far less likely to be damaged than the altitude bearing, but I still think it could do with a cover. It does look a bit fragile to me. The mount has brass screws to allow you to lock the altitude axis. I often have them at least partially screwed in just to stop the telescope shifting when I change from a heavy to a light eyepiece and I don't want to bother making the minor adjustment to the balance.

The tripod is made from ash and has a tray for eyepieces and your Sky Tour computer. The tray doesn't have any holes in it, which I like, as I find that if you have holes in the tray, pencils and other small items fall through. The Sky Tour is a compact calculator-sized unit. It has a red LED display and a dimmer to adjust the brightness. Using the unit is simplicity itself. All you do is align two marks on the mount and then do a fix on two stars. The procedure takes less than a minute. Now, you can choose an object on the system, and the unit will tell you where to push the telescope to in order to get the object in your eyepiece. It also has an Identify mode, which is useful on cloudy nights. It allows you to point the telescope to a hole in the clouds and the unit will suggest nearby objects you can look at and take you there if you wish. Before this telescope I had never used a computerized telescope before. I really love this system. I wish I had bought one years ago. I'd have spent more time observing and less time searching for objects. I can't praise it highly enough.

The Sky Tour unit does not offer the option of being driven via a PC and planetarium software, which some people may find a disadvantage. There is a free port on the unit, though, which may, in the future, allow the attachment of a PC – at the moment it's unused. Note also that the axes are not motorized; the system simply guides you to the desired target. It does not offer motorized slewing. However, this is, in my opinion, a good thing, as it keeps the weight and complexity of the system down and eliminates a potential source of failure.

To conclude I'll just say that this telescope really is a joy to use. It has superb optics, is quick and easy to set up, and, together with the Sky Tour, allows you to target objects effortlessly. I really am delighted with it, and it has increased my observing pleasure no end. To conclude, remember, a small telescope that you use often will show you more than large one which is left in a garage. If you're in the market for a small Apo, you won't go far wrong with the TV101 telescope."

There are some reports in the literature that seem to suggest that doublet Apos make better visual instruments than four-element Petzval Apos,

Nightfall (Image credit: Kevin Berwick)

the extra glass possibly contributing some slight loss of contrast in the image. Kevin was asked if he could provide his assessment on this matter, since he was also the proud owner of a lovely little Sky 90, a 3.6 in. F/5.6 fluorite doublet Apo.

"I did a side by side comparison of the two telescopes at 22:00UT on Saturday, September 12," he said. "It was a clear, slightly misty night, so the seeing was fairly good. First target was a faint star in the Double Cluster. I compared the view of this star using a 7 mm Nagler in both the TV101 and the Takahashi. To my eye it was definitely brighter in the TV101, as expected due to the extra aperture.

Using the same eyepiece in both telescopes, I compared the field flatness, again using the Double Cluster. The Sky 90 seemed to have stars at the edge a little softer than those in the center. In the TV101 they are sharp to the edge. If you move a bright star from the center to the field edge in the Sky 90 it gets softer and coma starts to appear. Doing the same experiment in the TV101, there is a small but noticeable improvement in field flatness, with the TV101 winning here.

Note, however, that stars in the center of the field appear to be a little more crisp in the Takahashi. I was using the same eyepiece in both telescopes, so the Sky 90 was operating at slightly lower power. Despite this, I still feel the Tak is crisper. I also did a side by side comparison on Jupiter, starting at 21:57pm UT. I put the two 4 mm Zoom Nagler in the Tak, and

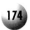

the 3 mm Radian in the TV101. There was a shadow transit of Io visible at the time. Looking at the planet using the Takahashi I could see the North Equatorial Belt, with a dark marking near the center. There was noticeably more detail in the TV101 in the cloud belts compared to the Tak 90. In addition, the image was brighter in the TV101 than in the Sky 90.

My final comparison object was Epsilon 1and Epsilon 2 Lyrae using the two 4 mm set at 3 mm. In the Sky 90 you can see nice diffraction rings at this high magnification. You can see clean black sky between both components in space. The diffraction rings are noticeably smaller in the TV101, so the star images are more natural in the TV101, but you still have nice black space between the components. In conclusion, the TV101 offers brighter, flatter images, while the Sky 90 has a shade more contrast. Both are lovely telescopes.

The objective lens of the newer NP101 is an SD air-spaced doublet design, where two lenses (crown and flint) are matched to work as one. The positive element is of a fluorocrown substitute with special dispersion glass. A matched doublet lens group at the rear compensates for some design characteristics of the objective lens. The system provides a flat field, wide-angle capability. Spherical correction is very good also, with the air space of the objective contributing to this correction. Images of the stars and the planets are presented in their natural colors; daytime objects viewed at commonly used magnifications will appear quite three dimensional, sharp, and contrasting.

The NP 101's eight air to glass surfaces have a multilayer antireflection coatings that improves overall light transmission across the entire visual spectrum (400–700 nm). If that weren't enough, the antireflection coatings used on the NP101 are in fact engineered to match the characteristics of each glass type and curve radii. This process virtually eliminates ghost images and flare and improves color rendition. All of this achieves a dramatic increase in image contrast and actual light transmission, with a corresponding reduction in flare that might otherwise originate by internal reflections. On most nights, the settling down time for the optics is on the order of 30 min.

In the last few years, TeleVue has offered all their scopes, with the exception of the TV 85, in an alternative, photographic form – the IS series.

So what's different about the NP101is and the NP101? Well, the former has a larger rear lens groups to further minimize vignetting in formats up to 50 mm. For these large chips, an optional field corrector was developed so the corners of the image are flat and undistorted. In order to take full advantage of the larger lenses, a non-vignetting focuser was developed to prevent any restriction of the larger converging light cone. The draw tube

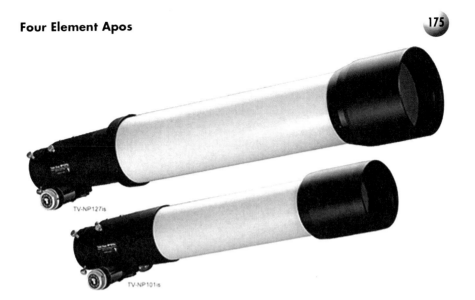

Two from TeleVue: The NP 101is and larger sibling, the NP 127is (Image credit: Venturescope)

has a 3-in. front aperture and 2.4 rear aperture. This new draw tube also permits a quick change from visual to imaging operation and allows full camera rotation without focus change. In addition, it has the capability to correct for any residual focal plane tilt and accepts a "position stop" for the company's digital micrometer, to allow repeatable focus measurement to an accuracy of 0.0001 in. What's more, to maintain alignment to the optical axis while changing camera orientation, the draw tube on the both the NP101is and NP127is have four lock screws that tighten against a taper on the "imaging insert" ring. This insert is threaded to accept TeleVue's new Imaging System accessories, including large diameter extension tubes, optical accessories, and camera and CCD attachments."

Jim Roberts, an amateur from Redlands, California, gave his opinion on the visual performance of the NP127. "I've had my NP127 for about five years," he said, "and use it often for planetary observing. I've compared it side by side to a number of other refractors, including several 130s of excellent quality and reputation. My take is that while the NP127 is a superb 'general purpose' telescope with absolutely perfect color correction – which is just how TeleVue describes it – it may not be the *very* best for visual planetary work among all 5″ scopes. At F/5.2, reaching a crisp/critical focus at higher magnifications is relatively harder than its slower brethren. I also detect just a bit of softness in the NP127 relative to some other high-end 5 inchers (although I think most observers would probably miss this unless they regularly use one).

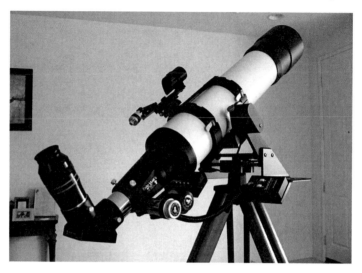

The NP 127 (Image credit: Jim Roberts)

"If visual planetary observing is your sole consideration, I would have to say there are better alternatives out there. As others have said, a slower F-ratio is probably going to be much more to your liking. There's a good choice of excellent 5-in. refractors available that would probably be better candidates than the TeleVue offering. A few will be more expensive, many about the same or less expensive. That said, I wouldn't sell my 'scope for any price because it meets all of my needs – some perfectly, others only extremely well. Portability (out the door in 41 lbs., alt-az), rich-field excellence, support/service, and robust build/design were my main considerations."

More from Takahashi

Takahashi doesn't only produce state-of-the-art triplet Apos. It also manufactures a range of super quality four-element Apos based around a modified Petzval design in their FSQ series. The smallest FSQ is a 3.3-in. (85 mm) F/5.3 instrument, followed by the FSQ 106, a 4.1-in. F/5 refractor in two formats – the standard FSQ, which has two doublet fluorite elements for excellent color correction, and the new Q, which is a mechanically upgraded version of the older FSQ. The new "Q," as it is called, has a heavier duty focuser (which has a load capacity of up to 5 kg) than its older counterpart to accommodate even the heftiest of CCD cameras and other photographic accessories. Where they differ is the type of glass employed.

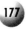

Takahashi decided to use more durable ED glass instead of fluorite in the new FSQ.

US amateur Bill Drelling has used the Takahashi FSQ 106 extensively over the last few years and gave us his take on the instrument:

"I tested the optics with a few setups, he said. "I started with a straight through look using a 26 mm Orion eyepiece, then moved to the Televue 2" Apo 2× Powermate with the same 26 mm eyepiece and an Orion 1-1/4" diagonal, then used the Powermate with a Televue 7 mm Type 6 eyepiece and the diagonal. With each optical train I centered Betelgeuse and then ran it around the field of view to check for flatness. The star remained the same shape everywhere in the field of view. I tried it while wearing my glasses (they correct for my astigmatism) and without the glasses. In all instances, the star did not distort from its original starting focus point at the center of the field of view. Of course, without my glasses, the star was slightly distorted by my astigmatism, but even then, the distortion did not change as I moved the star around in the field. With my glasses on, the star came to sharp, crisp focus and stayed that way no matter where I placed it."

What about color correction?

"Color correction on the scope was flawless, Drelling insisted." This was true even at high power. I wanted first light to be under the full Moon to specifically test this aspect of the 'scope. Looking at a full Moon makes things about as bad as they can get for inducing chromatic aberration. The color correction test was conducted by pointing the FSQ at the full Moon using the same setups as above. There was no chromatic aberration in the images that I can attribute to the FSQ

How did Bill rate the FSQ 106 as an astrograph?

"In a word, superbly."

Some of Bill's images can be seen in Chap. 15 and show the extraordinary detail this little instrument can deliver in the hands of a skilled CCD imager.

"The FSQ 106 does have one shortcoming. It's very heavy. The optical tube assembly alone weighs 14 pounds. Were you to use this instrument on an equatorial platform, even just for visual use, you'd have to invest in at least a mid-range mount that would allow better balancing in declination."

Pearls from Pentax

Though now sadly discontinued, Pentax (now absorbed by Hoya Corporation) produced some excellent four-element Apos for visual and photographic use. These are still available for sale from some retailers while stocks last. First in line are the Pentax SDP duo, modified Petzvals

The superlative Pentax 105 SDP (Image credit: Pollux Chung)

with a focal ratios of the order of F/6. Both instruments – the 4.1-in. 105SDP and the 5-in. 125SDP – are extremely versatile, enabling you to observe and photograph the Moon and the planets and deep sky objects with extraordinary detail and contrast. The color correction is excellent, even at very high magnifications, and nearly no false color can be seen. The excellent visual and photographic performance of both SDP telescopes is attributed to their special four lens design. The front lenses from both doublets are made of SD glass lovingly marinated in the famous Pentax SMC multi-layer coating.

Optics aside, the Pentax SDP telescopes have one weird-looking helical focuser that tapers out like a termite mound from the end of the optical tube. With a free diameter of 90 mm, it allows full illumination for the largest amateur CCD cameras. A large and ergonomic grip allows comfortable and precise focusing. Indeed the precision with which it can focus is very impressive, engraved as it is with a scale that allows alterations of 0.01 mm or better.

Pollux Chung, a Canadian amateur astronomer from White Rock, British Columbia, is a long time fan of all things Pentax. Here's his take on the Pentax 105 SDP: "The 'scope is very well made and heavy," he says, "about 14 pounds just for the tube itself. I managed to get the 'scope reaching 20 pounds using the usual visual accessories and dovetail mount. The scope is painted in metallic pearl color with a glossy overcoating. One thing that surprised me is that the dew shield of this 'scope is not retractable. However, this 'scope is still short – only a bit longer than a Takahashi TSA102 (with its dew shield retracted). The Pentax logo on the dew shield is painted on, unlike other brands, which use stickers. I really love the quality of this telescope's baffling and blackening, which, in my opinion, is very well done, ensuring it is perfectly dark and free of reflections. The fantastic coatings render the glass almost invisible when looking at the objective lens from the front. With a telescope built to this high level I was expecting the contrast to be very high."

Sweet outer appearances are all well and good, but how did he rate the optics?

"This scope, I have to tell you, doesn't know what false color is!" In general, good ED doublet refractors show no false color in focus but will show red or blue when out of focus. Perhaps, because this Pentax is not a simple doublet design it shows amazing color correction. You will never see false color whether you are in or out of focus. To my eyes, it is just as 'color-free' as a reflector. Not only that, image sharpness and detail are still amazing even at insanely high powers.

"Due to the completely sealed design this scope does take a noticeably longer time to cool down or warm up compared to other doublet refractors I have used. In extreme conditions (such as 15–20°C of difference in temperature) it can take almost 45 min to reach thermal equilibrium. The Moon is pretty much what you would expect from an Apo, namely sharp, contrasty images, black shadows, and zero false color even at high power. I am not too crazy about looking at Luna though, so I moved on to the next target. Saturn was still visible in May and June (though close to the horizon). Under medium and high powers, the image was very 3-D. The planet displayed a distinct yellow with darker belts highly visible (I saw three or four belts). The rings showed a contrasting white. Even with the ring's narrow opening, I still managed to see the Cassini Division clearly, although it took a little effort. Jupiter was absolutely breathtaking. I did a side-by-side comparison between the 105SDP and various popular Apos (doublets, triplets) from Japan and China. I looked through the 'other Apos' first. Jupiter looked great. Sharp, contrasty, and no obvious false color. The planet showed as a bright (slightly off-white) disc with medium-brown color belts. Then I moved to the 105SDP. I was shocked! The planet showed as a pure white disc with dark brown belts. The image was so sharp and contrasty that I could see the texture of the belts right away, even at medium power! Then I cranked up the power and the planet stayed sharp, contrasty, with zero false color."

That said, Pollux is under no illusion about the limitations of this telescope.

"Faint objects won't be visually spectacular, but brighter clusters aren't bad at all. Since the 'scope has a very short focal length, there really is no need to use a 2-in. eyepiece and diagonal. Of course, I could still use them, but they would make the 'scope needlessly heavy. The Perseus Double Cluster was absolutely unforgettable! The background sky is absolutely black. Stars are all pinpoint across the entire field of view. On M13, I managed to "resolve" the faint core of M13 despite the 'scope's limited aperture. Some other brighter nebulae were spotted without much difficulty due to the 'scope's high contrast view."

One of the "fastest" refractors on the planet: the F/4 Pentax 100 SDUFII (Image credit: OPT)

The latest Pentax scope to be made has been described as very unique, very fast, and very pretty. Called the 100 SDUF II, this is pushing optics to the extreme. Like the SDP series, the heart of the SDUF II refractor is a four-element Petzval design. The Pentax 100 SDUF II is an ultra fast (F/4) flat-field Apo refractor that is fastidiously designed for wide-field imaging with large format CCD cameras. It features a four lens/two group design with an integrated corrector that offers excellent image quality over the entire field of view and very good (but not great) color correction for such a fast instrument. Its precision helical focuser has a useful scale reference. The SDUF II's focuser has an 83 mm clear aperture, which easily covers a large 6×4.5 film or CCD format. As you might expect from its ultra short focal ratio design, the SDUFII is only 19 in. long and weighs in at only 8.8 pounds (4 kg). That makes it the most portable 4-in. astrograph on the market! But what's it like to look through?

Here is the opinion of Nathan Brandt from Pittsburgh, Pennsylvania, who has owned and used the SDUFII: "Over the few years that I had it, I've only looked through it a couple of times and only once at high magnification," he said. That's easy to understand, since this was obviously designed with astrophotography in mind.

"At low powers," Brandt continued, " it was very nice, but at high magnification Jupiter only showed one blurry band, and the focus was so touchy that false color was always ready to jump out at you should

your focus be off a few microns. For visual, I think you could do much better for the money. It's certainly a photographic instrument first and foremost. It's a dandy of a scope in many ways, though."

What are we to make of Brandt's report? Well, the telescope's very shallow depth of focus makes focussing accurately fairly difficult. And a slightly defocused image gets moved around by the seeing more. I'm glad he admitted it's better served as a photographic lens than a visual telescope!

About the time of this interview, Vixen North America launched their latest 4-in. refractor, the all new AX103S, F/8.0 refractor ($2,999), featuring an innovative four-element objective lens, incorporating a triplet front cell with a central ED lens. This reduces chromatic aberration and yields high contrast images like any other triplet Apo. But it also has a single rear corrector lens, which helps to flatten the field and delivers sharp images to the edges of the field of view. The Vixen website states that the AX103S has a "precision multi-coating" applied to the lenses, which presumably assures high light transmission. The AX103S has a nice dual speed focuser that enables coarse and fine focus adjustments. Manufactured in Japan, this medium focal length (800 mm) is unique among the four-element telescopes in that it is clearly intended primarily as a visual instrument, but it should also be an excellent imaging platform for smaller deep sky objects, too.

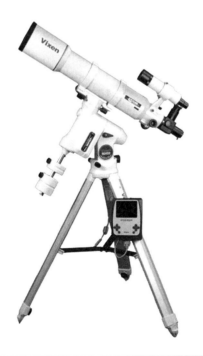

The Vixen AX 103S four-element Apo atop a Sphynx Go-To mount

As was said in the opening of this chapter, four-element Apos provide what many amateurs believe to be the ultimate multi-purpose instruments for visual and photographic work (see Chap. 15 for more on imaging). The multiple elements allow very short focal lengths to be achieved while still maintaining good to excellent correction for chromatic and Seidel aberrations. Their only real caveats are twofold – they are very expensive, and their short focal ratios deliver a very shallow depth of focus, making precise focusing difficult.

Finally, I'd like to briefly mention a new Apo from the Russian instrument makers, Tal. The new F/7.5 125R Apolar APO refractor features a premium quality Russian-made optic using two types of optical glass comprising 6 elements in 3 groups. It offers color free images with a flat field to boot! Bizarrely, this novel refractor does not make use of low dispersion glasses like all the other types of the market, but it appears to employ so called 'thin flints' similar to those used by Roland Christen back in the days where he was producing long focus Apos. In other ways though, it is quite remarkable. For instance, the 5-in. objective consists of a single (yes, single) crown element and much of the color correcting magic occurs further back. In this capacity, it is more like the dialyte refractors built by inventors like John Wall and Peter Wise in the U.K. Though it has not been reviewed by the any of the major magazines, many Russian owners report great performance from this complex refractor (U.K. price £1490).

Having looked at all the main players in the refractor market, classic and contemporary, we're now ready to discuss how to get the best out of your refractor in the field, and that's the subject matter of part 3 of this book.

Using Your
Refractor

Refractor Kit

Buying a refracting telescope is one thing, but kitting it out with the right equipment is quite another. This chapter is dedicated to discussing some of the most important accessories you'll need to get the most out of your instrument. Because of the huge range of accessories now available, we have had to be very selective in the items covered. Those wishing to dig deeper might want to check out some of the reference texts cited at the back of this book.

So, where to start? Eyepieces, of course! Eyepieces are the smallest accessories that come with your new telescope, and so a beginner might think that they're the least significant components. Yet any experienced observer will tell you that these diminutive devices play just as critical a role as your main optics in determining instrument performance. Advances in optical technology have led to the manufacture of high-quality eyepieces, the likes of which our Victorian ancestors could only have dreamed of. But what characteristics does a good set of eyepieces possess?

To start with, it's not necessary to have a dozen eyepieces in order to squeeze the very best performance out of your telescope. Indeed, just three carefully selected ones are usually all that's required. Choosing the right eyepiece depends as much on the nature of the object you're looking at it does on your the local "seeing" conditions.

In general, an eyepiece delivering a "low" power of about 5–10× per inch of aperture is usually best for making broad sweeps across the night

N. English, *Choosing and Using a Refracting Telescope*, Patrick Moore's
Practical Astronomy Series, DOI 10.1007/978-1-4419-6403-8_12,
© Springer Science+Business Media, LLC 2011

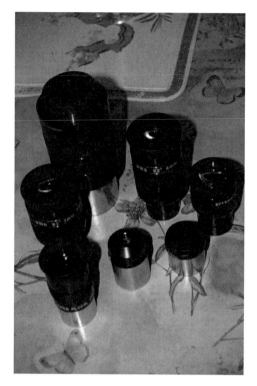

Essential kit: a good selection of eyepieces (Image by the author)

sky and for seeking out brighter deep sky objects and comets. For zooming in on objects such as galaxies or nebulae with low surface brightness, an eyepiece delivering a magnification of between 15 and 20× per inch of aperture provides comfortable, "medium" power views. Increasing the magnification increases the apparent contrast of the object under scrutiny by making the background sky appear darker. At these moderate powers, stars invisible at lower powers suddenly "pop" in your telescope.

For planets and small planetary nebulae, high magnifications are often necessary. For this purpose, a "high" magnification of the order of 40–50× per inch of aperture can be pressed into service. These powers are also most useful for splitting close double stars. In general, seasoned observers use the lowest magnification that enables them to see all of the details an image can yield. Amplifying the image beyond this point will only result in a larger image scale with little or no improvement in detail. That's certainly true in general, but for resolving very close double

stars even higher powers can be pressed into service with useful results. Certainly 75× or even 100× per inch of aperture (if your optics can take it) on smaller instruments is indispensible when conditions permit, to divine the secrets of doubles at or just below the Dawes limit for your scope. There will be more on this in the final chapter.

At the other end of the magnification scale, it is certainly true a telescope has a low-power limit. This is because an eyepiece's field of view is limited by the diameter of the light shaft that exits an eyepiece – the so-called exit pupil. If this light shaft exceeds about 7 mm – the size of a fully dilated pupil in younger people – then your eye will simply not be able to make use of all the light collected by the telescope. As a general rule of thumb, the longest focal length eyepieces your scope can usefully employ is found by multiplying the focal ratio of your 'scope by 7. Thus, in a short tube 80 mm F/5 refractor, avoid using an eyepiece with a focal length longer than about 35 mm (5×7). As you age, the muscles controlling pupil dilation and contraction get less agile, with the result that even smaller exit pupils are the norm, requiring still shorter focal length eyepieces. Exit pupils larger than 7 can be employed to get even larger fields of view, but some light loss will occur.

Wide-Angle Fever

Low magnifications always deliver wider fields of view, but just how much sky your eyepiece images also depends on its apparent field of view. A simple, empirical formula to use when calculating your actual field of view in angular degrees is to divide the eyepiece's apparent field by its magnification. You'll find a more accurate formula in Appendix 3 of this book. Thus, a 25-mm Plossl, with an apparent 50° field, yields a magnification of 40× with a 4-in. (102 mm)/F10 refractor, and so provides an actual field of view in the telescope of 50/40 = 1.25°. In contrast, a 25-mm ultra-wide-angle eyepiece, with an 82° field, gives you a substantial 2.1° at the same magnification. On paper, that doesn't sound like much of a field gain. But a studied look through both eyepieces will convince you that the latter takes in an area of sky nearly three times bigger than the former! Wide-angle eyepieces are popular in long and medium focal lengths. The former are used to obtain the widest true field the telescope can offer for low magnification sweeps, while the latter have proven very effective when observing more extended deep sky objects at moderate powers.

Today's eyepieces vary enormously in the apparent fields of view they serve up. Simple, traditional lunar and planetary eyepieces, such as orthoscopics and monocentrics, have very narrow apparent fields typically only

40° wide, while complex, multi-element eyepieces can give you apparent fields of 70, 80, or even 100°. Undoubtedly, eyepieces with even larger apparent fields will soon make their debut. Until fairly recently, only a few manufacturers, especially TeleVue, Meade, and Pentax were selling expensive, wide-angle eyepieces, but in recent years a torrent of new products from other companies, particularly Sky-Watcher, Celestron, William Optics, and Orion USA have flooded the market with attractively-priced models that boast Nagler-sized (60–82°) fields of view. One company, Explore Scientific, has even produced medium focal length eyepieces (14 and 20 mm) with a field of view of 100°, rivaling that of the market leader, the TeleVue Ethos.

There's a lot of debate online concerning the relative merits of using eyepieces that deliver different apparent fields of view. A 100° field might leave you mesmerized, but others will find it unnerving. To see a fully illuminated 82 or 100° field your eye has to do a lot of moving around to take in all the information your telescope is delivering. That's why some amateurs prefer smaller fields, typically 65 or 70°. High-power, wide-angle eyepieces are especially useful if you observe using a non-tracking mount, the extra field of view making it possible to view the object for a longer period of time. Try using them with a 4-in. F/15 refractor when observing double stars.

Do the newcomers live up to the views offered by the premium models? Yes and no, is the short answer. If you have a telescope with a long focal length, you can certainly get away with using less expensive eyepieces. The larger your scope's focal ratio is, the more forgiving they will be. Here's a case in point: a given eyepiece might deliver pinpoint stars across the entire field of view in an F/10 instrument, the same eyepiece will show significant field curvature and astigmatism in an F/6 scope. This means, sadly, that if you've got an expensive short focal ratio Apo refractor, you'll almost certainly want expensive eyepieces to correct it. And you really get what you pay for. That said, the finest (and most expensive) wide-angle eyepieces allow you to have your cake and eat it, so to speak, with expansive fields of view and tack-sharp star images all the way to the edge!

What's Your Comfort Zone?

Doubtless, a fair number of novice observers turn their back on the hobby because they're not comfortable at the eyepiece. Some eyepieces really are a pain to look through. If you have to plunk your eyeball right up to the lens to see the entire field, then your eyepiece suffers from low eye relief. Specifically, this measures how close your eye has to be the eye lens of your eyepiece to take in the entire field of view in comfort. If you

wear glasses while star gazing, you're going to need at least 20 mm and maybe even a tad more eye relief. Anything beyond 10 mm is usable in the shorter focal length range. Most eyepiece manufacturers market so-called long eye relief (LER) models to make viewing as comfortable as possible. As a general rule, within a given eyepiece range, the shorter focal length models have less eye relief than their longer focal length counterparts.

Having an eyepiece with great eye relief and a whopping wide-angle view sounds great, but for some, less is more. For example, many diehard lunar, planetary, and double star observers prefer to use simpler eyepiece designs that date to the nineteenth century. Orthoscopics, monocentrics, and traditional Plossls, in particular, have only a few glass elements (and a minimum of air-to-glass surfaces) compared with the more complex 7+ elements found on more modern designs. Some purists argue the former offer significantly higher contrast views, with reduced glare and light scatter compared with their super-duper ultra wide-angle eyepieces. Although there may be a grain of truth to this argument, it is unclear how significant it is in the grand scheme of things. Certainly, the finest ultra-wide angle eyepieces deliver comparable views to the traditional oculars, with the nod perhaps going to the latter.

To Zoom or Not to Zoom?

Why buy three or four eyepieces when you can purchase a zoom model that can do the same? There's no denying, zooms have their appeal. If you don't like switching eyepieces in the field, a zoom eyepiece is probably in your future. Up to fairly recently, zooms have been a hard sell with amateur astronomers because of their so-so performance. For one thing, they had fairly restricted fields of view, often as low as 40° at the lowest power setting, as well as requiring the need to re-focus at each magnification setting. In recent years, however, some new zooms have come on the market that deliver much better performance to the older zooms marketed by Vixen, TeleVue, Orion, and Meade. The Baader 8–24 Hyperion zoom has got high marks from many happy users, either in its spotting telescopes or in astronomical applications. Its excellent broadband multicoatings deliver images that are especially high in light throughput and contrast. It also delivers a very comfortable 15–12 mm of eye relief as you zoom. The William Optics 7–22.5 mm and Sky-Watcher /Orion premium (7.5–22.5 mm) zooms are also good performers in this category. Pentax also produces two nice zooms (the 7.5–19.5-mm XF and more expensive 8–24-mm XW), but some users have found the XF to have too much lateral color.

Want a cool, high-power zoom eyepiece that deliveries the goods? If you have a small ultra-portable refractor and want to extract the very last drop of high-magnification performance from it in a zoom setting then you should give the TeleVue 2–4 and 3–6 mm "click stop" Nagler zooms a closer look. They have a five-element design (similar to that of a good Plossl), generous 10-mm eye relief, and a constant 50° field, while zooming through the lowest to highest power settings. Both models work with the precision of a Swiss timepiece. Both are very sharp and well corrected eyepieces for lunar, planetary, and double star work.

Because the market has so many competitors, there's bound to be a level of subjectivity when it comes to finally deciding which eyepiece set is right for you. Of course, you really can spend years trying them all only to find that you end up re-buying a model you let slip through your fingers. Even expensive eyepieces can be had for modest sums if purchased on the used market. If at all possible, try before you buy, but if not, good quality oculars can be re-sold for reasonable prices, so you can always get some money back from your investment.

The Barlow Lens

There is yet another tried and trusted way of achieving high powers with your favorite eyepieces. Why not use a Barlow lens? This simple device has been around for quite some time now. The English mathematician and engineer Peter Barlow (1776–1862) hit on the idea of introducing a concave achromatic lens to artificially increase the effective focal length of any telescope by a factor of two or three times. Collaborating with George Dollond, the first one was made in 1833.

Barlow lenses have had a love-hate relationship with amateur astronomers over the years. The ones that came with cheap, department store telescopes did much to hide their real potential as power boosters for many decades. That was no doubt because of their poor optical and mechanical quality. Advances in technology, however, has made owning a quality Barlow lens a truly worthwhile investment, especially considering its modest price.

Not only will a good Barlow lens double or triple the power of your eyepiece, it will reduce any aberrations inherent to the eyepiece by creating a gentler sloping light cone that is more faithfully reconstructed by the eyepiece-eye combination. It will also flatten the field, helping to reduce edge of field distortions in short focal length refractors. So-so quality eyepieces will perform noticeably better when used with a high-quality Barlow lens, especially when the object is placed at the edge of the field.

Barlows come in two flavors – achromatic doublets and so-called apochromatic, or ED, triplet Barlows. You might think that having the name ED or Apo in the title implies better performance. However, extensive tests on a number of Barlows can be summarized as follows: Well made two-element achromatic Barlows (2 and 3×) consistently outperform the shorter, "cuter" Apo Barlows when it comes to overall image quality and light throughput.

That's not to say that your cherished Celstron Ultima or Klee (two highly respected "shorty" Barlows) is not a very good performer. It's just that a three-element ED Barlow is overkill from an optical point of view. All Barlow lenses increase (to a greater or lesser degree) the eye relief of eyepieces used with it. Viewing through a 6-mm Plossl, for example, without a Barlow, is tricky but becomes fairly easy when used in conjunction with one. A shorter, triplet Barlow will look less conspicuous on your telescope, but it will almost certainly increase the eye relief more than a traditional doublet Barlow. That might not be a problem for short focal length eyepieces, which have fairly modest eye relief to start with, but it may introduce uncomfortably long eye relief if you intend using it with low-power, longer focal length eyepieces. Both TeleVue and Astro Physics make some of the best. The Zeiss 2× Barlow is even better, but it'll cost you more ($495).

Although good Barlows work really well, they have one annoying drawback, especially when used with an eyepiece with just the right amount of eye relief. Using a Barlow forces the observer to place his/her eye into a new configuration, which may or may not help. In particular, Barlows work great with traditional high-power eyepieces such as orthoscopics and Plossls, which have little eye relief to start with. But when used with eyepieces that already have generous (>15 mm) eye relief they can extend it too much. What you'd ideally want in that situation is an amplifier that preserves the native eye relief of your eyepiece while still giving you the power boost you need.

Enter the Power Mate, an ingenious design introduced by TeleVue nearly a decade ago. Like an ordinary Barlow, it has a doublet tele-negative element but with the addition of a tele-positive element (also a doublet) that essentially reconfigures the light path so that it matches the eye relief of the original eyepiece. They really add nothing but raw magnification to your optical system and are an excellent way to achieve high power in fast refractors (short focal ratio). Meade also produces a very similar line of image amplifiers to the Power Mates. Called Telextenders, these come in 2, 3, and 5× (all in 1.25-in. format) as well as 2-in. 2× version.

The main astronomy forums are constantly abuzz with arguments about the pros and cons of Barlow lenses, with some innocently posed questions

quickly escalating into highly technical and heated debates. There is likely one main reason why lots of amateurs shy away from Barlows. They stick out a mile from the focuser, creating, at least in the minds of some folk, an aesthetically displeasing disposition. Diehard observers who doggedly refuse to use a Barlow would do well to remember that most high-power eyepieces with short focal lengths already have a Barlow built in! How else do you think modern eyepieces can easily achieve ridiculously short focal lengths (2–4 mm) while still maintaining comfortable eye relief?

Finally, I'd like to set the record straight concerning what Barlow lenses can and cannot do. While it can certainly replicate some of the benefits of long focal length instruments, it does not 'reconstruct' all the attributes of a long, native focal length. A common misconception is that Barlow lenses increase the telescope's depth of focus. Used in the way it is intended to be in normal use, it does not. However, if the Barlow lens is mounted in the optical train ahead of the focuser in such a way that the it does not move with respect to the objective lens, then it will increase a telescope's focus depth.

Colorful Controversy

What, beyond eyepieces, might enhance your visual explorations of the heavens? For many amateur astronomers, the answer is a set of astronomical filters to cover all eventualities, whether it's lunar and planetary work, or filters designed to enhance your views of faint deep sky objects. Maybe you've got a good achromatic refractor that works well at low power but provides overly colorful (specifically purple!) views at higher magnifications that reduces contrast and resolution? Could a filter help? To find out, read on.

First of all, let's start with the admission that many observers have never seen the need for filters. All such devices, they would argue, cut down on the amount of light transmitted to the eye. Since light-gathering power is at a premium for most backyard observers equipped with modest telescopes, why waste funds by using a filter? Moreover, from a purely aesthetic perspective, the strong color shift filters rendered at the eyepiece are, they claim, garishly displeasing. That said, there's another school of thought; a well designed filter can potentially greatly enhance the human eye's perception of small details on both Solar System as well as deep sky objects. After personally starting out as filter skeptics, some people have become convinced that their judicious use in many (but not all) circumstances can greatly enhance an observing session.

Let's begin with standard color filters. Adapted from photographic circles for over a century, these come in every color under the rainbow and are based on the Wratten color scheme adopted by Kodak in 1909. For

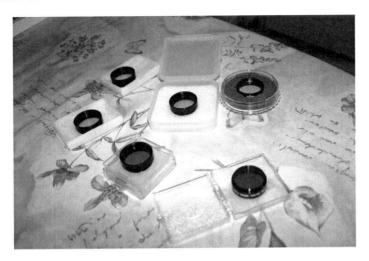

A nice selection of color filters should be in everyone's collection (Image by the author)

small telescopes – under 4 in. (10 cm) – it's best to stick with filters with a relatively high light throughput, such as the W8 (light yellow), W58 (green), and W82a (light blue), which can help to bring out subtle details on the Moon and bright planets by exaggerating differences in brightness. What's more, they really help find the focus "sweet spot" in short focal ratio achromatic refractors. With larger instruments, you can, of course, enjoy the full panoply of Wratten filters to help you tease out the finest images your telescope is capable of producing.

There is one other use of ordinary color filters worth mentioning. Some experienced observers have noted that a red filter can help steady otherwise turbulent images of the Moon and planets at low altitudes in the sky. The phenomenon is known as Rayleigh scattering – the bit of physics that makes the sky blue. The molecules making up the ocean of air above us scatter shorter (bluer) wavelengths more than longer (redder) ones, with the result that red light images are a good deal steadier. You can use this trick while observing Jupiter and Mars (and the inferior planets, too!) when they're less than 25° above the horizon.

High-Tech Wratten

Older filters make use of special dyes to color the glass, but in recent years a whole host of exciting new filters have become available that employ specialized coatings polished onto glass substrates. These so-called

"interference" filters block certain wavelengths of light and pass others in ways regular color filters can't. On short tube achromatic refractors and reflectors they claim to boost contrast and suppress sky glow, but they also dim objects considerably and are probably best suited to instruments in the 6–10-in. (15–25 cm) aperture range. There are many reports of these filters working as great "Moon-glow" filters, a tool for enhancing lunar detail in larger scopes. By reducing glare and increasing contrast, these filters are really excellent at keeping the overwhelming brightness of a gibbous and full Moon at bay. Because of their highly polished, flat surfaces they can also be used at higher magnifications than their low-tech counterparts, and can even be stacked together to create super-filters that combine the properties of the individual filters. Astonishingly, some optical companies now produce dedicated filters in this genre that are tailor-made for specific planets, such as Televue's Mars filter or Baader's Venus filter.

Long-time refractor fans have found a simple, light yellow (W8) filter to be a very versatile filter indeed, especially in helping to suppress the annoying violet fringes seen under high magnification with large achromatic refractors. For example, an old 3.2-in. (80 mm) F/5 short tube refractor, while delivering nice, color-free, low power views of the Moon, throws up the proverbial "gobs of color" at powers above 40×. A yellow W8 filter is the only panacea available to the refractor enthusiasts of yesteryear, and although they still work very well, they've been somewhat eclipsed by the new kids on the block – the dedicated "minus violet" filter.

First designed by the Sirius Optics in Washington State in the mid-1990s, these employ multiple layers of optical coatings on a glass substrate to cancel the blue/violet end of the spectrum. Such minus violet filters are now being manufactured by several other companies, including William Optics, Orion USA, and Baader. Well, how do they stack up?

For one thing, most impart some color shift to the image, presenting the world in vagaries of green or pale yellow and with some loss of light. But they do add a definite "punch" to the image, facilitating better high-power views. Working with a good 4-in. F/6.5 achromatic refractor, you can use a minus violet filter to comfortably divine delicate details in Jupiter's turbulent atmosphere that you could only weakly discern without one. What's more, it allows you to push the magnification limit of the scope from 150 to about 225× – not bad for a little inexpensive piece of glass! Objects seem to snap to focus better with these filters, too.

That said, the views are not *nearly* as good as an apochromatic refractor – utilizing exotic glass types to produce clean, color-free images – either. Because of their dimming effect, minus violet filters work rather poorly in smaller scopes, where light-gathering power is already in short

supply. On the other hand, if you've got an optically decent 6-in. (15 cm) short-tube achromat, one of these little filters could turn it into a very capable planetary telescope. So, while they certainly won't turn your "achro" into an "apo," minus violet filters can definitely extend its observing versatility. For the really adventurous, there's also a variable filter kit available from Sirius Optics that allows you to compare and contrast the views through various filters housed in a rotating eyepiece turret. One can readily select the right level of filtration to suit your observing conditions, and user reports attest to their great versatility.

Going Deeper

One would have thought that any kind of filter – with its inherent light loss – would be an anathema for probing dim nebulae of the deep sky. Ironically, this is one province of observational astronomy where filters have unequivocally proven their worth. These handy devices come in three varieties: light pollution reduction (LPR), ultra-high contrast (UHC), and line filters (OIII and hydrogen beta filters). LPR filters block quite a bit of unwanted artificial light (such as the ubiquitous sodium and mercury). Still, although they work very well in photography, they fail to excite many deep sky observers because they just don't seem to be aggressive enough at "pulling" faint nebulae out of the background sky. Nonetheless, LPRs can work quite well at low and medium power with small grab and go instruments from moderately dark skies. If you've got one somewhere gathering dust, give it another try!

Much better again are the UHC filters that pass a narrow bandwidth of light, typically 25 nm, centered on the most prominent visible radiations issuing from myriad emission nebulae scattered across the sky. These include hydrogen alpha (Hα) and beta (Hβ) radiation – both useful for diffuse nebulae, as well as the light emanating from doubly ionized oxygen (OIII), a wavelength that planetary nebulae shine brightly at. Although these filters typically dim stars by about one magnitude, they dramatically darken the sky. Yet despite the light loss, you *can* see faint emission and planetary nebulae better. UHC filters are especially useful for smaller telescopes. As a case in point, this author and his wife spent a few memorable evenings enjoying lovely views of the eastern and western segments of the Cygnus Veil using a UHC filter and a 76-mm F/6.3 refractor at 22×.

The acme of deep sky filters has got to be the venerable OIII – so called because it only passes a thin waveband (10 nm) of light centered on a pair of lines emitted by doubly ionized oxygen. Since this radiation is especially

enriched in planetary nebulae, OIIIs are the single best filter to use when studying these small, ghostly glows. Field stars are dimmed even more with OIII filters than with the UHCs, and for this reason they are best used with scopes larger than about 6 in (15 cm). There's quite a bit of variation in the quality of these filters (which come as 1.25-in. fit or a 2-in. version), so check out some reviews before purchasing or, better still, try before you buy. Both UHC and OIII filters work best at low and medium power applications with relatively short focal ratios (F/7 or lower), so don't be tempted to crank up the power too much while using them.

The hydrogen beta (Hβ) filter has an even narrower bandwidth (8 nm), centered on the Hβ line at 486 nm. This filter is far less versatile than either the OIII or the UHC and can only be used to good effect on a very limited range of objects such as the Horsehead Nebula in Orion or the California Nebula in Perseus.

Love them or loathe them, there's a filter for every occasion! As long as you are aware of the pitfalls associated with filter use and employ them judiciously, they will be invaluable tools in your exploration of the cosmos. Who knows, you may find that these little inexpensive accessories can add a new and colorful dimension to your previously monochrome (largely) observing experiences.

Reality through the...Diagonal

Nineteenth-century observers peered through their refracting telescopes in the "straight through" position, but unless provision can be made to comfortably view objects at high altitudes, adopting this purist approach to observing is bound to quickly disappoint. It is MUCH easier to observe using a diagonal – prism- or mirror-based. We've already looked at a number of terrestrial options, such as the 45° prismatic diagonals that allow low and moderate powers to be employed and give aesthetically pleasing views of the night sky in their correct configuration, that is, upright and correctly orientated right to left.

For astronomical purposes, a 90° diagonal is the preferred option. Inexpensive prismatic diagonals, as we have seen in Chap. 8, can help restore the normal color correction of short focal length ED refractors, which often have some red excess evident around bright objects. The best models from Baader and Takahashi, for example, are very well corrected indeed. Most amateurs, though, prefer to use high quality mirror-based diagonals either in a 1.25- or 2-in. format. The latter are prized because they allow the widest field of view when used in conjunction with wide-angle

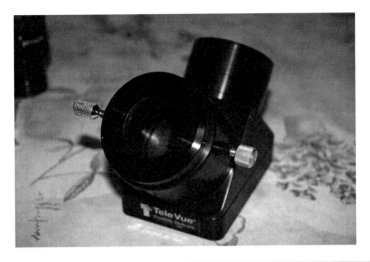

You get nice views with a 2-inch dielectric diagonal (Image by the author)

eyepieces. In theory, you should also get a slightly better image with a 2-in. diagonal in comparison to its 1.25-in. counterpart. That's because a 2-in. diagonal has a larger reflective surface than a 1.25-in. mirror, and so it is more likely to be figured more accurately – especially across the field of view of the eyepiece – than a 1.25-in. diagonal.

When choosing a diagonal, the quality of the optical components is of paramount concern. Older diagonals utilized highly polished aluminum or silver with a reflectivity as high as 95%. Today, most manufacturers now offer dielectric diagonals that are manufactured to extremely close tolerances using very high quality mirror coatings. These thin film coatings have extremely low surface scatter in comparison to metallic coatings. Indeed studies conducted with laser light suggest a fivefold reduction in surface scatter. What's more, dielectric coatings are extremely durable compared to metal coatings and can be cleaned repeatedly. How do they work?

Dielectric reflective surfaces are built up by depositing layer upon layer of special coatings to an optically flat mirror. As more layers are added, so, too, does its reflectivity increase. Once the number of layers exceeds about 50 it has a reflectivity similar to a high quality silver or aluminum surface. Dielectric diagonals can reflect greater than 99% of the light shining on them. Although some amateurs say that this small increase in reflectivity over a standard mirror diagonal can make a difference when trying to see the faintest of deep space objects, most would concede that you're not likely to see any difference at the eyepiece – the increase is just too small to

be perceptible. Of arguably greater importance is the figure of the mirror. The flatter, the better. Most high-quality dielectric diagonals are figured to an accuracy of 1/10 of a wavelength of green light (540 nm).

Bill Burgess, founder of Burgess Optical, has come up with a novel use for the dielectric diagonal, turning it into a kind of minus violet filter. Calling it Contrast Enhanced Diagonals (CED), it uses the physics of interference to selectively block out wavelengths of light that contribute to the false color in achromats and fast ED doublets. Quoting from the launch announcement, Burgess had this to say: "These new diagonals will boost low level contrast on all objects, and the results range from extremely subtle to very impressive. The CED 1 is for all 'scopes that have good to excellent color correction, such as Apos and ED doublets. In addition to contrast gains, the CED 1 will also improve the visible color correction of the ED Scopes. The CED 2 is for achromats, and here the results are shocking. Huge reduction in color or even elimination in C–F achromats – all the while maintaining absolutely neutral color balance. Contrast enhancement is also quite shocking on the planets."

Sol Robbins, a keen and gifted planetary observer based in Ohio, said he's tried both of these diagonals out and believes that they do work quite well. "The CED diagonals have a pretty deep light cut," Robbins says. "It's about a 40% cut for the CED1 and about 60% for the CED2. The CED1 would be good for small refractors when viewing bright planets such as Saturn, Jupiter, and Mars. The CED2 works better for Venus and the Moon. Some claim benefits for double stars and deep sky, but I don't see it that way."

Focusers

Telescopes are simple things; there's really not very much to using them. Point the telescope at your target, look through the eyepiece, and turn the focus wheel until a nice, sharp image appears. What could be simpler than that? Well, as it turns out, some companies dedicate themselves to making focusing a joyful experience by creating ultra premium focusing devices that can be fitted to almost any refractor. As you might expect, these accessories vary enormously in their complexity and cunning. They can be as simple as an improved focus knob and as complex as a remotely controlled, temperature-compensating autofocuser for CCD imaging.

Most budget-priced refracting telescopes have simple rack-and-pinion focusers with a draw tube that slides in and out when the focus knobs are rotated. In essence, they work well for most applications. That said, inexpensive rack-and-pinion focusers often suffer from either stiff movement or too much play and backlash. If the gear and teeth of the rack-and-pinion system

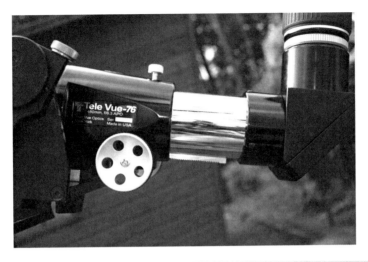

An exceptional rack and pinion on the TeleVue 76 (Image by the author)

is over-tight, then your focuser will probably be too stiff to use easily. That's down to the poor quality grease used to lubricate the system. However, you can usually adjust the tightness and replace the grease if necessary.

At the other end of the problem scale is the excessive play that you sometimes get if there's a poor fit between the draw tube and outer walls of the focuser. This can sometimes be adjusted, but in some extreme cases the excessive wobble in the focuser can cause the image in the eyepiece to shift position in the field as the focus is racked in and out. Achieving precise focus with such a wobbly focuser can be frustrating, to say the least. Backlash is the most common problem with rack-and-pinion focusers. It is inherent in the rack and pinion design, so even good quality focusers still suffer somewhat from this effect (although much less than poor quality focusers). Backlash occurs because of the necessity of having gaps between the teeth in the rack-and-pinion gears. If no gap existed, the gears would bind. If the gaps between the gears are badly engineered or are too widely spaced, the ability to focus precisely is lost because the focus knobs have to be turned more than would be necessary to cause the right amount of movement in the draw tube.

Nonetheless, if made well, rack and pinion focusers can be beautifully functional and an absolute joy to use in the field. One need only look at those employed by premium refractor manufacturers such as Takahashi and TeleVue to see what we mean. Of course, a bog standard rack-and-pinion focuser can be improved by replacing it with a better quality model, but most observers upgrade to a Crayford-style focuser.

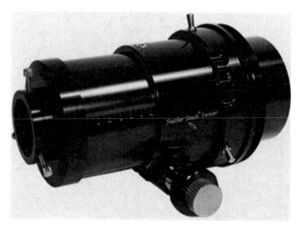

Starlight Instruments' Feathertouch focuser (Image credit: Harrison Telescopes.co.uk)

Invented back in the 1960s by the English inventor John Wall (born 1932), these eliminate many of the problems associated with standard rack-and-pinion focusers by doing away with it. Specifically, instead of turning a gear, the knobs on a Crayford turn a roller that is in contact with a flat plate on the bottom of the draw tube. This eliminates backlash, since there are no gears and no play. On the top side of the draw tube there are often small roller bearings. This provides a very smooth motion to the focuser. Although once very uncommon, Crayford focusers are now commonplace on most mid-priced refractors. Most often, the main focus knobs are fitted with a 10:1 fine focus adjustment. That's a nice touch, especially if you observe or image using a refractor with a short focal ratio. The shallow depth of focus on these instruments means you'll have to frequently tweak the focus to maintain the sharpest views, and the micro-focuser helps enormously with that. That said, if you observe with a telescope that has a focal ratio of F/8 or higher, don't rush out and buy one. The greater focus depth of these "slower" refractors means that finding a crisp image is easy and, more importantly, more steadily held in the eyepiece.

Crayfords have been taken into the stratosphere with the arrival of new, premium products such as Starlight Instruments' Feathertouch focusers, which deliver ultra-smooth (imagine gliding on ice) focusing, complete with an internal braking system.

The internal brake is engaged by a set screw on the underside of the focuser. By tightening or loosening it, you'll soon hit on the optimum amount of tension you want with your eyepiece or CCD camera. There is

no weight-induced slippage that can sometimes happen with less expensive Crayford models. Try pointing a 55-mm Plossl seated in a 2-in. diagonal at the overhead sky to see what we mean. Though not exactly cheap, Starlight Instruments' Feathertouch focuser enjoys a loyal fan club for good reason – it delivers affordable, precision twenty-first century focusers into the hands of the discerning amateur astronomer.

Feathertouch focusers are not the only high-end upgrades you can get for your refractor. MoonLite Telescope Accessories of Danville, Pennsylvania, manufactures over a dozen standard sizes of flanges that fit many different refractors. What's more, many outlets now sell custom flanges for any size telescope by request. The flange is attached to the focuser body with three bolts and acts as an interface between the refractor's OTA and the main focuser body. The thickness and diameter of the flange is designed for the telescope it is to be installed on. The smooth bore-type flanges all have collimation ability using a simple three-point push-pull bolt/setscrew arrangement. The threaded-style flanges do not provide collimation ability. All Moonlite focusers are precisely factory collimated before being shipped, and thus require little in the way of adjustment.

Moonlite refractor focuser (Image credit: Moonlight Telescope Accessories)

Baader Planetarium also manufactures a very nice line of beautifully functional heavy-duty Crayford focusers – the Steeltracks – so called because running rails made entirely of stainless steel are used for the roller bearings. This allows a higher load capacity and smoother focusing motion than a regular Crayford. It also features a nicely engineered locking screw with an anti-scratch tip. As you'd expect from any first class Crayford focuser, it also comes complete with a very high quality 1:10 micro-focuser with an all-stainless steel mechanism. The inside draw tube in these focusers are immaculately blackened and have anti reflection ridges to effectively curb any stray light. The main axis of the focuser can be rotated a full 360° without inducing any flexure between the camera and the telescope.

These are but a few nice products that can be bought as upgrades to your standard focuser. William Optics and Sky-Watcher also make some very nice focuser upgrades if you prefer. But, as with other items of equipment, you get what you pay for. If one product is, say, $50 more than another, there's usually a justifiable reason for it.

While doing high-power visual work or CCD imaging, it is annoying to have to induce vibrations to the focuser. Even when used with the steadiest of mounts – the subject of the next chapter – touching the focuser sends the image jiggling around the field of view. That's where adding a motorized focuser to your telescope can help because this enables hands-free focusing, which effectively stops any vibrations being transmitted to the eyepiece or camera. Of course, it also makes remote focusing possible when imaging the sky. Many focusers can have motors attached directly to them. Alternatively, some aftermarket focusers, including rack-and-pinion and Crayford types, are already motorized. The ultimate in accessory focusers is an auto-focuser. This is used for CCD imaging and allows a computer to automatically focus the telescope. It is more precise and faster than focusing manually. Some auto focusers also include digital readouts and temperature compensation that refocuses the telescope as the temperature changes, keeping a perfect focus during the course of a night.

The Binocular Universe

Over the last decade there has been a large increase in the number of amateur astronomers switching from traditional monocular viewing to binocular observing with their refractors. This has no doubt been accelerated by the introduction of budget priced units – such as Denkmeier, Burgess Optical, and Baader Planetarium, for example – to the amateur market. They can deliver spectacular views that are incredibly comfortable to use.

The trick, though, as we shall shortly discover, is to learn how to use them properly. The image will appear slightly dimmer than monocular viewing, owing to the splitting of the light beam before it gets delivered to the eyes. Mike Bacanin from Stoke on Trent, England, a keen lunar and planetary observer who has had experience with using this hardware offered his pearls of wisdom:

"Using a bino-viewer with a refractor makes for a much more comfortable experience," he insisted, "and my specialist interest – planetary and lunar observation – are particularly suited for bino-viewers. The lack of strain, which often occurs when using one eye, is very relaxing. This makes fine detail easier to see. I don't think that more detail is visible than using one eye, but the bino-viewer allows a much longer examination of the image. However, I have come to several conclusions regarding bino-viewers. There is a definite improvement in the view when a high-quality bino-viewer is used, primarily because the higher end units, with their more precisely collimated prisms, make merging the images easier. That's critical because if you struggle to merge the images, due to possibly miscollimation of the bino-viewer, you'll not find them of much use. Also bino-viewers with self centering eyepiece holders are best, as again, they reduce merging issues. I have found good-quality orthoscopic eyepieces to be excellent for planetary bino-viewing. In addition, the apparent field of view always seems bigger in a bino-viewer than with a single eye view. Probably an illusion, but it seems so!"

Another fan of bino-viewing, Chris Lord of Brayebrook Observatory, Cambridge, had some amazing things to say on the matter. "There is an optimum magnification for using a bino-viewer, he told me," and not all amateurs seem to be aware of this, and why. Stereoscopic vision achieves optimum visual resolution when the eyes' pupils are 2 mm diameter. You need to arrange your set-up in such a way that the detail at the Rayleigh limit is just resolved (that is, increased to 1 s of arc) when the exit pupil is 2 mm. For my TEC 140 Apo, this occurs at full aperture at 70×. That's a suitable power for viewing the Sun or Moon, but not Jupiter. Increase the power to 140×, and I have a 1-mm exit pupil. That's pushing things right up to the wire.

Below 1-mm exit pupil diffraction begins to degrade the image, and the visual cortex does not do quite as good a job of combining the right and left images. What occurs is your dominant observing eye begins to take over, and the image in your other eye becomes suppressed. Bino-viewing bright globular clusters at 140× enhances the view marginally. Bino-viewing close doubles is largely a waste of time. You need too high a power for it to work. When I look at M31 (the Andromeda Galaxy) using

Solid performer: the Baader Steeltrack focuser (Image by the author)

my bino-viewer and 32 mm Brandons (30× with a 4.6-mm exit pupil), I don't see a 3D image, it still looks flat.

Lord admits that many amateurs have shied away from using them because they take a bit of getting used to. "Not every observer I've met can fuse the images, though," he said," and after several thwarted attempts they dismiss it as a gimmick. They lack patience and the necessary perspicacity, and more fool them, I say. They are denying themselves a wonderful visual experience because of their myopic lack of comprehension. The visual cortex somehow combines the information from the right hemispheres of both eyes that gets fed into the left side, and vice versa. It seems only the cones are wired up in this way, not the rods.

So as you transition to dark adaptation you lose the pseudo 3D effect. You still maintain stereoscopy, of course, but it's not parallax that produces the pseudo 3D effect – it's something going on in the cortex. I don't think it's understood yet. Ordering the distance of objects by parallax is readily understood. Ordering the distance of objects by mutual occultation is easy

to understand. And there is a subconscious tendency to order the distance of known objects by their apparent size, which is the explanation of the Moon illusion. But splitting the retinal sensor data into left and right parts for each macula, and somehow combining them in a way that reveals the shape of an object is puzzling. It implies prior knowledge of the shape of the object, and a databank of fundamental geometric shape elements, and an ability to recognize elements of those geometries. This is not improbable. We know babies go through a visual learning process. That's why they insist on "looking with their hands." Adults still resort to it in the end when they can't figure out what precisely it is they're seeing. We know that the Moon is in reality a ball shape. It looks like a flat disc to the unaided eye, even though the terminator gives us tell tale visual clues as to its roundness.

On the face of it, you'd think that you'd be able to get a 3D effect using only one eye. You can see from the lighting you're looking at a round ball, so why does it appear flat? Why do you need to use both eyes to get the pseudo 3D effect? If you hold a cricket ball in your outstretched hand and close one eye, it still looks round – it doesn't suddenly go flat shaped. But you're holding it in your fingers, and you have touch sensations that tell you it's round. You can still tell you're holding a ball with both eyes shut! You can't do that with the Moon.

The Demon of Dew

If you observe from the Australian outback or the deserts of the Arizona, then you can skip this section. You'll almost never encounter dew; the insidious accumulation of tiny droplets of water on a cooled objective. For the rest of us, dew is a major obstacle in spoiling the pristine images served up by a good refractor. Even small amounts can seriously degrade contrast on planets and greatly impede your searches for faint deep objects. Fortunately, all refracting telescopes come with dew shields that fit snugly round the objective lens cell.

A dew shield increases the time it takes for dew to form by insulating the objective. It also helps reduce glare during daytime applications. In humid climes, like in bonny Scotland, it can significantly extend the time spent at the eyepiece. If you're observing for longer than an hour at a time, you can usually use a small 12-V hair dryer – powered by electricity to blow off any dew that you see forming on the objective.

If you want a fully portable dew prevention strategy, then you'll have to invest in a battery-powered dew removal system. Consisting of a simple array of electrical resistors that dissipate just enough heat to keep the

objective above the dew point, these units (Canadian company, Kendrick Astrosystems is a market leader) are especially popular with CCD imagers as they ensure the lens is crisp and dry for the entire duration of a long time exposure. Some argue that using dew heaters slightly degrades the images seen through a telescope, but if so, it is hardly noticeable. With a little tweaking and experimentation you can always get the minimum amount of heat that gets the job done.

Comfort Is...a Nice Chair

So you've got a top-of-the line refractor and wish to observe the night through with it. If you're not comfortable you'll soon be boxing it up eager for your bed. Comfort at the telescope is a hugely under-emphasized issue. Many a budding amateur astronomer has lost interest because he/

An adjustable-height chair is an essential accessory for comfortable viewing (Image by the author)

she wasn't comfortable enough at the eyepiece. We're all guilty of neglecting comfort sometimes. Eager to get a quick look, we stand with neck strained peering into the eyepiece. A properly designed chair for observing will greatly increase viewing comfort and in turn increase your visual acuity. Ideally, the chair ought to be air cushioned with a strong support to rest your back on. Because your viewing posture will change as you move up and down the sky, your chair should be height-adjustable. Fortunately, there are many such chairs to choose from, ranging in form and function from just adequate to downright exorbitant. Contact your local telescope store or browse online to explore the possibilities.

That ends our brief exposition of some of the accessories that you should at least consider when venturing out with your refractor. A full exposition of accessories available to the intrepid amateur is best consulted in the recommended texts cited at the beginning of this chapter.

We now move on to a weighty topic – telescope mounts.

Observing Platforms

Having a super telescope with "super duper" accessories is all very good. But if you don't have a steady platform to mount the instrument, you'll soon tire of it. Thankfully, there is now a huge variety of options to suit the wallet of almost every backyard observer – from simple human-powered set-ups to fully computerized behemoths capable of doing high-quality science and imaging. Selecting the right kind of mounting for your telescope can be daunting, though. For one thing, it must be strong enough to support the telescope's weight and keep vibrations at an absolute minimum. That said, unless you wish to permanently house your instrument, it must be portable enough to set up in a reasonably short amount of time. Mechanically, it must have smooth motions on both axes, so that a celestial object can be easily tracked, either manually or with a control pad.

Choosing a mount also depends on your particular needs. Are you wanting a system that can be set up in a jiffy for just a quick look, or do you want to do high-resolution astro-imaging, necessitating a precision, electronically controlled GoTo system? The task can seem bewildering, especially if you're new to the hobby. Luckily, though, all mounts can be divided up into just two categories – so-called altitude-azimuth mounts and equatorial mounts.

N. English, *Choosing and Using a Refracting Telescope*, Patrick Moore's Practical Astronomy Series, DOI 10.1007/978-1-4419-6403-8_13, © Springer Science+Business Media, LLC 2011

Keeping It Simple

Altitude-azimuth (abbreviated alt-az) mounts work by moving the telescope in both the azimuth (horizontally) and in altitude (vertically) in the same way you'd move a photographic tripod head. They're intuitive and easy to use. Usually, alt-az mounts are supplied with smaller, more portable 'scopes. For example, Synta's inexpensive AZ-3 mount can be used with small spotting telescopes and astronomical refractors up to about 80 mm in aperture. The AZ-3 has slow motion controls – usually in the form of knobs that can be twisted – on both axes, allowing fairly smooth tracking in both axes.

The trouble with this type of design is that it can provide less than adequate stability, especially when your telescope is aimed high overhead and weighted down with heavier instruments. Although a fairly good performer using low and medium powers, this mount won't live up to your expectations if you want to track objects at higher powers. Something

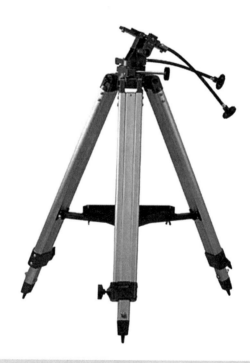

The Sky-Watcher AZ-3 alt-az mount (Image credit: Optical Vision Limited)

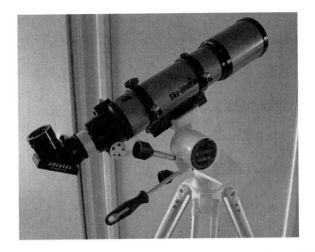

The Sky-Watcher ED 80 on the Vixen Porta mount (Image credit: A. McEwan)

with greater mechanical dexterity will be required; something like the Vixen Porta.

Attached via a common dovetail plate, the telescope is held securely on a simple tripod head that employs a worm gear to execute rapid (low tension) 360° movement but with much smoother (high tension) slow-motion controls for tracking objects at high magnifications. Though such mounts are good for using with small refractors up to 80 mm in aperture and compact Maksutov Cassegrains smaller than 100 mm in aperture, they aren't really stable enough for high power views.

Takahashi do an even better version of the Porta in their Teegul alt-az mount. To their credit, Vixen has introduced a heavier duty version of the popular Porta. Called the Porta II, it has identical mechanics to the original but with double the payload capacity (20 pounds as opposed to the Porta's 10-pound capacity)! More recently, Oklahoma-based Astro-Tech has launched its own version of the Porta in the form of the Voyager alt-az mount.

A notch up from the original Porta are the TeleVue's Telepod and Gibraltar mounts and their clones. They are superb performers even used at higher powers. The Telepod is used for refractors up to 85 mm or small Maksutovs up to 90 mm in aperture.

The Gibraltar, with its sturdy ash wood or walnut tripod, is excellent for telescopes up to 5 in. (127 mm). Stars at magnifications as high as 375× can be tracked by some amateurs with this remarkable mount.

It has one weak spot, and you'll find it when the telescope is pointed near the zenith, where smooth movement is hard to maintain. One can even retrofit encoders on both axes of the TeleVue mounts that gives you the power to locate thousands of celestial objects rapidly. One tried and tested example is TeleVue's own Sky Tour, featuring a 2,000+ collection of objects selected by North Carolina amateur astronomer and author Tom Lorenzin. The Sky Tour offers a rather eclectic selection of interesting and observable double and triple stars, bright and dark nebulae, galaxies, star clusters and colored stars most suited to small portable refractors (especially TeleVue telescopes, though). The objects are organized into six catalogs: NGC (New General Catalog), M (Messier), IC (Index Catalog), ST (Star), NS (Non-Standard), and PL (Planets). For quick reference, another feature – called Favorites or FAV – is available to store an additional 99 objects. The Sky Tour has not changed in over 15 years and it doesn't really need to. It'll keep a skilled observer going for years.

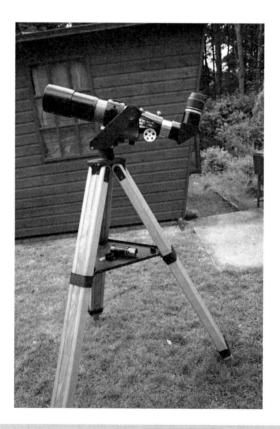

Elegant simplicity: The TeleVue Gibraltar alt-az mount (Image by the author)

Double your Money

In recent years, a number of manufacturers have launched a totally new kind of alt-az mount that can allow two telescopes to be used simultaneously. The US-based company William Optics demands respect with their EZtouch. There are no weights with this mount, and neither will you see slow-motion controls, cables, hand controllers, or any leveling or alignment tools. Quite simply, you extend the legs, attach and balance the telescope, and start observing. It doesn't even have to be level.

The device has dual mounting ends, which allow for the attachment of two telescopes at the same time, or one telescope on either side. There is no need to add any counterweights with small telescopes, but the company recommends that if you have a larger telescope on only one side, you balance it with a weight on the other side for greater stability. Provided

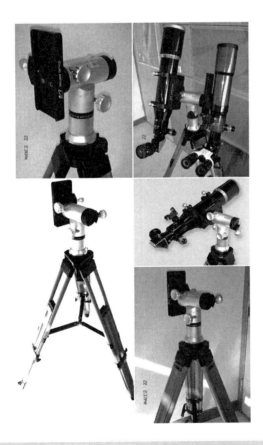

The William EZTouch Altizumith (Image credit: Ian King)

that you are using a good-quality tripod, you can mount up to 10 kg on either side without any need for a counterweight.

The great thing about these mounts is that you can use two different-sized instruments to observe the night sky. That means, for example, an 80 mm refractor and 200 mm reflector can be easily handled simultaneously! The smaller scope can almost be used as a super "finder" to get an overall feel for the object being observed, and then you can "zoom in" using the larger instrument. Used skillfully, these double jointed alt-az mounts offer a degree of versatility unmatched for the strictly visual observer with a disdain for all things electronic! Sky-Watcher has also introduced a competitively priced version of the EZTouch in the form of their HDAZ alt-az mount.

Motorized Alt-Az

If you want to spend all your time looking and not searching and manually tracking, then some sort of motorized mount is in your future. In the last few years, a number of telescope manufacturers have brought simple, inexpensive alt-az mounts that can automatically track celestial objects,

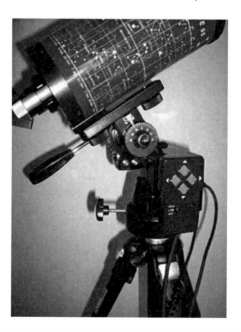

The Hutech AZM-100 motorized slewing mount (Image credit: JD Metzger)

and some models now have full GoTo capability. The Hutech AZM-100 ($229 for the mount head only) is a great option if you want to go light. With a load capacity of 3 kg, it's ideal for spotting telescopes and small astronomical refractors up to 80 mm in aperture. The Hutech AZM-100 has proven especially popular with owners who desire basic slewing functions but do not need a heavier astronomical equatorial mount. The AZM-100 is good for travel, too. It'll happily sit in the corner of your brief case. Just don't forget to bring a tripod. For even greater versatility, the AZM-100 can accommodate digital cameras, camcorders, and binoculars. Powered from 8 AA batteries, it can be used to slew at "high" speed (1°/s) and "low" speed (0.2°/s), so you can keep the object in the field of view comfortably. Although by now a tried and trusted product, the AZM-100's only drawback is that it's very difficult to keep objects centered at high powers, and for that you'll need a proper tracking mount.

A number of relatively inexpensive alt-az mounts are now available that not only provide smooth automatic tracking of celestial objects but full GoTo capability. One example is the Sky-Watcher SynScan mount. Once you've gone through a simple initializing exercise taking

The Sky-Watcher SynScan alt-az GoTo mount (Image by the author)

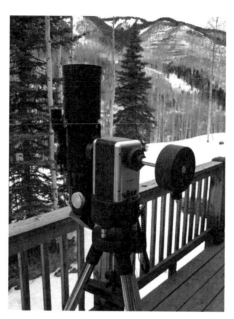

> The iOptron MiniTower alt-az GoTo mount with an Astro Physics Traveler (Image credit: John Cameron)

less a few minutes, you then can use the SynScan computer to select an object from a 49,000-object data base. With the touch of a button, the telescope sets off across the sky, places the desired object in the field of view, and tracks the object diligently. You can also enjoy a number of slewing speeds from 1× up to 800× the sidereal rate. This mount is so versatile it can be used with small refractors up to 100 mm in aperture. However, the aluminum tripod it comes with is rather flimsy, but this can be replaced with something more substantial if need be. Celestron produces a very similar mount for their no-frills SLT series of small portable telescopes.

Two from iOptron

In the last few years, a new company, iOptron Corporation, has launched two neat little alt-az GoTo mounts called the CubePro and the heavier duty Minitower. The CubePro was designed with extreme portability (12-pound payload) in mind and is well matched for small portable travel telescopes, such as short focal length refractors up to 80 mm in aperture.

It features a SmartStar computerized control system with a database of an impressive 130,000 celestial objects and an 8-line backlit LCD screen. The addition of a 32-channel internal GPS, easy alignment procedure, and accurate GoTo and auto-tracking allows the user to start observing in less than 5 min. The unit comes with a stainless steel tripod with 1-in. diameter legs, together with a metal platform and metal hinges that render the mount very sturdy. The standard Vixen-style dovetail makes this mount compatible with just about every optical tube.

Although the CubePro apparently had a few quality control issues when the first models hit the shelves, many users are thrilled with the versatility of the new products. For more heavy-duty applications, iOptron recommends the MiniTowerPro for payloads up to 33 pounds.

Going Equatorial

Although all alt-az mounts are quite easy and intuitive to move, they're not ideal if you wish to use your refractor at very high powers, or indeed, if you wish to perform guided astrophotography. Alt-az mounts have to be adjusted both horizontally and vertically to keep track of an object. What you really need for these projects is a mount that only has one rotational axis parallel to Earth's axis of rotation – an equatorial platform.

When doing astrophotography with an equatorial mount, the image does not rotate in the focal plane, as occurs with alt-az mounts, where they are guided to track the target's motion, unless a rotating erector prism or so-called field de-rotator is installed. The equatorial axis (also called right ascension) is coupled with a second, perpendicular axis of motion (declination).

Although the simplest equatorial mounts can be operated manually with little fuss, almost all are, or can be, equipped with a motor drive for automatic tracking of objects across the sky. The better models are also equipped with setting circles to allow for the location of objects by their celestial coordinates. In the last 20 years, motorized tracking has increasingly been supplemented with computerized object location. There are two main types.

Digital setting circles take a small computer with an object database that is attached to encoders. The computer monitors the telescope's position in the sky. The operator must push the telescope until the encoders inform you that the target has been reached.

GoTo systems use (in most cases) servo motors, and the operator need not touch the instrument at all to change its position in the sky. The

computers in these systems are typically either hand-held in the control paddle or supplied through an adjacent lap-top computer, which is also used to capture images from an electronic camera.

If long-exposure astrophotography is your thing, then an equatorial mount is a necessity. Most mid-priced to high-end equatorial mounts often include a port for autoguiding. Usually, a smaller instrument – co-aligned with the main telescope – tracks a star and makes adjustment in the telescope's position while photographing the sky. To do so the autoguider must be able to issue commands through the telescope's control system. These commands can compensate for very slight errors in the tracking performance, such as periodic error caused by the worm drive that makes the telescope move. Some experienced observers even let new telescope drives run continually for up to 24 h to help "iron out" any unevenness in the gears and reduces periodic error.

Although many different types of equatorial mounts have been patented, two major types dominate the amateur market: the German equatorial mount and the fork mount. Refractors used by amateur astronomers are almost exclusively placed on German equatorial platforms in the tradition of the very first equatorial mount designed and built by Joseph Fraunhofer for the Great Dorpat refractor dating from the mid-1820s.

Shaped like a lopsided letter T, the German mount allows the telescope to be placed at one end and is counterbalanced by a weight at the end of a long shaft. Although these allow free access to all parts of the sky, they cannot undergo a west–east sweep in one fell swoop. Instead, when the telescope nears the north–south line (the meridian), it must be swung away from the target object and re-aimed back on track.

Secondly, these mounts tend to be quite cumbersome, especially when a heavy counter weight is attached. Sadly, one of the best German mounts available to the amateur on a strict budget – the Vixen Great Polaris mount – is now discontinued. This famous Japanese-made mount has and still does provide a high-quality telescope platform for visual and photographic use. It can even be upgraded to a fully robotic telescope mount via the installation of the Vixen Skysensor 2000 system.

In more recent years, the Vixen GP mount has been replaced by the more beefy German equatorial – the Sphynx – which is fully robotic. The leading telescope manufacturers, Meade and Celestron, also produce a line of GoTo German equatorial mounts in the form of the LXD-75 and the GC-5 (and the less sturdy GC-4), respectively. These can comfortably hold instruments up to 5 in. (127 mm) in aperture, so long as the length of the telescope tube is not excessively long. These mounts work very well for both visual work and astrophotography. Of course, if you're

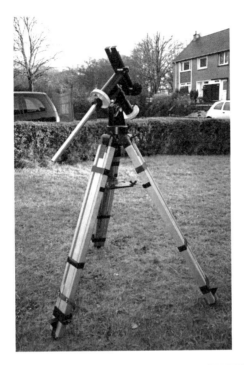

A lightweight German equatorial mount (Image by the author)

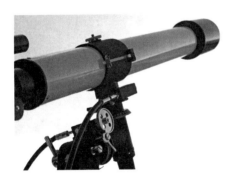

A manually operated equatorial mount carrying a classic Towa 80 mm F/15 refractor (Image credit: Dennis Boon)

looking for nothing but the best you can always explore the precision of a Losmandy German equatorial. The GM-8 and GM-11 are especially favored by astrophotographers for their rock-solid sturdiness and exceptional tracking accuracy. Other high-end companies such as Celestron,

Astro Physics, and Takahashi also supply state-of-the-art German equatorial mounts with price tags that will leave you truly breathless!

Now that you've got the basics of telescope mountings, you can begin to make more informed decisions on the best ones for your needs. This is especially true if, like so many amateurs these days, you purchase the optical tube assembly separately. Indeed, by making judicious choices you can acquire an equatorial mount and an alt-az mount for the same telescope, and then, you'll truly have the best of both worlds. Now, what could be better than that?

In the next chapter, we'll get back to basics again, exploring the many and various ways of testing out the mettle of your prized refractor.

CHAPTER FOURTEEN

Testing Your Refractor

A large box arrives at your doorstep. Inside, your latest telescope has arrived, ready to be fed starlight. Excitedly, you carefully remove the optical tube assembly from its protective housing and fetch a couple of eyepieces and a diagonal. After setting it up on its mount you're ready to give it a once over.

What kind of information can you glean from your observations? This chapter shows you how to easily perform a few tests to evaluate your optics during both daylight hours and at night. However, before carrying out any tests, you've got to make sure your optics are well aligned, and here's where we'll begin, with a brief overview of how to check whether or not your telescope is well collimated.

To perform at its best, your telescope's optics must be properly aligned with your diagonal and eyepiece. Thankfully, most objectives available on commercial telescopes come in collimatable cells. Specifically, a hex key can be used to push and pull the objective cell against the optical tube at three locations, placed 120° apart, on the rim of the objective. To perform a collimation test, you need a simple and inexpensive tool called a Cheshire eyepiece.

Put the objective lens cap on the telescope. Leave the diagonal at the focuser end in place. Next, place the Cheshire eyepiece into the diagonal and direct a bright light source into the aluminized opening of the eyepiece. Now look through the small sighting hole at the top of the Cheshire eyepiece and slowly rotate it until you get the brightest image.

N. English, *Choosing and Using a Refracting Telescope*, Patrick Moore's
Practical Astronomy Series, DOI 10.1007/978-1-4419-6403-8_14,
© Springer Science+Business Media, LLC 2011

An indispensible collimating tool, the Cheshire eyepiece (Image by the author)

If your objective is properly collimated, you'll see one dot smack bang in the center of the field. The dot is actually a tiny reflection off the Cheshire eyepiece's reflective surface. If that's what you see, congratulations! Your refractor is collimated. Now leave it alone!

If, however, your telescope's objective lens is misaligned, you'll see two bright dots in the center of the lens. Carefully adjust the three collimating screws with a hex key, with the aim of getting the two dots to come together and overlap.

Of course, all of this is merely academic if your refractor doesn't have a collimatible lens cell. Most mid-priced and high-end refractors now come with cells that allow you to tweak the alignment of your objective. If your telescope doesn't have such a cell, don't despair; you may be able to get around the problem by carrying out the following exercise. Loosen the lens cell, and, after placing it on its mount, point it directly overhead. Next, gently strum the sides of the tube around the rim of the cell with your fingers for a few minutes. Tighten the cell again and check alignment with the Cheshire. You might need to repeat the process a few times, but chances are good that you'll achieve an improvement in performance. Once that's done, your refractor is ready for more extensive testing. We'll begin with some daylight tests first.

Testing for Color Correction

Set your telescope up outside and let it acclimate for half an hour. Insert a moderate power eyepiece delivering, say, a 30× per inch of aperture. Point your refractor at a high contrast object, such as green leaves against a bright background sky or a distant TV antenna. Carefully focus the telescope until you get the sharpest image you can. If you see blue or purplish fringing at the boundary between light and dark areas, then the telescope is showing chromatic aberration. At these moderate powers, short- and medium-focal ratio achromats will usually show some, but ED doublets and long focus achromats usually pass this test – that is, by not showing up obvious color fringing. Now crank up the power by inserting an eyepiece that serves up 50× per inch of aperture and focus carefully. Do you see more fringing? Even good ED scopes – doublets and triplets alike – usually show a hint of color at these high powers.

You can even go one step further by quantifying the color excess of your refractor. To do that, you'll first need to accurately determine the focal length of your refractor. Don't be satisfied with the value quoted by the telescope manufacturer, as it is usually off by as much as a few percent. Remove the objective lens cell from the optical tube and mount it on a table positioned between an indoor wall one side and a window on the other. Hold the lens cell against the wall opposite the window and move it away from the wall until it produces a sharply focused (and upside down) image of the outside world. Measure the distance from the lens to the wall. Repeat this process a few times and take an average. That's the focal length of your objective.

With the focal length of your telescope accurately determined, you're now ready to do some quantitative color testing. The approach outlined here is based largely on the recommendations of the late Ernie Pfann-enschmidt, an optical engineer and keen amateur astronomer who pub-lished an excellent article on daylight testing in the April 2004 issue of *Sky & Telescope* magazine. The glint of white sunlight reflected off a surface on a nearby rooftop served as the test image.

At the position of best focus, the image should be as bright and white as possible. In a well-corrected achromat, focusing inwards throws up a bright purple glow, while focusing outwards shows up a strongly green hue. The linear distance between the positions of these purple and green glows tells you how much false color your scope will throw up. The differ-ence is very small – typically only a fraction of a millimeter – so you'll need a Vernier calipers or some such to measure it accurately. After repeating

Simple tools used to measure chromatic and spherical aberration (Image by the author)

the measurements several times and taking an average, I then express the value as a percentage of the focal length of the lens.

This technique was used to evaluate a nice 4-in. F/10 achromat, the Tal 100R, which yielded a result of 0.042%. In comparison, the best apochromats have color errors less than 0.015%. Short and medium focal ratio ED doublets exhibit color errors in the range 0.015–0.024%. The visual threshold for seeing color, according to Pfannenshmidt, is about 0.03% (a value that is amply borne out in field tests). Most commercial achromats fall within the range of 0.04 and 0.06%. So the Tal objective seems very well corrected for chromatic aberration.

Measuring Spherical Aberration

If your telescope is F/5 or slower, then you can also measure the spherical aberration of your objective by performing this simple technique, again adapted from Ernie Pfannenschmidt's original recommendations. Spherical aberration, you'll remember, is one of the principle errors that turns the image "soft" on planets and stars at high powers. Make yourself two aperture masks, one to block off the central 50% of the area of the lens and another to block the outer 50%.

Inner (left) and outer (right) masks used to measure spherical correction (Image by the author)

The idea here is that if you look at a sharply focused image of an object at least 100 m away, the presence of spherical aberration will show up as tiny changes to the position of best focus using the different aperture masks. Averaging your readings gives very encouraging results. The Tal 100R objective gave a remarkably small value of 0.059 mm. This corresponds to a correction of about 1/8 wavelength for this Russian objective! It was certainly well above the 1/4 wave standard set by Lord Rayleigh.

Now do a high magnification test. Insert an eyepiece that yields 50× per inch of aperture and aim at something nearby; say less than 50 m away. You might wait until the trunk of a nearby tree – say, about 40 m away – is strongly illuminated with direct sunlight. Larger distances can be used to reduce the effects of spherical aberration but at the expense of atmospheric turbulence playing havoc with the image. Focusing sharply and examining the central field of view, examine the image carefully. Scrutinize the fine grains running through the wood, the rich contours of light and dark winding their way through this "alien" landscape. This can rapidly become a very addictive activity! Then there's the wildlife, i.e., a platoon of brown ants frantically going about their business. Short focal length achromats show some false color at high-contrast boundaries across the wood surface, but long focus instruments (and some short focal ratio ED doublets) fare a lot better, showing far more subdued colors. Fully apochromatic models should show nothing but color-pure images with beautiful contrast.

Daylight tests are all well and good, but they cannot reveal the whole story about the optical quality of your refractor. To give you an example, this author once put an old 4-in. refractor through its paces. The objective was very well collimated, and images served up with low-, medium-, and

Baubles imaged at a distance can be used to do a crude star test during daylight hours (Image by the author)

high-power eyepieces produced lovely, high-contrast images of daylight test objects. It was only while doing a nighttime star test that I discovered that there was something amiss with the optics. While in focus, bright stars produced a nice round Airy disc – again all normal behavior – but when I racked the high-power eyepiece out of focus I could see a strange and tiny fork-like "shadow" on the outermost diffraction ring. It was present both inside and outside focus and didn't go away when I switched eyepieces. Puzzled for a few moments, I removed the dew shield hiding the objective to find that the lens had a tiny chip at its periphery!

The Star Test

If you want to evaluate the nighttime color correction of your telescope and you're in a bit of a hurry, just pop in a high-power eyepiece and point it at the brightest points sources in the sky; brilliant Sirius is a great example, but Vega is good, too. If the bright planets Venus or Jupiter are visible in your skies, point your telescope at those as well. Look for purple or violet fringing around the object. Note that low altitude objects (such as Venus and Sirius from a northerly vantage point) pick up a bit of atmospheric refraction – easily identifiable as a red and blue tinge at opposite

ends of the star or planet. Even the most color-free refractors can't help but pick that up, so you'll have to try to mentally remove that from any assessment that you make.

The star test is by far the best and most sensitive analysis you can subject your optics to. It's fairly easy to do but can sometimes be very difficult to interpret. One book that can help you unravel this amazingly sensitive test is Harold Suiter's *Star Testing Astronomical Telescopes* (now in its second edition), which allows you to appraise the severity of any aberrations you may or may not pick up. It's important to star test your telescope over a number of observing sessions. What looks bad on one night might improve significantly on another night. Give it time.

Let your refractor cool off to ambient temperatures. Pick a good eyepiece yielding a power of between 30 and 50× per inch of aperture. Pick a bright white star (Vega is perfect for northern hemisphere observers with small telescopes). Alternatively you can use an artificial star. First examine the star at sharpest focus. It should reduce down to a nice, sharp Airy disc surrounded by one or two bright diffractions rings. Next examine the space immediately around the star. Do you see an unfocused halo of violet light around the Airy disc? If so, your telescope is picking up the unfocused red and blue light that mixes to give the purplish color of chromatic aberration.

Virtually all achromatic refractors show this unfocused halo of purple light. ED doublets will also show it, although it should be much more subdued than in an achromat. High-quality triplets and four-element Apos should show little or no color. Next examine the Airy disc itself. It should be bone white in an Apo and pale yellow or green in an achromat. If the Airy disc focuses poorly with a bluish tinge your objective is probably over-corrected. On the other hand, if it presents as a poorly focused red tinge then the objective is under-corrected.

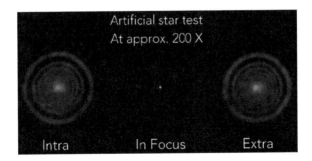

A great star test (Image credit: Pollux Chung)

Next, examine the intra-and extra-focal image of the star by racking inside and outside focus, respectively. As a first approximation, what you should look for is a series of round, perfectly concentric diffraction rings inside and outside focus. The pattern should be as symmetrical as possible. If you're star testing a typical C–F achromat refractor, the outer rim of the intra-focal image should appear a crimson color and the extra focal rim should appear greenish yellow.

Most ED doublets and triplets will also display these colored rims, although they will be less prominent than in an achromatic refractor. If the rings are easier to see inside focus than outside (or indeed vice versa), then your telescope is probably showing spherochromatism. As we already seen, this aberration results from your telescope being better corrected for spherical aberration at some wavelengths more than others. You can test this idea by doing the star test at three different wavelengths using inexpensive color filters. Examine the intra-focal and extra-focal images using first a red, then a green and finally a blue filter. Do the rings look the same through each filter? If so (the exception), then you've got an exceedingly well-corrected optic; if not (the reality for most of us), you've got some spherochromatism. You'll probably find that the stellar diffraction rings are easiest to see using a green filter, as this is the color your eye is most sensitive to and which your telescope optics are usually best corrected.

Testing for the Seidel Aberrations

As we saw in Chap. 2, there are five Seidel aberrations that the star test can pick up on. These are astigmatism, coma, spherical aberration, field curvature, and distortion. Let's now look at each in turn.

Astigmatism

Point your scope at a bright star and focus it as sharply as possible. Now move the star *ever so slightly* outside focus. The Airy disc should remain round. If it appears egg shaped, rack the telescope *ever so slightly* inside focus. Did the egg flip in shape through 90°? If so, you've got some astigmatism. Most short- and medium-focal length telescopes, apochromats included, show some, especially when tested at very high powers. A little bit will not appreciably degrade your images.

Coma

Focus the bright star as well as possible once again. Is the light emanating from the star symmetric in all directions? Or can you see, ripples, like the gills of a fish (or a comet tail if you prefer), emanating from one side of the star?

Pause for thought: Both these aberrations are often (but not always) caused by mis-collimation. I'd get that Cheshire eyepiece out if I were you, just in case!

Spherical Aberration

Examine the intra- and extra-focal image of the bright star again. Are the rings noticeably easier to see on one side of focus compared with the other? In particular, is the outer ring brighter on one side of focus relative to the other? If yes, then you're probably picking up some spherical aberration. There's little you can do to ameliorate this defect from your telescope. It is usually caused by inaccurate figuring of the lenses making up the objective.

Field Curvature

Take a good, low-power eyepiece with good edge of field correction and insert into your telescope diagonal. Center a bright star in the field of view and focus the image as sharply as possible. Now slowly move the star to the edge of the field and examine how the image of the star changes. When the star is at the edge of the field, do you have to refocus it slightly to get the sharpest image? If so, your telescope is probably showing some field curvature.

Distortion

Not an aberration in the same way as the other four. It usually is seen when using wide-angle eyepieces. It comes in two forms – pincushion (positive distortion) and barrel (negative distortion). These are best spotted during daylight hours by pointing your scope at a flat roof and looking for bending of the image near the edges of the field. These defects often arise in the eyepiece rather than your telescope's objective lens, and although they can be slightly distracting during critical daylight tests, they can't be seen during observations conducted at night. So if you're an astronomer, distortion matters little.

High-Power Test

Like the daylight tests described above, it's also fun to test the mettle of your telescope by cranking up the power on a nighttime target. The obvious choice here is the Moon, which can be observed equally well from a city or country setting. Look at the image the first (or last) quarter Moon throws up when your telescope is charged with a magnification of at least 50× per inch of aperture. If the views are sharp and well defined at these high powers, then rest assured you have a decent optic.

When all testing is done; how do you evaluate what you've seen? I mean, are some aberrations worse than others? Is there in any sense a "league table" of optical defects that you can use to appraise the optical quality of your cherished refractor? I asked Es Reid, an optical engineer based in Cambridge, England "I would say that asymmetry is always going to be spotted first since the eye is good at seeing it. So coma and astigmatism might be the first two. Some coma might be inherent in the optical design so nothing will remove it; same with astigmatism but that can arise from strain in polishing or mounting and might be removable. Some spherical aberration, if smooth, can be tolerated because at least one zone of the optics will be in focus. Roughness is a complex combination of many small errors and is the source of persistent poor contrast – you could have an objective with a wave-front with peak to valley (p–v) less than 1/10th wave but rough, with fast slope changes, which gives worse images than smooth ¼ wave p–v objective. Achromat color doesn't seem to worry some planetary observers. Perhaps the brain can filter this to some extent. Suppression of the violet end of the spectrum is always the tricky bit and people vary in their sensitivity to this. One can always put a minus violet filter on. As for distortion, it hardly matters in small refractors because it's only really seen in wide field systems."

Double Stars and Planets as Optical Tests

One enduring belief among amateur astronomers is that splitting close double stars makes for an excellent optical test. There's certainly more than a grain of truth to this, but it's not entirely accurate. The Dawes limit is an empirical result – amply borne out in field tests – derived by the nineteenth-century English clergyman and amateur astronomer

William Rutter Dawes, who found that a telescope will not resolve two equally bright, sixth magnitude stars if their separation in arc seconds is less than 4.56/d, where d is the aperture in inches. So, for example, a 3-in. scope should resolve pairs as close as 4.56/3 = 1.52 arc seconds, and a 5-in. should do considerably better (0.91 arc seconds).

Now, according to Harold Suiter, an authority on the analysis of a star test, a scope with a quarter wave of spherical aberration will split close doubles down to the Dawes limit, yet it'll give noticeably softer, less well defined lunar and planetary images compared to a telescope corrected to, say, one sixth of a wave or better. Certainly, if your telescope doesn't resolve close binary stars close to the Dawes limit for your aperture (see Appendix II in this book) on a night of good seeing, then it's obviously not performing to its potential and should be investigated further.

That said, probably the most all-encompassing and simplest test of your telescope's optics is a high magnification examination of a bright planet. Jupiter is often the best target. Do you want to know if your telescope is optically sound? Point it at Jupiter when it's at least 30° (the higher the better) above the horizon and away from any sources of heat on a calm, transparent night. Examine the planet at 30–50× per inch of aperture. Do you see a slightly flattened disc against an ink-black background sky? Does the planet look off-white or maybe yellowish, crisscrossed by darker bands that vary in hue from milk chocolate brown to fawn? Is there structure within these bands? Can you see fragile ovals with odd colors merging with or separated from the bands?

If you've answered "yes" to all these questions, then chances are you have a very nice optic. Is your telescope an Apo? Search for a halo of unfocused violet light – it might be ever so slight – around the planet? Don't just glance; have a careful look. Most ED doublet telescopes throw up some around Jupiter, but good triplet Apos will show little if any. Of course, aperture will have a bearing on what you can expect to see. Planets are hard objects to image, and their low-contrast surface and/or atmospheric markings are most easily discerned when the telescope is well corrected for Seidel errors as well as false color. If you're happy with the views your telescope serves up, then that should be the end of the matter for you!

Optical Reports and All That

The leading refracting telescope makers sell their telescopes complete with certificates of optical competency. Although this generally serves to reassure customers that the investment they have made has been justified, don't

let spot diagrams, Strehl ratios, and intereferometry reports cloud your visual judgment. This author once reviewed a 8-in. aperture scope whose manufacturer claimed had a Strehl of 0.99 (virtually perfect) but failed to split the famous Double Double in Lyra (Epsilon[1] and Epsilon[2]) – a task more suited to a decent 3-in. refractor. Most telescopes sold today are designed by opticians who probably wouldn't know a planet from a star. They're not astronomers. Rather they do what they do best, optimizing their designs for the maximum theoretical optical punch. Not surprisingly, these products provide textbook results when tested in a laboratory aligned on an optical bench.

After purchasing the telescope, the excited amateur astronomer takes it outside, into an alien world that is often far removed from the climate-controlled environment in which it was first contrived. Temperatures fluctuate wildly and winds induce vibrations. If that weren't enough, the act of moving the objective into different positions while going from one object to the next warps the optics (if only a little). Net result: the telescope fails to impress! Refractors, especially premium models, should be thoroughly field tested by manufacturers to ensure that they work in the field as they're supposed to. Telescope opticians should become star gazers, too! Let's reiterate this: The eye is the ultimate arbiter when it comes to the discernment of optical quality. Look, see.

Photography with Your Refractor

One of the great virtues of refractors, especially apochromats, is that their well-corrected, wide-field, unobstructed optics allow the user to create some great photos of both terrestrial and celestial objects. These photos are rich in detail and contrast and are faithful color renditions. In addition, refractors have more back focus than many other telescope models allowing cameras of all sorts to come to focus. For these reasons, some of the most photogenic nature and deep sky objects can be captured with small, ultraportable refractors with focal lengths in the range of 350–800 mm. In this chapter, we'll provide a brief overview of the field of photography using refracting telescopes. Of course, the interested individual is advised to consult some specialized books on the subject, some of which will be cited in the bibliography at the end of this book. Our aim here is to provide some essential information needed to allow you to get started in this exciting and constantly changing field.

Digiscoping by Day

It is fairly easy to begin taking nice pictures of nature with your small refractor, but it may take a lifetime to perfect the art. The simplest way of getting an image through your telescope is to simply point your camera into the eyepiece of your telescope. Such a "low-tech" approach has its limits, though, with less than perfect results. However, to do the job well and

N. English, *Choosing and Using a Refracting Telescope*, Patrick Moore's
Practical Astronomy Series, DOI 10.1007/978-1-4419-6403-8_15,
© Springer Science+Business Media, LLC 2011

achieve consistent results, you'll require an adaptor that holds the camera centered at the correct distance from the spotting telescope's eyepiece and which also holds the camera steady when the shutter is tripped, to minimize blurring from camera shake. This technique is called digiscoping.

The popularity of digiscoping has grown rapidly in recent years with the widespread availability of inexpensive digital cameras and a wide range of accessories that enable them to be easily mated to any spotting telescope. Digiscoping is especially popular with birders because it provides a means – if done well – of quickly capturing impressive detail and the essence of what the observer sees in the eyepiece. What's more, digiscoping is not even restricted to still photography anymore, as most consumer digital cameras have the ability to capture short video clips of the subject, and more specialized camcorders can also be attached.

There are essentially three parts to the digiscoping system: the spotting telescope, the camera you wish to use to capture the images in, and the mounting bracket you need to securely attach the camera to the spotting telescope. What follows are some brief notes on the author's experiences.

Fortunately, almost any modern spotting telescope can be used for digiscoping. Of course, the higher the quality of your instrument, the better results you will potentially obtain. Achromatic spotters will give you slightly lower contrast images with some false color, especially if used at higher powers. Apochromatic models fare better here.

A good tripod or mounting for the telescope is probably more important than the design of the telescope itself. Many modern spotting telescopes have features that are specifically designed to allow easy attachment of digital cameras. Almost any digital camera can be used, so if you already own one, try it before investing in anything new, as it may be an unnecessary purchase. A camera with a minimum of 3 megapixels (3 million pixels) will give quite good results but maybe not quite enough to allow you to make high-quality prints. A minimum of 5 megapixels is desirable for top-quality results.

Most modern digital cameras and camcorders have a zoom lens built in, and that's perfect for digiscoping. The zoom lens is essential for minimizing the effects of vignetting (darkening of the corners of the image), found when pointing the camera into the telescope eyepiece. It is best to avoid models that only offer a digital zoom feature, as they invariably produce inferior results compared with those with an optical zoom.

Superior results are obtained when the front element of the camera lens is the same size or smaller than the eye lens of your eyepiece. Thus, smaller cameras are generally more successful than big ones when used for digiscoping applications. How about an LCD screen? For digiscoping,

it's an absolute necessity! The bigger and brighter the LCD the better. Higher resolution LCD screens make framing the target easier as well as allowing you to achieve a sharper focus of your daytime target.

Does your camera have a remote release facility? It's a very useful feature if your camera can be operated from a remote or cable release mechanism. Because of the fairly high magnifications (up to 60×) employed by most spotting telescopes, it's best to keep vibrations to an absolute minimum. A cable release system allows the camera to be tripped or fired without direct contact and will keep camera the camera steady, ensuring pin-sharp pictures. Finally, you need the right camera bracket for your digiscope mount (for connecting the camera to the spotting telescope). Most of these brackets are designed to allow any camera with a tripod fitting to be easily and quickly attached to the eyepiece of your spotting telescope.

Digiscoping is fun and highly addictive! Press the shutter button and the picture can be instantly reviewed on the cameras built-in LCD display screen. If you don't like it, delete it and take another at your leisure. What could be easier? With such a large range of cameras on the market, it can seem hard to make a selection of a model that would be suitable for digiscoping needs. In fact, the majority of smaller cameras can be used with success.

Apogee Inc. has gone one step further by including a digital imager with their spotting telescope. Marketed as the Galileo IMKT-80 Imaging Kit/Spotting Scope ($349), it consists of an 80 mm F/5 refractor (the short tube 80 discussed in Chap. 3) and a 2-in. focuser that accepts a supplied 3 megapixel camera capable of capturing images in three modes – single, continuous, and timer released – as well as a video recorder. The camera images on a scale equivalent to a 37× eyepiece. The telescope also comes equipped with a 1.25-in. adaptor and a small tabletop mount with slow motion controls built in. For visual use, the package also includes a 45° erecting prism diagonal and a 25 mm eyepiece in an aluminum carry case. Although the optics are decent on these telescopes, the mount is too light to hold the telescope steadily. Consider upgrading to a sturdy photo tripod.

Want something similar but more high tech? In recent years a number of companies have started producing spotters with fully integrated digital imaging systems. One example is the Sky-Watcher/Acuter 70 mm spotting telescope ($299). This nifty little instrument delivers a bright image with its 70 mm aperture at 14× for visual use, but it's also got a built-in 3 megapixel digital camera to boot! The image is displayed on a color 2-in. LCD flip screen and run with two AA batteries.

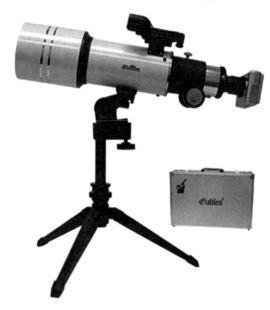

The Apogee Galileo IMKT-80 (Image credit: Apogee Inc.)

The Sky-Watcher/Acuter 70 mm imaging spotting telescope (Image credit: Optical Vision Limited)

One owner, a dedicated birder, had this to say about this instrument. "The 'scope itself is OK. Visually at 14× the Acuter gave fairly good views of wading birds and could capture enough detail for the purposes

The Minox digital camera module (DCM)

of identification. The camera and its functions are a different matter, though. The controls lack smoothness and are too clunky for my liking. If you want to zoom in, the controls are just too stiff, and you wind up moving the entire setup and focusing on a different view entirely! Maybe with some practice I can get it sorted out, but that is not what it said on the tin."

If you're in the market for something more sophisticated, you might like to take a closer look at the new MINOX Digital Camera Module (DCM). This nifty little digicam can be fitted to a variety of high-quality spotting telescopes, including those from Minox, Leica, Swarovski, Zeiss, and Kowa.

The DCM ($399) has very compact dimensions ($68 \times 56 \times 71$ mm) and weighs only 220 g, so portability is never an issue. The 2-in. color screen allows simultaneous viewing by more than one person. It's not only compact and lightweight, it is also watertight and shock-proof and so can comfortably be used in less than ideal weather conditions. A folding "flip-up" shield is a nice built-in feature that protects the viewing monitor and cuts down on glare to help you see the image more clearly. To store the image data this camera has an internal memory of 128 MB as well as a port for SD memory cards with a capacity up to 16 GB. The MINOX DCM comes with everything you need to get started, including a battery, soft pouch, wireless remote control, USB cable, and manual.

Sounds like a great package, but is it significantly better than the cheaper 3 megapixel digiscopes described previously?

Frank Bosworth, a very experienced birder from Oban, Scotland, uses the Minox DCM on his Leica spotting telescope. Here's what he had to say about it: "For nesting or slow-wading birds, or languishing seals you can get some very decent shots with little or no vignetting at the corners of the image, but I find it next to useless on fast-moving things. You have to keep refocusing the telescope all the time, then retighten up the tripod, which is a nuisance, to say the least. I have also had a bit of trouble keeping the camera on the telescope. It's easy to fit on the telescope, all right, but not so securely that you can move about with it while it's attached to the spotter. All in all, I'm very happy with the unit and would recommend it to other birders in the market for a no-hassle (well relatively speaking) imaging unit." The moral of the story is that capturing the finest wildlife images takes skill, patience, and a sizeable measure of good luck.

Imaging the Night Sky

Small refractors in the 2.4- to 6-in. (60–150 mm) range are ideal for framing the vast majority of interesting and colorful deep sky objects at night. What follows is a distillation of notes from Doug Sanquenetti, a highly accomplished astro-imager from Cicero, Indiana, who images almost exclusively with 4- and 6-in. refractors – a Takahashi TSA 102 and TMB 152.

For deep sky imaging, a CCD camera fares better than a digital camera because the former has dramatically less electronic noise and is cooled (typically 30° below ambient temperature), which allows you to take longer exposures. That said, digital cameras make excellent solar, lunar, and planetary imagers. With a wide variety of CCD imagers now on the market, the question naturally arises as to which one best matches your refractor. You'll have to consider a number of things – the CCD pixel size and its sensitivity, whether or not it has a blooming or anti-blooming facility, and the actual size of the CCD sensor you decide to use, for example.

A picture element, or pixel, may be thought of as a photon (the smallest piece of light you can get) counter. For color images, each pixel is represented by three numbers registering red, blue, and green photons. Pixels are arranged in an array of rows and columns, with each pixel counting the number of photons striking it. More photon hits correspond to brighter pixels. All the pixels combine on the screen to simultaneously create the final image. Seeing conditions on any given night will limit the image scale, the resolution to which your images will be limited. For

most locations an image scale of 2–4 arc seconds per pixel will be most useful. But on nights of exceptional seeing, 1–2 arc seconds per pixel will be possible.

To calculate how much of the sky each pixel is imaging, simply divide the pixel size (in microns) by the telescope focal length (expressed in millimeters), and finally multiply the result by 206:

$$\text{Image scale (arc seconds per pixel)} = \text{Pixel size (microns)/focal length (mm)} \times 206$$

Most CCD imagers use a technique called binning, which combines groups of pixels together in different ways, giving you, in effect, different pixel sizes with the same camera. This allows you to match pixel size to your telescope's focal length more flexibly. In general, for a given telescope, small pixels require longer exposures but provide greater resolution. Binning also reduces the final image size because the image is made from fewer pixels.

Blooms are artifacts created when a pixel that images a bright object becomes saturated and overflows with light. As a result it leaks into surrounding pixels and causes a "bleeding" effect in the image. Now, if you have a CCD camera with an anti-blooming gate installed, it renders it less sensitive than one that has no anti-blooming gate. So, a camera without an anti-blooming gate is better if you plan to do photometry.

The Bubble nebula (M8) as imaged through a William Optics FLT 110 triplet Apo (Image credit: Kurt Friedrich)

That said, most good CCD imaging software can remove the effects of blooming from your images, if required.

Recently, large chips have become available to the astro-imager. These chips are the same size or larger than a 35 mm film negative. As you might expect, these large-format chips do provide a very wide field of view. That all sounds great, but there are a couple of things you need to remember. Large chips are usually less sensitive with quantum efficiencies (the percentage of photons hitting the CCD chip surface that registers an electronic effect). More sensitive large-format chips are available, but they're very expensive. In addition, your telescope must produce a flat field large enough to cover the chip.

Currently, only four-element designs such as the Pentax SDUF, Takahashi FSQ, and the TeleVue NP series produce readymade telescopes with nice flat fields ready for wide-field CCD imaging. If you plan to image with a triplet or doublet Apo refractor, you'll need to buy a field flattener. Most leading refractor manufacturers now produce their own dedicated field flatteners, which usually shorten the focal length of the telescope as well. Of course, good results can also be obtained using field flatteners that are of a different make from your own telescope. Quite often, though, you'll need to do a little tinkering to adjust the spacing between the reducer and the camera to get the best results.

Most CCD manufacturers now offer so-called "single shot" color cameras that simplify imaging considerably and can be had for prices that no longer break the bank. However, these are usually less sensitive than monochrome cameras. In addition they don't do narrow band imaging as well as their monochrome counterparts. Single-shot color cameras also lose some resolution because each pixel only records only one color. Most advanced CCD imagers use monochrome CCD cameras and a variety of filters such as hydrogen alpha (Hα), OIII and Sulphur II. These can be combined by mapping each emission line to a particular color (red, green, or blue) to render a false color or "mapped color" image. One downside to using monochrome cameras is that, while using narrow band filters, longer exposure times are required, and finding bright guide stars through these dim filters can be very difficult.

When taking long exposures (>1 min), you'll need a dedicated guiding system. That can be done in a number of ways. Some CCD cameras such as Starlight Xpress have a built-in autoguiding facility. The advantage of this approach is that it avoids the need to get a separate guiding camera and telescope. It also "sees" what the imager sees, which reduces flexure in the optical train. In addition, you have the advantage of being able to pick any star in the field of view as your guide star. The disadvantages of

The Majestic M20 and its hinterland taken through the Takahashi FSQ 106 and the Canon 20DA (Image credit: Bill Drelling)

M8 imaged in hydrogen alpha light using a Takahashi FSQ 106 (Image credit: Bill Drelling)

The majestic Pinwheel Galaxy (M33) imaged with a Takahashi FSQ 106 refractor (Image credit: Bill Drelling)

using so-called self-guiding systems such as these is that half the imaging exposure time is used to guide and the other half to image, so longer exposure times are again required. Other approaches involve using a dedicated guide telescope and guiding by eye using an illuminated reticle eyepiece. Alternatively, one can purchase a relatively inexpensive autoguider (such as the Meade LPI and Orion Starshoot). Of course, such a set up must be very securely mounted to avoid flexure during the exposure.

Anyone wishing to pursue this hobby needs to be aware of some fundamental facts. The focal ratio of your telescope determines the exposure time *and not* the aperture. Lower focal ratios are said to be "faster" and allow shorter exposure times compared with "slower" telescopes with bigger focal ratios. Larger apertures provide better resolution, and longer focal lengths produce smaller fields of view. With short focal ratio refractors (typically up to 400 mm in focal length), short, 30- to 60-s unguided exposures are eminently possible.

Of course, you can have in your possession the very best imaging camera and telescope and still get poor results if you image on a shaky mount. On the other hand, you can get great images using relatively

inexpensive imaging equipment if you use a very stable mount. Most amateurs adopting refracting telescopes for astrophotography use some form of German equatorial mount. This can be made to track very accurately, but its Achilles heel – with the possible exception of state-of-the art high-end models – is that it tracks least well near the meridian (your local north–south line) when most objects of interest are at their highest (and best) position for imaging. Now, many amateurs have approached astro-imaging through a small refractor in an entirely different way. By mounting your refractor and CCD camera atop a large Schmidt Cassegrain telescope (SCT), you can image by setting the refractor to work capturing photons while you guide the exposure by looking through the larger telescope. Neat!

Whatever method you adopt, it pays to spend that extra 5 min accurately polar aligning your mount-telescope combo. That extra bit of effort will pay off in smoother and easier guiding. Always try an easy and relatively bright celestial target first, and confine your efforts to one object per night. Of course, have a laptop ready to download those images from your CCD! Test it a few times before making the real exposures you're after. It also pays to learn how to use your imaging software properly. Remember, most beginning CCD imagers have a tendency to over process their images. It pays to remember that each time you perform a modification of your raw image, some information is jettisoned. And no amount of processing will turn a bad raw image into a great astrograph.

Small refractors, as we have seen, provide excellent platforms for all kinds of photography. Whether it's imaging wildlife by day or distant star clusters and galaxies by night, their unobstructed optics will get you there. In the next and final chapter, I'll be taking stock of the amazing and fast-moving universe of the refracting telescope, exploring its future and giving you a compelling reason not to forget the genius of our telescopic forebears.

CHAPTER SIXTEEN

Looking Back,
Looking Forward

Introduction

Refractors are the royalty of telescopes. Their amazing variety of form and function is truly astonishing, reflecting, no doubt, the great popularity they enjoy with amateur astronomers, birders, and collectors alike. As we've seen, purchasing a good all-around refractor will not break the bank, and even a modest investment will secure an instrument that will serve up a lifetime of great views.

The biggest change in recent years, of course, is the proliferation of low-cost Apo models using synthetic ED glass. A century ago, the keen amateur astronomer had a long focus instrument with an uncoated lens, typically an F/15, in apertures ranging from 3 to 6 in. Although a 3-in. instrument was affordable (after saving for some time, perhaps) to the average working man, 6-in. instruments were prohibitively expensive to all but the most wealthy of individuals.

How times have changed! In the early twenty-first century, a small refractor of high optical quality can be had for less than half the weekly salary of the average US worker. Back in 1910, there was little or no way to dodge the issue of size; achromats of great optical quality could only be made in long focal length formats. In 2010, portability is the new driving

N. English, *Choosing and Using a Refracting Telescope*, Patrick Moore's
Practical Astronomy Series, DOI 10.1007/978-1-4419-6403-8_16,
© Springer Science+Business Media, LLC 2011

force behind the advent of the Apochromatic era – an era that really only started when Synta unveiled their affordable ED 80 refractor in 2004. Since then it seems, small, high-performance Apos have been on everybody's shopping list.

Doubtless, the rapidly growing activity of CCD imaging has played a major role in shaping the direction in which much of the high-end refractor market is now headed. After all, it was the truthful eye of the CCD camera that revealed the weakness of achromats and ED doublets in showing up spurious color around bright (and not so bright) stars, necessitating the need for three-element designs with still better correction. And, in turn, the cold and calculating CCD camera has unveiled the deficiencies of the triplet Apo, which included field curvature. Thus, we have arrived at the four-element flat field Apo – a group of multipurpose instruments with extraordinarily short focal ratios (F/4 or F/5), capable of rendering the most illustrious wide-field images of the variegated cosmos in which we live.

And if optical perfection (>0.99 Strehl) has been achieved in a modern Apo, where else has the refractor to go in the decades ahead? Included here are the opinions of a few optical gurus willing to hazard a guess. "The ideal telescope is one with 100% light transmission, zero Seidel errors, and longitudinal color and zero mass," England's Chris Lord said. "People want a powerful portable telescope with a wide field of view, for as little as possible. That is the market driver. The future lies in even shorter optical tubes with multi-element, maybe even hybrid objectives, faster than F/5. The technology already exists and is in big telephoto lenses used by sports and wildlife photographers. Super-low-dispersion glass, hybrid aspherics, and molded glass ablation figured. A hybrid element is one in which a resin element is bonded to a glass substrate. This technology was used in the Leitz Super-wide aspheric eyepiece. It is now being introduced into top-of-the-range spotting 'scopes, and it's only a matter of time before it will be used in smaller ultra-compact Apo's."

Lord had even more interesting things to say about eyepieces. "The future of the refractor is also linked to the future of the eyepiece. Fast Apo objectives lend themselves to hyper-wide angle eyepieces. It will be only a matter of time before 120° hyper-wides are marketed. It's taken 30 years to progress from 70 to 100° apparent field of view. It will probably be only a decade or so before 120° eyepieces are realized. That's not new either," he said. "There were 120° eyepieces designed and made in the 1960s by the German and US military. Another unheralded development in eyepiece optics (currently only found in digital camera lenses) is diffractive optics."

And what of the humble achromatic doublet? Is it destined to fall on the trash heap of human imperfection, especially now that ED lenses with improved color correction can be made cheaply? Chris Lord was pretty resolute in his answer. "The achromatic will have a future, as a finder, in binocular objectives, and in both terrestrial and small astronomical refractors. It will also be required for specialist instruments as one-offs," he said. "But for anything larger than medium aperture astronomical refractors, I don't think so. Tube length, optical tube mass, and concomitant mounting costs make the Apo better value."

Barry Greiner is the co-founder of D & G Optical and maker of very fine, large aperture (5-in. and upwards) long-focus achromats. He was asked about whether he thinks long-focus telescopes like the ones he builds will be around at the end of this century:

"Every telescope has its strength and weaknesses," Greiner explained, "and D & G refractors are no exception. Our customers know exactly what they're getting when they make a purchase. D & G 'scopes appeal to a certain type of observer, and I have every confidence that these classical refractors will be around a century from now!"

Utah amateur Siegfried Jachmann, whom we met back in Chap. 6, where he described his acquisition and use of a fine 9-in. Alvan Clark refractor of 1915 vintage, is also the proud owner of one of the finest

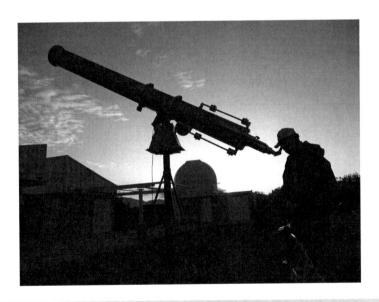

A 9-in. Clark refractor awaits a Utah sunset (Image credit: Siegfried Jachmann)

"large aperture" Apos money can buy – a TEC 160 oil-spaced triplet. Now, here's a man with a weird and wonderful collection of the old and the new. Which did he prefer?

"I think it can be fairly said that they are different experiences, with each telescope having its strong points with few weaknesses. The advantage of a long focus refractor is in the delivery of a sharp, steady, contrasty image. The focal length needs to be long enough for the chosen glasses to be nearly color free. The long focal length allows relatively inexpensive eyepieces to work well and some highly corrected eyepieces extremely well.

"It cannot be overstated how important the depth of focus is to the viewing experience. Without having to constantly re-focus and chase focus an observer can study an image for extended periods of time. The advantage of an Apo is that you get much of that, except the depth of focus, in a smaller package. Even at the shorter focal ratios, the high end Apo tends to have better color correction than even a long focus achromat. The reason is simple. In most cases it becomes impractical to make the refractor long enough to suppress the chromatic aberration to the level of an Apo. This factor becomes important in viewing the objects of which refractors excel. Chromatic aberration is at the very least a distraction and at worst, degrades the image quality.

"In looking at the Moon side by side with an 8" F/12 refractor I prefer the image of a 160 mm Apo simply because of the lack of the purple cast to the image in the 8-in. The same side by side with a 6-in. F/17.5 – it's a really tough choice if based only on the image. Both views are essentially color free and very sharp. The long focal ratio has so much depth of field it holds the image better than the 160 mm F/8. There is no more or less detail favoring either scope. Based just on image quality my preference would be a long focus achromat. However, the length required of such an achromat quickly becomes impractical. The rule of thumb is a focal ratio three times the diameter. In the case of the 6-in., F/17.5 is very nearly there. But an 8-in. F/24 is problematic. So the long focus refractor quickly becomes a compromise. Length and focal ratios are sacrificed and chromatic aberration is compromised.

"When all things are considered, except cost, I believe the modern Apo is the finest all-around inch for inch telescope. My 160, while optically slightly larger than the 6-in. F/17.5, is physically smaller at F/8 and is easier to transport, set up, and use. It is a much more practical telescope. The slight size advantage can be seen on critical objects. However, at any given time, my telescope of choice would still be my 9-in. Clark. Yes it's more work to transport, set up, take down, and use, but there is more to the viewing experience that just looking through an eyepiece. There

is also the presence, the ambiance, of a magnificent instrument sticking 14 feet in the air."

The Hidden Strengths of the Achromat

Suppose you have a passion for looking at double stars. After spending many happy years looking at your favorite doubles using 4" F/10 achromats, you decide to take the plunge into the brave new world of color-pure observing. Now, it has been said that once you get a taste for the color free, there's no going back to achromats. But it may not be as easy as that. There is no real advantage with Apos in regard to their ability to split even the toughest pairs for this aperture class. In fact, there is not likely to ever be a pair to split by an Apo that you couldn't split in your humble achromat.

As the many testimonies gathered in this book show, Apos serve up awesome views on high contrast objects such as planets and Luna, but it is interesting to note that achromats, despite showing modest secondary spectrum, in no way hinder your ability to split doubles. And that is seriously puzzling. While this book was in preparation I carried out some research in collaboration with optics expert Vladimir Sacek. To gain further insight into the differences between classical achromats and apochromats, it is necessary to assess their performance over *all* visible wavelengths. This is achieved by measuring how their polychromatic Strehls (found by integrating all the Strehl values over the visible spectrum) change as a function of linear defocus. So, Vladimir took the problem to OSLO. And boy, were we in for a surprise!

Fig. 1 shows how polychromatic Strehl changes as a function of linear defocus for a 4" F/15 achromat and a F/6.3 doublet apochromat of the same aperture with a 0.05 RMS spherical aberration (1/6 wave P-V) error. The error in the latter scope was considered typical based on a bench tests conducted on a variety of doublet apochromats carried out by Markus Ludes (APM) and presented on Cor Berrevoet's website http://aberrator. astronomy.net/scopetest/. For the record, the data is weighed by photopic eye sensitivity for 25 wavelengths between 440 nm and 670 nm (using 10 nm intervals, except the e-line).

The grey plots are those for the apochromat. The red plots are for a high F ratio (F/15) achromat. These graphs demonstrate some points already mentioned, namely, that the greater the F ratio and lower the

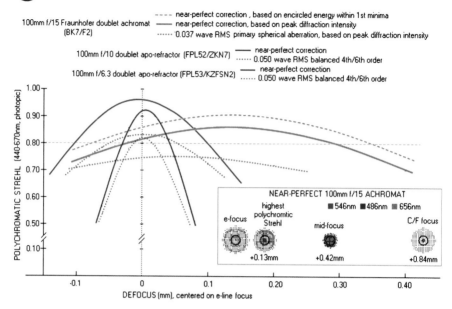

Fig. 1. Graph showing how polychromatic Strehl varies as a function of defocus for a sensible perfect F/15 achromat and a F/6.3 apochromat.

spherical error, the greater the diffraction limited defocus range (0.8 Strehl on Fig. 1). But they also reveal that the high F ratio achromat has some remarkable properties! First, let's get acquainted with the curves.

As expected, the F/15 achromat has a better polychromatic Strehl than the apochromat with 0.05 RMS level of e-line correction error. The steepness (gradient) of the parabola indicates the defocus sensitivity of the instrument and you can clearly see how the 'slow' achromat enjoys a diffraction limited defocus range nearly three times larger than the 'fast' apochromat.

Intriguingly, Fig. 1 also shows that the location of best polychromatic Strehl in the F/15 achromat is significantly higher than that exhibited at the e-line focus. Notice especially that the peak is offset toward the yellow 580 nm/green 520 nm focus. This is caused by all the other visible wavelengths – including those to which the eye is very sensitive – focussing behind the optimal visual wavelength.

It is the defocused nature of chromatic error in the achromat (which increases exponentially towards the ends of the visible spectrum) that

places more energy in the central maxima for a given Strehl value and less in the rings area, especially the first bright ring.

The finding that achromats have a greater amount of encircled energy for a given Strehl, to my knowledge, has not been reported in the literature before. Certainly, the time-honoured authorities such as Conrady and Sidwick, make no mention of it. Nor is there any relevant discussion of this subject matter in any of the contemporary optics texts. I ask, in all humility, just who would explore such a novel and obscure avenue such as this? For these reasons, I propose that this significant discovery be credited to Vladimir Sacek, and henceforth I suggest we refer to the phenomenon as the "Sacek Effect."

So, there could well be an optical explanation to support these impressions gathered in the field? The surprising properties of the long focus achromat, embodied in the Sacek Effect, provide a robust explanation.

One of the first things you'll notice if you look through a high quality classical refractor is that the Airy disks really 'pop', by which I mean, they are clearly discerned with very subdued diffraction rings. Now, both *spherical aberration* and *defocus* have the effect of subtracting light from the Airy disk and adding it to the diffraction rings.

Observers judge atmospheric conditions by measuring the extent to which these rings degrade from moment to moment. If the rings are brighter, atmospheric turbulence will cause them to jiggle about more. Because the long focus achromat exhibits lower spherical aberration and suffers less from a focussing inaccuracy, the Fresnel rings surrounding the Airy discs will be far more subdued, even in fairly bad seeing, compared with the less well corrected apochromat, with its greater defocus sensitivity and greater spherochromatism (which also brightens the rings). These data, together with the greater elevation of the classical refractor away from body and ground heat, would almost certainly cause the observer to report that the images are steadier. If there is substance in this idea then achromats, especially high-end models, must surely have a bright (and colorful) future. An Apo is clearly overkill for this kind of work.

As we saw in Chap. 2, all aberrations fall off rapidly as focal ratio increases. We've listed them again here for convenience.

Aberration	How it scales
Spherical	$1/F^3$
Astigmatism	$1/F$
Coma	$1/F^2$
Distortion	$1/F$
Field curvature	$1/F$
Defocus	**$1/F^2$**

Now, well designed short focal length Apos can be well corrected for all five Seidel aberrations (the first five listed above), with excellent color correction. But does the lack of false color create some sort of Royal Road to superior image quality? To answer that question we needed to do some testing.

For these tests, we used a little Vixen A80SS (formerly known simply as the 80SS) and a standard Shorttube 80 (both 80 mm F/5 achromats). The former costs twice as much as the latter, so you'd expect a difference in performance. Both telescopes deliver nice low power images during daylight, but when you push the magnification to 40× or so, most anyone would notice an immediate difference. Both the Vixen and the generic Shorttube throw up comparable "gobs of color" around bright objects, but there the similarities end. The Vixen units all rendered images that remained sharp at powers up to 150× – almost twice those comfortably held by the generic model. Star testing one such unit showed very well corrected optics and much less spherical aberration – definitely a step up from the mass-produced F/5 ShortTubes. The lesson was clear: when you tidy up the Seidel (especially spherical aberration, coma and astigmatism) aberrations you get a telescope that truly breaks the mold. This takes on a whole new meaning when you compare long-focus achromats to comparably priced Apos. In a nutshell, you can have a telescope that is superbly corrected for the Seidel aberrations, but compromising in its color correction or vice versa. So which is better? Both camps claim victory, as evidenced by the heated debates conducted here and elsewhere over the years.

Fig. 2 shows how Strehl ratio (a measure of optical quality) varies over the visual wavelengths for a "typical" small 3.5-in aperture ED doublet and also for a 3.5-in. F/15 classical achromat.

Although the data presented in this graph may not be characteristic of the design performance of the instrument, it could well be typical for its genre. How are we to interpret the differences? Though short-focus ED doublets have undoubtedly better color correction than their longer focus achromatic brethren, it doesn't necessarily imply better image quality. Note especially the middle of the graph – covering the wavelength range over which the eye is most sensitive. Note how the Apo's Strehl value is lower in the green (550 nm) than the long-focus achromat which has a higher value (~0.99) over the same wavelength range. What's causing this?

In short, the F/6 Apo has a less well figured lens than the F/15 achromat. Greater Seidel errors in the faster Apo are the most likely culprits. This is the principle reason why long-focus achromats throw up excellent images despite their lower polychromatic (measured over all wavelengths) Strehls. Some might quip that a difference of a few percentiles can't result

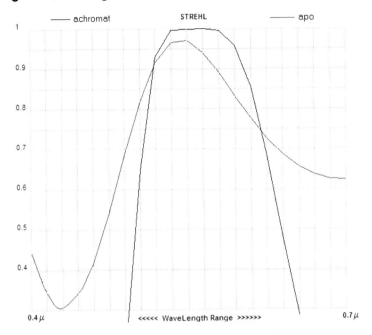

Fig. 2. Strehl ratio versus wavelength for an 88 mm F/6.7 APO and an 88 mm F/15 achromat. Image Credit: Yang Lim.

in a significant improvement in image quality. That might be true at red and blue wavelengths, but as the eye is about an order of magnitude more sensitive to green, the difference is greatly accentuated. Could a casual observer tell the difference? You bet!

But these graphs also reveal that Apos and achromats really are entirely different beasts. The achromat's inability to precisely focus longer (red) wavelengths (notice the huge red "throw out" of the achromat compared to the Apo) plays with the eye in a fundamentally different way to the Apo. There's something comforting about the faint blue halos thrown around otherwise white double stars at powers of 100× or so and the subtle shades of yellow achromats impart to Saturn and Jupiter. The Martian deserts have a pale, greenish marinade, while they appear more of an austere fawn through the Apo. You can begin to understand how the planetary observers of yesteryear imagined them to be vast tracts of vegetation! You could possibly say that one can learn to love the color the achromat delivers to the retina. Of course, it's an entirely personal perspective.

The long-focus achromat might have other advantages still. As you can see from the table earlier, we've deliberately bolded the one that longer focal ratio telescopes enjoy less – defocus aberration, or, in other words, they've got more depth of focus. As was explained earlier, long-focus telescopes produce more stable images. At first one might think that their greater elevation off the ground and away from heat sources might provide the complete answer, but, as it turns out, it may well have a basis in physics, too.

Earlier in the book, I stated that long focus refractors produce more stable images. One reason is due to the more sensitive focussing requirement of an instrument with a shallow depth of focus. Their entrance pupils are also further off the ground, away from both ground and body heat. After consulting with Vladimir Sacek, I discovered that quantitatively, the allowed defocus range remaining at the conventional "diffraction-limited" level, or better, is given precisely by the expression $4.13\lambda(1-16W^2)^{0.5}F^2$ (TelescopeOptics.net), where W is the P-V wavefront error of primary spherical aberration present. As more spherical aberration is introduced, the allowed defocus range rapidly diminishes and actually becomes zero when $W = \frac{1}{4}$. Thus, any additional seeing perturbation introduced to the system could adversely affect the image, impelling the observer to refocus frequently in moments of poor seeing.

Based on these ideas, here is the empirical result:

Image stability α (F-ratio)2

And therein seems to lie the Achilles heel of the modern, compact Apo. There's no way around it, either – unless you purposely build a very high focal ratio Apo – and it's ever present, irrespective of what compact Apo design you consider. To date, there has not been sufficient attention paid to this aberration, especially in relation to observers who live in turbulent climes. For these reasons, you might want to turn your back on the exciting Apo market and put your faith in a modern long-focus achromat of classical design. Remarkably, a number of amateur astronomers including Loren Toole from New Mexico, U.S.A., Jim Barnett and Ging-Li Wang of Petaluma, California, U.S.A. and the Canadian Clive Gibbons, have confirmed this to be true in careful field tests.

Which ever way you look at it, a high quality achromat of high F ratio is best seen, not so much as ancestral to the modern apochromat, so much as being its legitimate sibling. Like the fabled Goldilocks, younger brother 'Apo' is an all together more sensitive creature. Everything has to be 'just right' in order for it to reach its dizzying optical heights. In good seeing, 'Apo' serves up better colour corrected images over the visible spectral range. But the compounding effects of greater spherochromatism, larger seeing induced focussing inaccuracy and greater proximity to ground and body heat, conspire to render the short focus apochromat more unstable.

In contrast, Elder brother Achro is a 'big bruiser,' being far less sensitive to changing temperatures, focussing inaccuracies, and, by virtue of greater elevation off the ground, less prone to convective turbulence. Perhaps most remarkably of all, 'Achro' has a secret weapon, buried deep in the wave theory, which gives it an edge over younger brother Apo, especially in relation to image stability.

A Personal Favorite: the Skylight F/15

What is the *ultimate* telescope for indulging a passion for double star observing? Not necessarily some ultra-compact high-end apochromatic. Portability is important here if you like to set up and get to observing in less time. The D & G achromats, while remaining dream scopes, were not an option, as the smallest instrument currently being made by the company was a 5-in. F/12 instrument that would be prohibitively cumbersome, given a need to move the scope a few times during a typical observing session. Nor would it be nearly as well corrected (CA index 2.4) for color as a 4-in. F/15 instrument (CA index 3.75). The beautiful, all brass, long-focus achromats made by I.R. Poyser (Wales, UK) are a great temptation, but they are prohibitively expensive (and maybe a bit too decorative for some tastes) and are not nearly long enough. That left the more economical 105 mm F/15 Antares Elite Series achromat (discussed in Chap. 5) as the only viable option. It would have, from a visual perspective, color correction approaching that of a short focal ratio ED doublet and minimal Seidel aberrations. But it would also have a huge depth of focus, nearly an order of magnitude more than an F/5 Apo!

But wait! There's a curious new instrument to consider, called the Skylight F/15, a hand-built 4-in. F/15 classical achromatic refractor inspired by the golden age of English telescope making and the refractors of T. Cooke & Sons.

Having had an opportunity to evaluate the performance of the Skylight F/15 prototype, this author asked its designer, Richard Day, of Skylight Telescopes, London, what his motivations were in designing such an "antiquated" instrument in view of the current trends towards miniaturization in the Apo market. His answers were impressive, as was his knowledge of the design of achromatic refractors from the Victorian era. I decided to make a purchase. Six weeks after placing an order with Skylight, the instrument arrived. Layer by layer, the meticulously wrapped refractor was unveiled, revealing how utterly enchanting

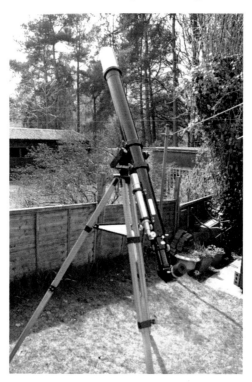

The Skylight F/15 ready for a night under the stars (Image by the author)

shining brass presents against the long, slender lines of a charcoal black, powder-coated tube. And boy did it go on and on! Spanning 1.6 m in length from tip to toe, you could pole vault with this telescope! Seriously, though, it's immediately obvious that the maker of this instrument ardently tried to connect the owner with the halcyon days of F/15 refractor building. The finder telescope was found in a lovely decorative box along with a personalized note from Day providing brief instructions on how to get the most out of the instrument.

Let's work our way around this beauty. Starting with the dew shield – well, what can one say? Nearly 10 in. long and made of solid brass! I'd never seen this on a Cooke refractor before, though another British firm of repute, William Wray of London, who flourished in the mid-nineteenth century, did produce very fine instruments for the serious amateur astronomer with brass dew shields equally long, relatively speaking.

The cell is fitted with a flange that mates with the corresponding flange on the main tube of the telescope, and the flanges are held together by

The Fraunhofer achromatic doublet objective of the Skylight F/15 (Image by the author)

three, equally spaced brass bolts. The lens cell flange is also provided with three equally spaced push bolts, so that the objective lens can be collimated. This fluted lens cell is characteristic of the types used by many of the finest craftsmen of the Victorian era, including those by Wray, Clark, and Cooke. Inserting a Cheshire eyepiece into the focuser, I did some minor tweaking with a hex key to achieve essentially perfect collimation. The Japanese-made objective is of older pedigree – a classic Fraunhofer air-spaced doublet that is still widely acknowledged to be the optimal optical design in achromats for the elimination of coma and spherical aberration. The anti-reflection coatings, though meticulously applied to the lens, are very subdued, with a pale lilac tinge, and light transmission appears to be excellent. Indeed, were it not for the presence of these coatings, the objective probably wouldn't have looked out of place on a mid-nineteenth-century instrument.

Removing the objective, you can really see that Day has done his homework with this telescope. The interior is matte black with knife edge baffles carefully positioned, as derived from optical ray tracing. That much was obvious when I was able to detect faint stars right down to the magnitude 14 limit (at my site) of a 4-in. aperture. Incidentally, a 3-in. Cooke I examined had similar baffles in place, only in the Skylight there were fewer of them.

Moving to the brass finder and its bracket. Again, totally and utterly unique! Japanese-made, it actually came as part of a complete observing system, with a brass tabletop mount and three 0.96-in.-sized eyepieces marked 20, 30, and 50×. It has what appears to be a single magnesium

fluoride-coated objective with a clear aperture of 40 mm. Its retractable (yes, retractable!) dew shield glides smoothly along the body with a satisfying amount of tension. A rack-and-pinion focuser holds a very charming little prismatic diagonal that can be freely rotated to obtain the best viewing position relative to the eyepiece of the main instrument. Optically it is quite good and delivers a well corrected field of about 2° with the 20× ocular, which proved surprisingly useful, as will be explained shortly.

The finder bracket had an interesting background, related in conversations I had with Day by phone while the telescope was being built. "I wanted something special for the finder, but I could find nothing as an off-the-shelf item that was suitable. As a result, I decided to use this as an opportunity to have something custom made. The final result is unique, and I'm very pleased with it. I admit that the style of adjustment screw is an unusual choice...they were suggested by the company who made the brackets. They had some new/old stock that had been around

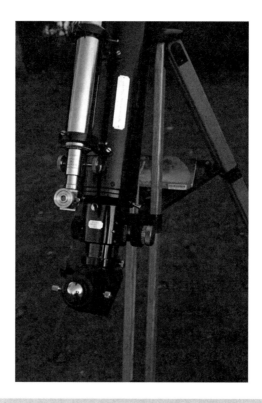

The brass finder and Baader Steeltrack focuser on the Skylight F/15

for many years, and they thought they would look good. They fit well into the ethos of the instrument. Those screws are old, and that patina is real (however, I've not got an endless supply). Indeed these types of screw were in vogue when T. Cooke & Sons were still making telescopes! I liked that thought." Mounted against the "Darth Vader" black of the main telescope, its brazen caste is similarly proportioned to those found on the classic achromats of yesteryear.

The focuser – a very high quality Baader Steeltrack design, with a nicely color-matched 1;10 microfocuser – is obviously a big departure from the simpler rack and pinion used by the ancestors of the Skylight F/15. Its fit and feel is robust and the motions are ultra smooth. When racked out rapidly, the focuser makes a curious "whirring" noise. A simpler rack and pinion design would have been fine on this telescope, but having the extra luxury afforded by the focuser was a nice bonus. The solid brass focus plug is another unexpected and appreciated novelty.

As a visual observer, you probably have a strong preference for simple, non-nonsense observing with minimum set up time. And while those

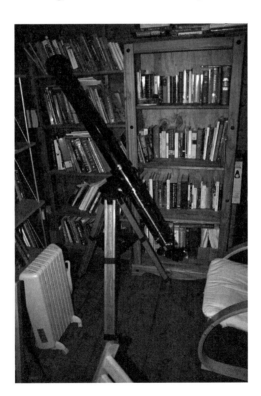

The ultimate in office décor (Image by the author)

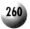

wishing to carry out measurements of double stars will obviously want to dedicate this refractor to a sturdy motorized equatorial mount, you might prefer the elegant simplicity of a stable, yet portable alt-azimuth. The TeleVue Gibraltar is a good overall match for the size and weight of this telescope (8 kg with the dew shield and just under 7 kg without it) and you can opt for the same company's mounting rings to securely fasten the Skylight F/15 to the mount head, using two large wing knobs. Set up takes just a few minutes, and the mount offers just enough tension to allow you to track objects – even at high magnification – across the sky. When you're finished observing, the instrument can be stored neatly in a corner somewhere.

One of the first things you'll learned while using the Skylight F/15 in this mounting configuration is the undue heaviness of the brass dew shield. Removing it conferred two advantages. First, the scope became considerably less front heavy (over a kilogram less, actually), allowing the telescope to be pushed forward a bit. That brought the objective further off the ground, raising the level of the eyepiece a little that made for more comfortable observing when the instrument was pointed near the zenith. Although there is something utterly compelling about seeing a telescope objective elevated 8 feet off the ground, it also has a practical function. Heat emanating from your body and the ground below you is effectively dissipated by the time it reaches the objective, leading to less turbulent views.

The optics on the Skylight F/15 are first rate. Think Takahashi in a classical accent. In careful star tests you could not detect coma, astigmatism,

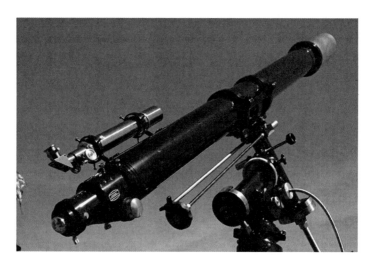

The Skylight F/15 astride the Unitron equatorial mount (Image credit: Richard Day)

field curvature, spherical aberration, or distortion of bright stars. It had, as expected, a trace of false color around first magnitude stars while in focus and only at powers of 150× or so. With a chromatic aberration index of 3.75, it well exceeds the Sidgwick standard (>3) and approaches that of the more stringent Conrady standard (>5), so you'll never complain about the color purple in this telescope. Star testing reveals textbook perfect results, with very similar intra and extra-focal images. Eyepieces such as the Meade 56 mm Plossl, which shows up any mild astigmatism when used with a F/6.3 Apo scope, performs like a champion in the Skylight F/15, with pinpoint stars right to the edge of the field. With that eyepiece you could achieve a near 2°field, which is wide enough to frame most deep sky objects comfortably. That said, this instrument isn't really a rich-field scope.

Although the big Plossl worked well with the Skylight F/15, I refrained from using it very often, as it tended to introduce a slight imbalance (heavier toward the back) compared to when used with a 1.25 eyepiece. The remedy came in the form of the 20×40 mm finder, which serves up a similar field of view to the 2-in. eyepiece.

The Skylight F/15 takes magnification with poise. You can enjoy comfortable views of double stars at powers well beyond the oft-prescribed 50× per inch of aperture in average conditions, and tests on the Moon showed that you could easily push the optic to 100× per inch of aperture on steady nights. One thing you'll notice at these high powers is the strikingly large size of stellar Airy discs caused by the telescope's long focal

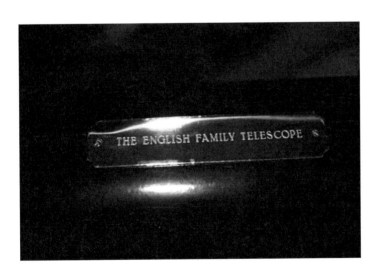

(Image by the author)

ratio. Charging the Skylight with a power of 375× on a calm October night, I watched in amazement as the four components of the Lyra Double Double floated across the field of view, their tiny yellow-green "globes" rippling in the seeing. It was impressive at how steady the image held at such high magnifications, something difficult to achieve with shorter focal ratio scopes, irrespective of their specification. Mars, hurtling towards its January 2010 opposition, displayed tack sharp, high-contrast details that were comfortably held at 214×. Despite its diminutive size (11 arc seconds), you could more easily make out all the details that a premium 4-in. F/8 ED doublet could discern, most notably a prominent northern polar cap, traces of a southern cap, and a wealth of detail in the mottled Martian tundra during moments of fine seeing.

The Skylight F/15 is a beautifully designed and well executed instrument. OK, maybe it's a little ostentatious, but you can get used to that, too! All in all, this simple, elegant instrument has helped fill a great void that separates us in space and time from the workshops of the great refractor builders of the nineteenth and early twentieth century, and no mass market telescope can do that. Far from being a copy, it's a truly novel and well studied re-interpretation of the best the past has to offer. It will appeal to the heart as well as the mind. And a telescope like that ought to stay in the family!

Lessons from the Past

Using the Skylight F/15 and other long focal length telescopes has been an inspiration in more ways than one. It has helped this author to resolve some vexing questions that have come up on while exploring the rich and varied milieu of the telescope. Let's start with the distant past and cast our minds back to the long focus, non-achromatic aerial telescopes used by Hevelius, Huygens, and Cassini. By making the focal length very long with respect to the aperture of the lens (>F/50), these early pioneers could get a simple convex lens to deliver images sharp enough to discover the basic structure of Saturn's rings and four of its the brighter satellites, the first surface markings on the Red Planet, and even an accurate measurement of its rotation period. Indeed, studies show that these early refractors had resolving powers just a notch below those of modern refractors. What was their saving grace? Focal length, of course! More significantly, anyone exploring the fascinating history of the refractor over the last four centuries is sure to have encountered many tales of astronomers charging their telescopes with impossibly high powers. For

example, how could Wilhelm Struve "routinely" use 700× on the newly constructed 9.5 in. Dorpat refractor while conducting his masterly survey of double stars? We may conjecture that the air around the observatory was the stuff of legend, but we know for sure that he was looking through an F/18 instrument!

We must also call attention to the extraordinary feats of the visual astronomers based at the Lick Observatory, which houses the great 36-in. (0.9 m) Clark refractor. There are numerous entries in the Publications of the Astronomical Society of the Pacific from 1900 to circa 1909 of separations of extremely difficult double stars measured with the Lick refractor by Robert Grant Aitken. What's more, these data were used to establish the orbital elements of these binary stars and are broadly accepted today. Yet, despite its tenfold greater theoretical resolving power and even with the assistance of adaptive/active optics, the Keck telescope atop Mauna Kea can only achieve resolving powers that are broadly similar to those achieved by Aitken et al. using the refractor. How can this be? Perhaps the F/18 focal ratio of the Lick refractor (the Keck is F/1.75) was the decisive factor in stabilizing the images enough to allow these early – and extremely difficult – measurements to be made.

Many seasoned observers have also reported the alleged greater contrast of longer focal ratio refractors over their shorter counterparts. For many years, this idea was dismissed as an urban myth, a result probably of the greater magnifications reached by a given eyepiece in a longer F ratio scope. But the combined effects of depth of focus and less eyepiece astigmatism have led people to re-evaluate these reports. Perhaps it lies in its ability to "hold together," as it were, the image of already diffuse deep sky objects, presenting them in a more stark, contrasted way against the backdrop of a dark sky.

The Emperor's New Telescope

History teaches us lessons. By ignoring its mistakes, we are likely to repeat them in the future. But with equal measure, if we chose to discount its achievements, then we are equally at a loss. These lessons apply to our hobby, too. No one wants to go back to the days of the Galilean spyglass or the unwieldiness of the aerial telescopes of Hevelius. But we have largely forgotten some of the amazing achievements of our telescopic ancestors; accomplishments that still have no equal in the contemporary world of the amateur refracting telescope. These conclusions have been reached in recent years only after this author had an opportunity to look

through one of the rarest and most sublime refractors ever built; a Cooke 6-in. F/18 photovisual refractor, erected in 1896, that now graces Calton Hill Observatory, Edinburgh. Indeed, I have had the good fortune to look through several of these instruments over the last few years, ranging in size from 4 to 6 in. (both privately and publically owned), and I must say, hand on heart, that the images they serve up of the Moon and planets are painfully beautiful and quite simply in a different league from any commercially produced Apo currently on the market. Their long focal lengths enable them to take enormous magnifications routinely and well beyond the 50× per inch maxim promulgated by popular culture. Indeed, I've enjoyed views of double stars through a 4-in. F/18 Cooke Taylor photovisual refractor at powers up to 700×.

Nothing in my 30 years of observing experience had quite prepared me for the views I have enjoyed with these antiquated instruments; and no amount of learning or received wisdom could explain away their many attributes! The great power of the Cooke photovisual, quite apart from their unsurpassed color correction and nonexistent Seidel aberrations, lie in their ability to serve up extraordinarily stable images, a direct result of their enormous native focal ratios. While observing through these great instruments, there is simply none of the image breakdown at high power that you see with the short, commercially produced Apos on the market today. Even on an average night, it is almost as if you can transcend the atmosphere. It is no longer the limiting factor.

As we have seen, there is some tantalizing evidence that focal ratio is strongly linked to image stability. Vladimir Sacek and I have shown that this stability, which scales with the square of focal ratio, is of great advantage when temperature changes occur while observing, although it has yet to be proved that this stability applies generally, in all conditions of seeing. The reasons for this may be related to the defocus aberration, a largely understudied optical phenomenon that is vanishingly small in long focal length telescopes and shoots up rapidly in short ones. This has been, for the most part, unknown to the current generation of amateur astronomer, as the vast majority of you reading this have never had the opportunity of looking through a refractor of large native focal ratio on a regular basis.

The future of the refracting telescope may be driven, unfortunately, by the need to create even shorter optical tubes with multi-element, maybe even hybrid objectives, faster than F/5. These instruments will be supremely difficult to build – not to say expensive – and will be even more frustrating to use. Have you ever tried focusing an F/4 refractor? And do you really think that the control of Seidel aberrations in these super-fast instruments will be anywhere near as well controlled as in their longer focal length counterparts? Has the emporer, as in the fairy tale,

gone mad? Truly, if we are to raise the bar of the refracting telescope, it will not come about by further miniaturization.

Some Suggestions

The current line of Apos are indeed superb performers. The problem is those manufacturers who want to reduce the telescope to something akin to a glorified telephoto lens. We already have telescopes that are ultraportable and those that are optimized for astrophotography, and there is no need to go any further in this direction. As Chris Lord alluded to earlier, the future direction of refractor building seems to be inextricably linked to the evolution of the eyepiece at the present time.

However, is it sensible to build a super short Apo – say a 6" F/3 – or some such just because we can? Although we may marvel at the optical engineering inherent in such a design, who benefits? If more amateurs are to enjoy the dividends of the Apo revolution and already enjoy the look and feel of a long focal length instrument, common sense must prevail. Long focal length provides the following benefits:

1. Supremely comfortable views – especially if you are getting on in age.
2. Easier and more precise focusing.
3. Inexpensive eyepieces that perform like champs.
4. Easier acquisition of high powers without Barlows.
5. More stable images (which I define as the ability of a telescope to resist defocus).

Of course, as focal ratio increases, so, too, does portability suffer. So, the introduction of a long focus Apo should start with models that are easy to build and relatively portable. Here are two suggestions:

* Model no. 1: 80 mm F/12 doublet with one element made with FPL 51 glass.
* Model no. 2: 102 mm F/15 doublet with one element made from FPL 53 glass.

These telescopes would be supremely capable performers on the Moon and planets and would be portable enough to set up in minutes. Of course, we should not overlook larger aperture models – possibly in a folded design? How would these hypothetical long focus Apos square up to the common ED Apos on the market?

Let's do some comparisons with the hypothetical telescopes suggested – an 80 mm F/12 Apo and a 102 mm F/15 Apo – with two popular Apo telescopes in the same aperture class used by amateurs, an 80 mm F/7.5 and an 102 mm F/9 Apo. As mentioned previously, all aberrations fall off rapidly as focal ratio increases. You will note that we are comparing like with like; they are all ED doublets.

First let's compare the 80 mm F/12 Apo to the 80 mm F/7.5 Apo of the same optical figure. A few simple calculations show that the 80 mm F/12 would have 4.1× less spherical aberration, 2.56× less coma and defocus aberration, and 1.6× less astigmatism, field curvature, and distortion. When you do the math with an 102 mm F/15 Apo and a 102 mm F/9 ED Apo you will see that the former will have 4.9× less spherical aberration, 2.8× less coma and defocus aberration, and 1.7× less astigmatism, field curvature, and distortion. Remember the longer telescopes would actually have better color correction owing to their longer focal lengths. All in all, do you think the longer scopes would give you noticeably better images? You bet! Is that a justification for making such telescopes? Absolutely!!

Those who own more complex Apo designs might protest that these are better corrected for the Seidel aberrations than standard ED doublets. But these hypothetical long-focus doublets would be easier and cheaper to make well, would have less issues with collimation, would cool down more rapidly than more complex designs, would be much easier to focus, and would offer more comfortable views even when used with inexpensive eyepieces. In other words, it's a no brainer! New companies such as ISTAR Optical, Arizona, are now beginning to offer reasonably priced 5- and 6-in. ED F/12 objectives, which can also be purchased in high quality tube assemblies at additional cost. This is a new wave in the telescope market – build your own refracting telescope!

Large native focal length is a worthy optical commodity that is rapidly disappearing from a telescope market driven by the incessant need to miniaturize. Focal length is the friend of the astronomer. As has been argued here, far from just being nature's way of ameliorating the imperfections of human handiwork, it is also an unassailable asset in improving image quality and viewing comfort. In our feverish quest to diminish the size of our refracting telescopes, we have forgotten something that was common knowledge to our telescopic ancestors and we ignore it at our own loss. Furthermore, the future is not exclusively Apo. High specification achromats are as good as their color-pure cousins as dedicated double star telescopes.

Thus, we return to the original question posed at the beginning of the chapter. What is the future of the refractor? The answer is – wherever we want it go!

Appendices

Appendix A: Refractor Design Through the Centuries

1761–1764 Clairaut Doublet – Second & Third surfaces in contact (four possible bendings)

1898 Harting Doublets – aplanatic (coma-free) cemented lenses crown forward

Contact doublets – with air gap, crown forward:
 1760 Dollond
 1760–1810 Clairaut, d'Alembert, Boscovitch, Kleugel
 1815 Fraunhofer
 1829 Littrow
 1846 Clark modified Littrow
 1855 Cooke
 1864 Grubb
 1879 Hastings-Brashear

Contact doublets – with air gap, flint forward:
 1758 Dollond
 1842 Stenheil
 1879 Hastings

Contact triplets – crown forward:
 1763 Dollond

Non-contact doublets – crown forward:
 1860 Clark
 1867 Gauss
 1945 Baker Aplanat
 1980 Buchroeder

Non-contact doublets – flint forward:
 1867 Gauss

Apochromatic doublets:
 1886 Czapski – modified Fraunhofer
 1888 Czapski – modified Gauss flint forward
 1892 Cooke-Taylor f/18 (Taylor)
 1899 Zeiss A halb (Konig) f/20
 1926 Zeiss AS f/10 (Sonnefeld)
 1987 Gregory Fluor-Crown f/15

Apochromatic triplets:
 1894 Cooke-Taylor PV f/18 (Taylor)
 1896 Zeiss B f/15 (Konig)
 1950 Zeiss F f/11 Schwerflint (Kohler & Conradi)
 1977 Busch HAB f/15 (halbapochromat bausatz) oiled - not sealed
 1981 Christen f/10 – modified Taylor PV/Zeiss B oiled - Kapton sealed
 1986 Zeiss APQ f/10 fluorite
 1990 Fluor-crown FPL51 / FPL53 air spaced
 1995 Fluor-crown FPL53 oiled – Kapton sealed

Apochromatic quadruplets:
 1999 Laux FPL53 f/7

Dialytes:
 1828 Rogers
 1834 Plossl
 1840 Petzval
 1985 Christen (Fraunhofer doublet with triplet sub-aperture corrector)
 2000 Chromacorr (Fraunhofer doublet sub-aperture corrector)
 2006 Zerochromat (Single OG with dialytic field corrector)

Appendix B: Double Star Tests for Refractors of Various Apertures

The Dawes limit for your telescope (in arc seconds) is given by 4.56/D where D is the aperture of your telescope in inches. Use a high-power eyepiece yielding 30–50× per inch of aperture on a calm night. Pairs displaying wide separations are chosen to test your telescope's ability to pick out pairs that vary greatly in brightness.

Tests for a 2.4-in. (60 mm) Scope

Star	Right ascension	Declination	Mag	Separation
εBootis	14 h 45 min	+27° 04	2.6, 4.8	2.9″
αUrsa Minoris	02 h 32 min	+89°16	2.1, 9.1	18.6″
λOrionis	05 h 35 min	+09° 56	3.5, 5.5	4.3″

Tests for a 3-in. (76 mm) Scope

Star	Right ascension	Declination	Mag	Separation
δCygni	19 h 45 min	+45° 08	2.6, 6.3	2.5″
ιCassiopeiae	02 h 29 min	+67° 24	4.6, 6.9	2.9″
θAurigae	06 h 00 min	+37° 13	2.7, 7.2	3.8″
πLupi	15 h 05 min	−47° 03	4.6, 4.6	1.6″

Tests for a 4-in. (102 mm) Scope

Star	Right ascension	Declination	Mag	Separation
μCygni	21 h 44 min	+28° 45′	4.7, 6.2	1.9″
αPiscium	02 h 02 min	+02° 46′	4.1, 5.2	1.9″
γVirginis	12 h 42 min	−01° 27′	3.5, 3.5	1.3″
βΜὺσχαε	12 h 46 min	−68° 08′	3.5, 4.0	1.1″

Tests for a 4.7-in. (120 mm) Scope

Star	Right ascension	Declination	Mag	Separation
32 Orionis	05 h 31 min	+05° 57′	4.4, 5.8	1.2″
κ Leonis	09 h 25 min	+26° 11′	4.5, 9.7	2.4″
α Σχορπιι	16 h 21 min	−26° 26′	1.0, 5.4	2.5″

Tests for a 6-in. (150 mm) Scope

Star	Right ascension	Declination	Mag	Separation
ζBootis	14 h 41 min	+13° 44'	4.5, 4.6	0.8″
ζ Herculis	16 h 41 min	+31° 36'	2.9, 5.5	0.8″
α-2-Capricorni	20 h 18 min	−12° 33'	3.6, 10.4	6.6″
λCentauri	11 h 36 min	−63° 01'	3.1, 11.5	16″

Appendix C: Useful Formulae

Eyepiece magnification = focal length of the objective/focal length of eyepiece.

Field of view (angular degrees) = Apparent field of view of eyepiece/eyepiece magnification (approximate). A more accurate formula is given by: (eyepiece field stop diameter/focal length of telescope) × 57.3.

Focal ratio of telescope = Focal length of telescope/objective diameter.

Chromatic aberration (CA) index = Focal ratio of telescope/aperture (in inches).

Exit pupil = telescope aperture (mm)/magnification of eyepiece.

Depth of Focus = $\Delta F = \pm 2\Delta F^2$, where Δ is the wavelength of light and F is the focal ratio of the telescope.

Angular measurement = 1 angular degree = 60 min of arc (60′) = 3,600 s of arc (3,600″)

Limiting magnitude of a telescope = $6.5 - 5 \log d + 5 \log D$, where d is the diameter of the observer's pupil when dark adapted and D is the aperture of your telescope.

Appendix D: Glossary

Abbe number: A number indicating the dispersion of an optical substance. The larger the Abbe number (V), the lower its dispersion. Numerically,

$$V = \frac{n_D - 1}{n_F - n_c},$$

where n_D, n_F and n_C are the refractive indices of the material at the wavelengths of the Fraunhofer D (yellow)-, F(blue)- and C(red)-spectral lines (589, 486 and 656 nm respectively).

Achromat: Type of refractor that uses a doublet objective made from crown and flint glass.

Airy disc: The disc into which the image of a star is spread by diffraction in a telescope. The size of the Airy disk limits the resolution of a telescope.

Alt-azimuth: A type of mount, like a simple photographic that allows you to make simple movements from left to right (azimuth) and up and down (altitude).

Antireflection coating: The application of a very thin layer of a substance (e.g. magnesium fluoride) to the surface of the lens which has the effect of increasing light transmission and reducing internal reflections in the glass.

Apochromat: Type of refractor that uses exotic glass types that produces colour-free images in focus.

Astigmatism: An aberration that occurs when there is a difference in the magnification of the optical system in the tangential plane and that in the sagittal plane.

Autoguider: An electronic device that makes use of a CCD camera to detect guiding errors and makes automatic corrections to the telescopes drive system.

Barlow lens: A concave achromatic lens with negative focal length, used to increase the magnification of a telescope.

Chromatic aberration: A phenomenon caused by the focusing of light of different wavelengths at different positions relative to the objective.

Chromatic Aberration (CA) Index: A measure of color correction in achromats found by dividing by the focal ratio of the telescope by its aperture in inches. The larger the CA index, the better color corrected the instrument.

Coma: An aberration which causes a point object to be turned into a pear or comet-shaped geometry at the focal plane, and which most commonly manifests itself off-axis.

Depth of focus: A measure of how easy it is to attain and maintain a sharp focus. The larger the focal ratio of your scope, the greater its focus depth.

Diffraction: A wave phenomenon which occurs when waves bend or distort as they pass round an obstacle.

Dispersion: The tendency of refractive materials (e.g. a lens or prism) to bend light to differing degrees causing the colors of white light to separate into a rainbow of colours.

Doublet: A telescope with an objective made from two glass elements.

ED: Short for extra low dispersion, usually referring to glass which focuses red green and blue light more tightly than a regular crown flint objective resulting in better color correction.

Extrafocal: Outside focus.

Eye relief: the distance from the vertex of the eye lens to the location of the exit pupil.

Fluorite: A mineral with very low dispersion made from crystals of calcium fluoride (CaF_2).

Focal length: The linear distance between a lens and the point at which it brings parallel light rays to a focus.

Focal ratio: The focal length of a telescope divided by its aperture.

Fresnel rings: The set of diffraction seen round stars just outside and inside focus.

Intrafocal: Inside focus.

Magnification: The factor by which a telescope makes an object larger.

Minus violet filter: A filter designed to block shorter wavelengths of visible light (blue and violet) to reduce the spurious color seen round bright objects using achromatic refractors.

Multi-coated: The lenses are antireflection coated with more than one layer of coatings.

Petzval: A four element optical design consisting of two widely spaced doublets used to reduce chromatic aberration and flatten the field of view for photographic applications.

Refraction: A wave phenomenon that causes light to change direction (and consequently the speed) upon entering or leaving a transparent material.

Refractive index (n): A measurement of much light slows down in the material it is travelling through. If a given glass has a value of $n = 1.5$ light slows down on entering the glass to $1/1.5$ or 66% of the speed of light in air. Experimentally, $n = \sin i / \sin r$ where i and r are the angles of incidence and refraction of the glass, respectively.

Refractor: Type of telescope that uses glass lenses to bring light to a sharp focus.

Spherical aberration: The inability to focus rays of light emanating from the centre and edges of a lens at a single point in the image plane.

Spherochromatism: The variation of spherical aberration with wavelength (colour) of light used.

Triplet: A telescope with an objective made from three separate glass elements.

References

History of the Refractor

King, H.C., *The History of the Telescope*, (1955), Dover.
Hoskins, M. (ed.), *The Cambridge Concise History of Astronomy*, (1999), Cambridge University Press.
Warner, D.J., *Alvan Clark & Sons, Artists in Optics*, (1968), Smithsonian Institution Press.

Refractor Optics

Bell, L., *The Telescope*, (1981), Dover.
Suiter, H.R., *Star Testing Astronomical Telescopes*, (2009), Willmann-Bell.
Roth, G.D., *The Amateur Astronomer & his Telescope*, (1972), Faber & Faber.
Kitchin, C.R., *Telescopes and Techniques*, (1995), Springer.
Pfannenschmidt, E., *Sky & Telescope*, April 2004, pp 124–128.
Binder, A., *Sky & Telescope*, April 1992, pp 444–450.
Robinson, L.J., *Outdoor Optics*, (1990), Lyons and Burford.
www.brayebrookobservatory.org The website of Christopher Lord, an authority on refractor optics and double star observing.

Observational Astronomy Books

Ridpath, I., & Tirion, W., *Star & Planets*, (2007), Collins.

Ridpath, I.(ed.), *Norton's Star Atlas and reference Handbook*, (2003), Longmann.

R Consolmagno, G. & Davis, D.M., *Turn left at Orion*, (2000), Cambridge University Press.

P Argyle, B.(ed.), *Observing and measuring Double Stars,* (2004), Springer.

Haas, S., *Double Stars for Small Telescopes*, (2006), Sky Publishing.

Mullaney, J. & Tirion, W., *The Cambridge Double Star Atlas*, (2009), Cambridge University Press.

Price, F.W., *The Planets Observer's Handbook*, (2000), Cambridge University Press.

General Guides to Equipment

Backich, M., *The Cambridge Encyclopedia of Amateur Astronomy*, (2003), Cambridge University Press.

Dickinson, T. & Dyer, A., *The Backyard Astronomer's Guide*, (2008), Firefly Books.

Harrington, P.S., *Star Ware*, (2007), Wiley.

Mobberley, M., *Astronomical Equipment for Amateurs* (1998), Springer.

Astrophotography

Ratledge, D., *Digital Astrophotography; the State of the Art*, (2005), Springer.

Reeves, R., *Introduction to Digital Astrophotography*, (2005), Willmann-Bell.

Recommended Monthly Periodicals

Astronomy Now; the leading and best established British astronomy magazine.

BBC Sky at Night Magazine: a popular choice amongst UK amateurs.

Sky & Telescope and *Astronomy* magazines; for up to the minute reviews and all the latest news, with a North American slant.

Astronomy & Space; published by Astronomy Ireland, a good resource for all things astronomical in the Emerald Isle.

Websites of Interest to Refractor Enthusiasts

Vladimir Sacek's excellent website on telescope optics www.telescopeoptics.net.

Roger Ceragioli's Refractor Construction Page, http://bobmay.astronomy.net

Back, T.M., *Defining Apochromatism*, http://geogdata.csun.edu/~voltaire/tmb/definition.html

www.excelsis.com: A surprisingly good review site for telescopes and astronomical accessories.

www.cloudynights.com: A superb resource to the astronomical community.

www.Astromart.com: A market place for astronomical ware and equipment reviews.

www.telescopejunkies.com

www.iceinspace.com.au: An excellent online resource for Australian amateurs.

www.Scopereviews.com: Ed Ting's eclectic website featuring mini-reviews on some nice refractors of older pedigree.

Index